Warm Days, Cool Knits

Warm Days, Cool Knits

LIGHTER DESIGNS FOR EVERY SEASON

—

CORRINA FERGUSON

INTERWEAVE
interweave.com

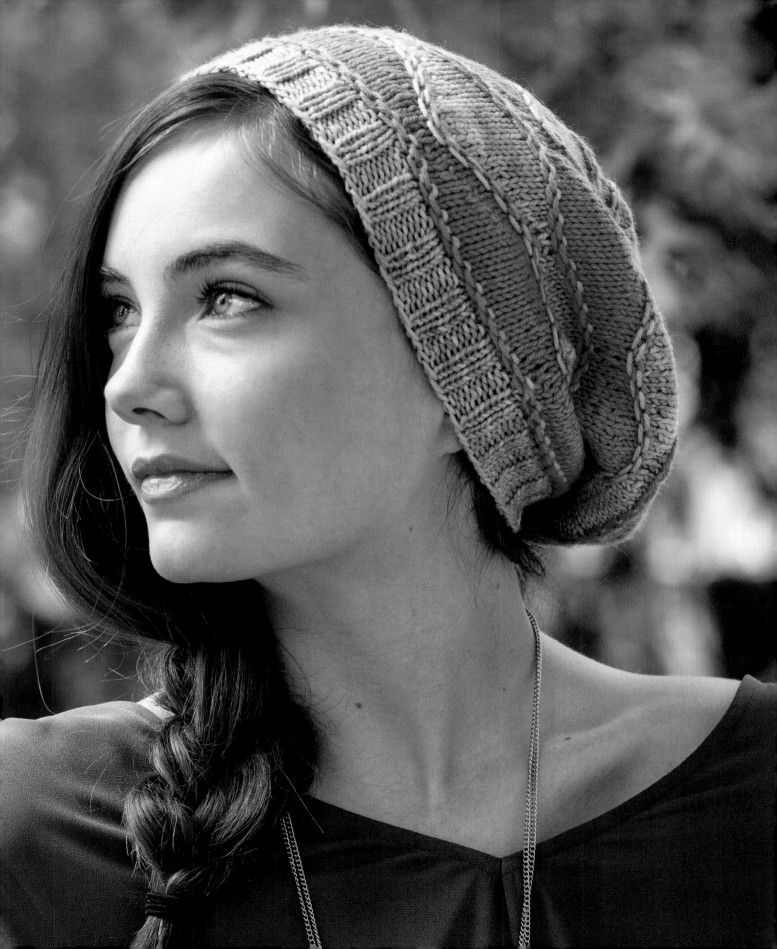

EDITOR *Michelle Bredeson*
TECHNICAL EDITOR *Renée Lorion*
ASSOCIATE ART DIRECTOR *Charlene Tiedemann*
DESIGN *Pamela Norman*
LAYOUT *Connie Poole*
PHOTOGRAPHER *Joe Hancock*
STYLIST *Allie Liebgott*
HAIR & MAKEUP *Kathy MacKay*
PRODUCTION *Kerry Jackson*

Interweave
A division of F+W Media, Inc.
4868 Innovation Drive
Fort Collins, CO 80525
interweave.com

Manufactured in China by RR Donnelley Shenzhen.

Library of Congress Cataloging-in-Publication Data
Ferguson, Corrina.
Warm days, cool knits : Lighter designs for every season /
Corrina Ferguson.
 pages cm
 Includes index.
 ISBN 978-1-62033-852-0 (pbk.)
 ISBN 978-1-62033-855-1 (PDF)
 1. Knitting. 2. Sweaters. 3. Shawls. I. Title.
TT825.F448 2015
 746.43'2--dc23
 2014035045

10 9 8 7 6 5 4 3 2 1

*To Daniel, Jeremy, and Justin:
Thank you for putting up with my
craziness (and a lot of takeout)
so I could achieve this goal.*

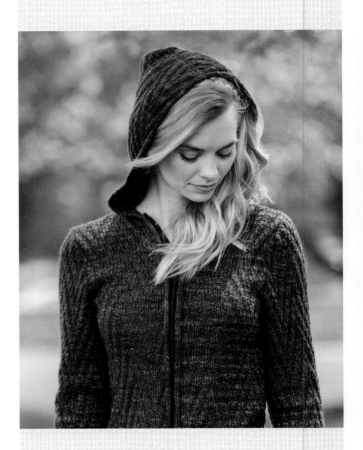

Acknowledgments

*With special thanks to Heather
Zoppetti for making me do this and to
the amazing sample knitters who worked
on projects for me: Kristin Bellehumeur,
Connie Buckwalter, Chris Gagnon,
Brenda Pirie, Dolly Quinn, Kim Stubbs,
and Karen Verbenko. I also owe a debt
of gratitude to the customers and friends
who encouraged me along the way and
to my editor, Michelle Bredeson,
for putting up with me!*

Contents

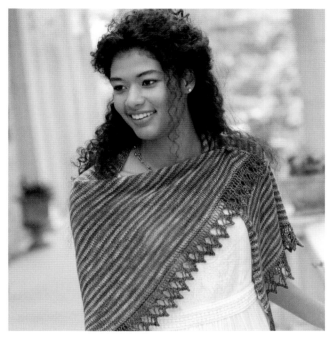

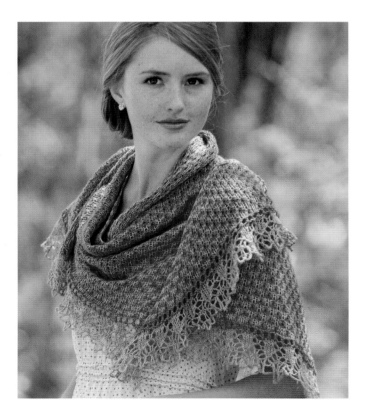

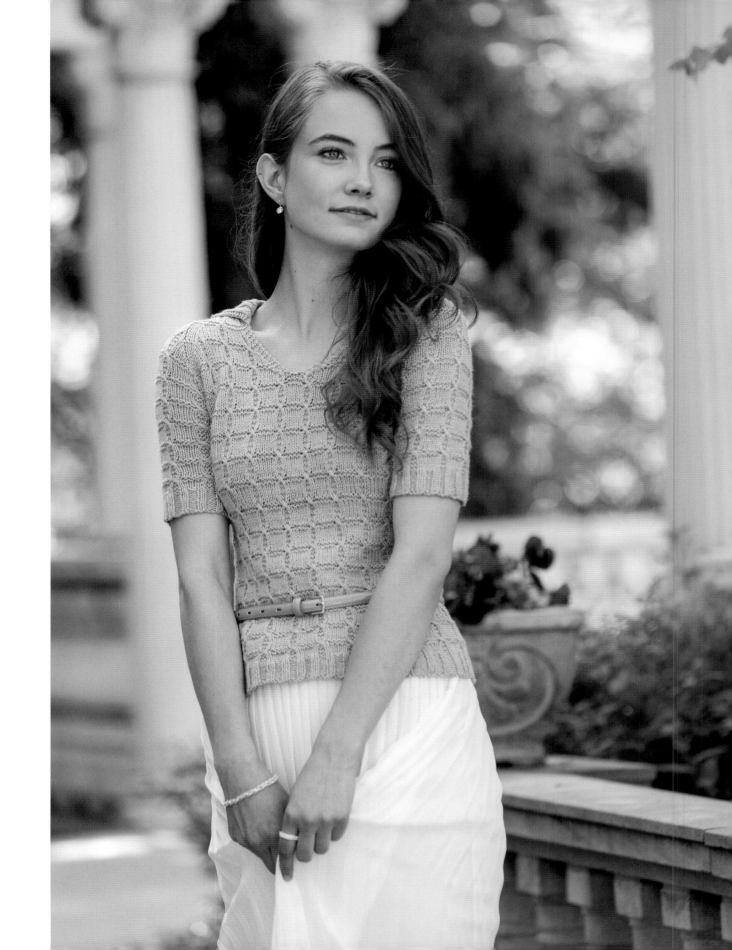

Introduction

↠ WHEN I MOVED TO FLORIDA over a decade ago,
I experienced a bit of culture shock. I had lived in Ohio nearly
my entire life, and the subtropical weather and Southern customs
were quite foreign to me. To add insult to injury I had given
up my career to be a stay-at-home mom, but then my boys
promptly started school! I did not know what to do with
myself, so I decided to take up knitting. Because you know,
it's such a useful hobby to pursue in Florida.

If you're a knitter and you live up North—or in any climate that has four discernible seasons—it makes sense. You make cozy things for winter. You need woolly hats and mittens and such things. You talk about "sweater weather." It would have been great to be a knitter while dealing with those Ohio winters.

But if, like me, you live in the South, or other places where snow is a novelty, and the air conditioning runs most of the year, it's a bit trickier. When you tell people you're a knitter they look at you funny. The local yarn shops are few and far between. There are only a handful of days of sweater weather each year, and those sweaters are usually worn as coats.

But even in the South we love to knit. And we want to knit pretty wearable things, not just accessories and household decorations.

That's why I created this collection of patterns to showcase the knitted seasons of the South, with projects that are fitting for any climate.

To keep things a bit cooler, all the yarns used are DK weight or lighter, and many of the blends knitted up for spring and summer wear include warm-weather fibers such as cotton and linen. This also makes for more comfortable knitting in warm climes—no bulky wool projects to heat up your lap!

So break out your knitting needles and whip up some cool knits for warm days and all of the days in between. The beautiful yarns used in the book will definitely become some of your new favorites if you don't know and love them already. And even if summer passes you by in the blink of an eye where you live, you can still find year-round pieces to knit and wear.

WHAT'S IN A NAME?

All of the projects in the book are titled with old-fashioned Southern names, some of which may be familiar, but most of which have passed into history. Lovely, storied names that fit the projects they are bestowed upon, with the frilliest of names going to the laciest of things.

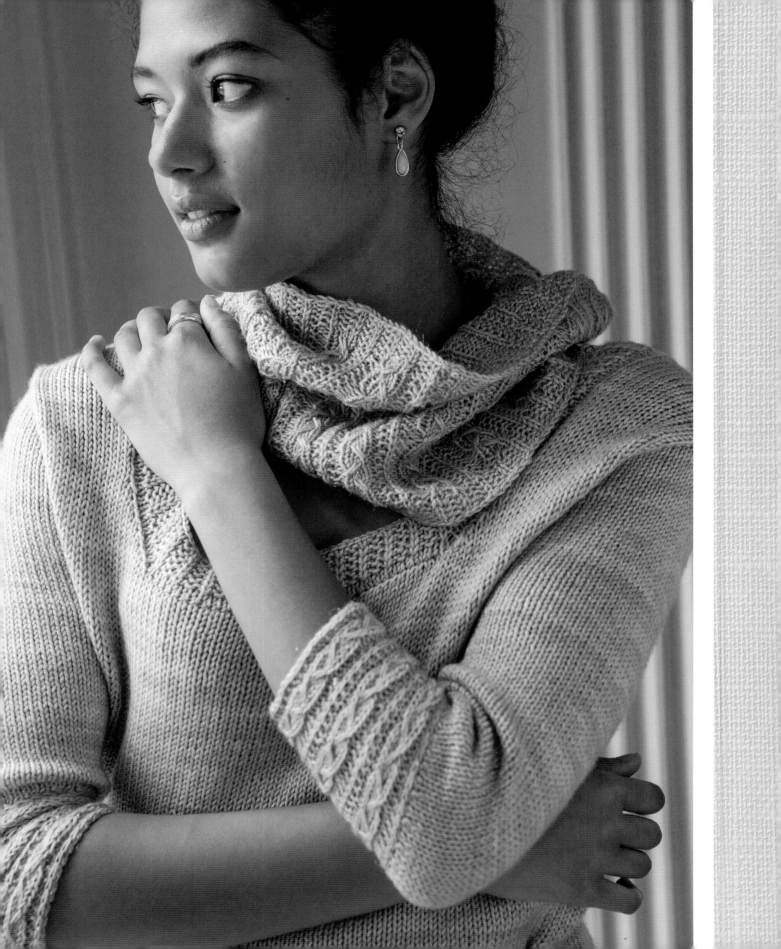

ONCE YOU GET used to living in a warm climate, you get cold a whole lot faster. Sixty degrees sounds like the perfect temperature to toss on a cozy lightweight cardigan, and if it drops much lower than that you can opt for the hooded one!

Winter

A slouchy hat in ocean blues will keep your head warm in style, and lacy socks are just enough to keep your toes toasty. Winter is also the season of holiday parties, and a pullover with just a touch of bling in the yarn and a removable cowl is perfect for dressing up or down.

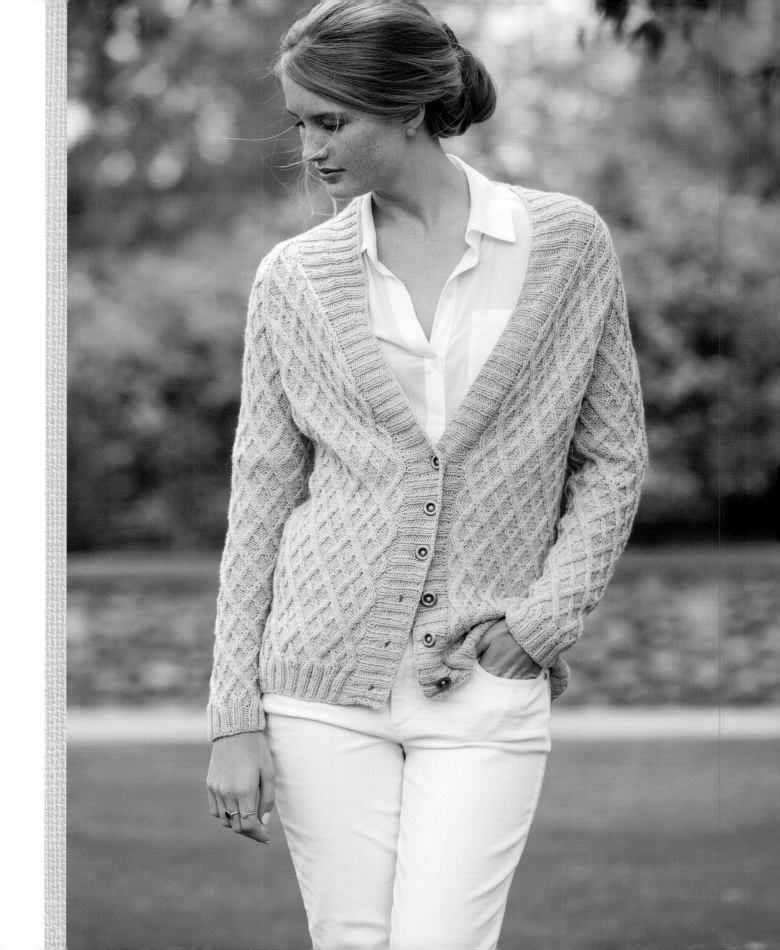

Denford

ARGYLE-CABLE CARDIGAN

Even in the South, you sometimes need something to wrap up in. A lot of folks down here don't even own winter coats, but a cozy cardigan is just the right amount of weight and warmth. This one is worked in a wool-silk blend that's next-to-the-skin soft, so go ahead and wear short sleeves!

FINISHED SIZE
About 36 (44, 52, 60)"
(91.5 [112, 132, 152.5] cm)
bust circumference.

Sweater shown measures
36" (91.5 cm).

YARN
DK weight (#3 Light).

Shown here: Sincere Sheep
Luminous (85% wool, 15%
silk; 330 yd [302 m]/4 oz
[115 g]), cumulus (light
gray), 5 (6, 7, 8) skeins.

NEEDLES
*Ribbing, front bands,
and collar:* Size U.S. 5
(3.75 mm): 40" (100 cm)
or longer circular (cir).

Body and sleeves: Size U.S.
6 (4 mm).

*Adjust needle size
if necessary to obtain
the correct gauge.*

NOTIONS
Markers (m); cable needle
(cn); waste yarn; tapestry
needle; six ¾" (2 cm)
buttons.

GAUGE
27 sts and 31 rows = 4"
(10 cm) in Argyle Cable
Chart on size 6 needles.

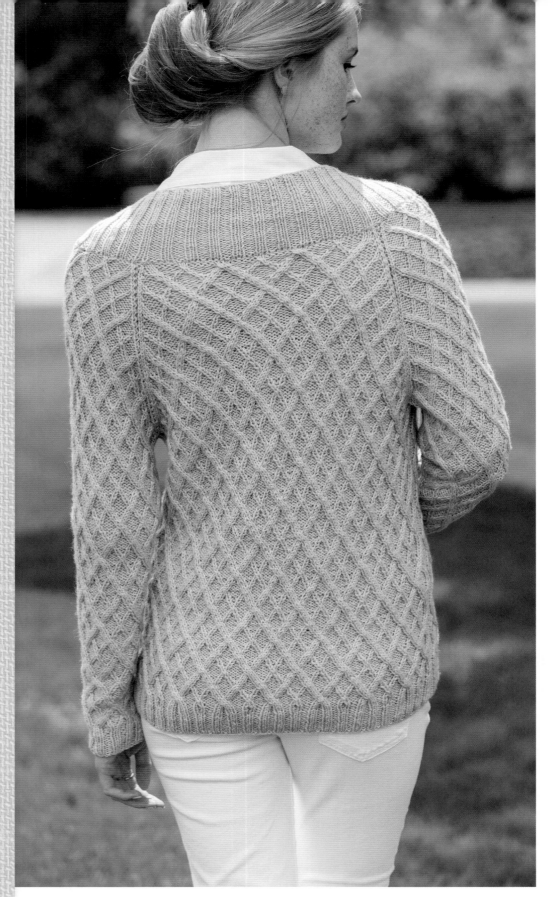

Back

With smaller needle, CO 100 (124, 148, 172) sts.

ROW 1: (RS) K1, *p2, k2; repeat from * to last 3 sts, p2, k1.

ROW 2: (WS) P1, *k2, p2; repeat from * to last 3 sts, k2, p1.

Work 8 more rows in k2, p2 rib as established, then work increase rows as follows:

INC ROW 1: (RS) K1, p2, k2, p2, *k1f&b, k1, p2, [k2, p2] twice; repeat from * to last 9 sts, k1f&b, k1, p2, k2, p2, k1—108 (134, 160, 186) sts.

ROW 2: (WS) P1, k2, p2, k2, p1, k1, p1, *k2, [p2, k2] twice, p1, k1, p1; repeat from * to last 7 sts, k2, p2, k2, p1..

INC ROW 3: (RS) K1, p2, k2, p2, *k1f&b, p1, k1, p2, [k2, p2] twice; repeat from * to last 10 sts, k1f&b, p1, k1, p2, k2, p2, k1—116 (144, 172, 200) sts.

ROW 4: (WS) P1, k2, p2, k2, p1, k2, p1, *[k2, p2] twice, [k2, p1] twice; repeat from * to last 7 sts, k2, p2, k2, p1.

Change to larger needles and work the 24-row Argyle Cable Chart until the back measures 16 (16, 17, 17)" (40.5 [40.5, 43, 43] cm) from the cast-on edge, end with chart Row 12 (12, 20, 20).

BACK RAGLAN SHAPING

Note: Work dec's one st in from each side edge, maintaining knit st at each edge. For 52" and 60" (132 and 152.5 cm) sizes, alternate single decreases with double decreases each side until 5 (14) double decreases have been worked, then cont with single decreases only.

BO 5 (7, 9, 10) sts at the beg of next 2 rows, then dec one st at each side of needle every RS row 30 (34, 38, 40) times—46 (62, 68, 72) sts. Work 1 WS row. BO all sts.

Right Front

Use smaller needles and CO 52 (64, 76, 88) sts.

ROW 1: (RS) K1, *p2, k2; repeat from * to last 3 sts, p2, k1.
ROW 2: (WS) P1, *k2, p2; repeat from * to last 3 sts, k2, p1.

Work 8 more rows in k2, p2 rib as established, then work increase rows as follows:

INC ROW 1: (RS) K1, p2, k2, p2, *k1f&b, k1, p2, [k2, p2] twice; repeat from * to last 9 sts, k1f&b, k1, p2, k2, p2, k1—56 (69, 82, 95) sts.

ROW 2: (WS) P1, k2, p2, k2, p1, k1, p1, *k2, [p2, k2] twice, p1, k1, p1; repeat from * to last 7 sts, k2, p2, k2, p1.

INC ROW 3: (RS) K1, p2, k2, p2, *k1f&b, p1, k1, p2, [k2, p2] twice; repeat from * to last 10 sts, k1f&b, p1, k1, p2, k2, p2, k1—60 (74, 88, 102) sts.

ROW 4: (WS) P1, k2, p2, k2, p1, k2, p1, *[k2, p2] twice, [k2, p1] twice; repeat from * to last 7 sts, k2, p2, k2, p1.

Change to larger needles and work the 24-row Argyle Cable Chart until the front measures 16 (16, 17, 17)" (40.5 [40.5, 43, 43] cm) from the cast-on edge, end with chart Row 13 (13, 21, 21).

FRONT RAGLAN AND V-NECK SHAPING

Note: Work dec's one st in from each side edge, maintaining knit st at each edge. For 52" and 60" (132 and 152.5 cm) sizes, alternate single decreases with double decreases each side until 5 (14) double decreases have been worked, then cont with single decreases only.

BO 5 (7, 9, 10) sts at beg of next WS row, then dec one st at armhole edge every RS row 30 (34, 38, 40) times.

At the same time, dec one st at neck edge every other RS row 8 (4, 6, 6) times, and then every RS row 12 (24, 24, 26) times—5 (5, 6, 6) sts remain. BO all sts.

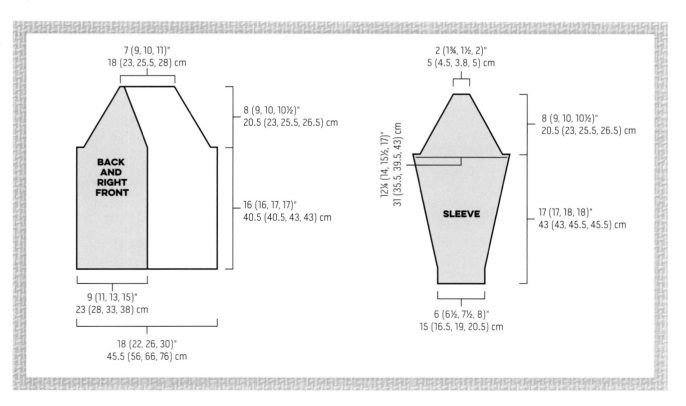

Left Front

Work as for right front, ending before raglan shaping with Row 12 (12, 20, 20) and reversing all shaping.

Sleeves

Note: When inc'ing into chart patt, if there are not sufficient sts to cross a cable, work sts in patt (k the knit sts and p the purl sts).

With smaller needle, CO 48 (52, 60, 64) sts.

ROW 1: (RS) K1, *p2, k2; repeat from * to last 3 sts, p2, k1.
ROW 2: (WS) P1, *k2, p2; repeat from * to last 3 sts, k2, p1.

Work 8 more rows in k2, p2 rib as established, then work increase rows as follows:

INC ROW 1: K1, p2, *k1, ssk, p1, [k1, k1f&b, p2] twice; rep from * to last st, k1—51 (56, 64, 69) sts.

ROW 2: P1, [k3, p2] 1 (2, 1, 2) times, k1, p2, *[k3, p2] twice, k1, p2; rep from * to last 3 sts, k2, p1.

INC ROW 3: K1, p2, *k1, ssk, [k1, k1f&b, p3] twice; rep from * to last st, k1—54 (60, 68, 74) sts.

ROW 4: P1, k4 (0, 4, 0), p4 (0, 4, 0), *[k4, p2] twice, p2; rep from * to last 3 sts, k2, p1.

Change to larger needles and work Argyle Cable Chart beg with Row 17, as foll:

ROW 17: (RS) K1, p1, beg one st before rep line, work 14-st rep to last st, k1.

Cont to work chart as established. *At the same time,* inc one st at each side of needle every 6th row 15 (17, 18, 20) times, working inc'd sts into chart patt—84 (94, 104, 114) sts.

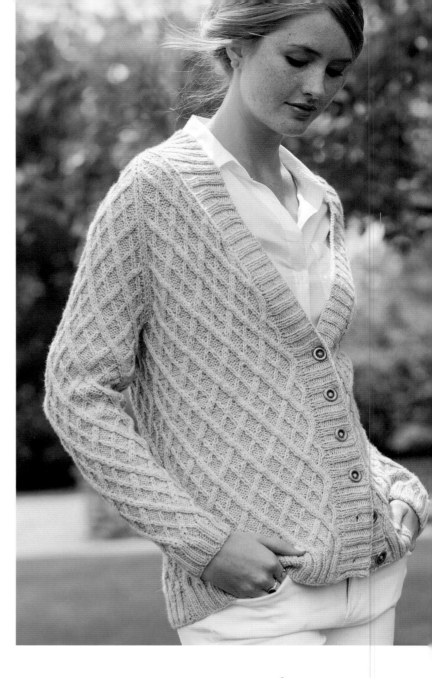

Work even until sleeve measures 17 (17, 18, 18)" (43 [43, 45.5, 45.5] cm) from beg, end with chart Row 12 (12, 20, 20).

RAGLAN SLEEVE SHAPING

BO 5 (7, 9, 10) sts at the beg of the next 2 rows, then dec one st at each needle end every RS row 30 (34, 38, 40) times—14 (12, 10, 14) sts. Work 1 WS row. BO.

Finishing

Block pieces to measurements. Sew raglan sleeve seams. Sew side and sleeve seams.

FRONT BANDS AND COLLAR

With smaller needle, starting at right front lower edge, pick up and k 148 (152, 156, 158) sts evenly along front edge to shoulder, about 3 sts for every 4 rows,

ARGYLE-CABLE CHART

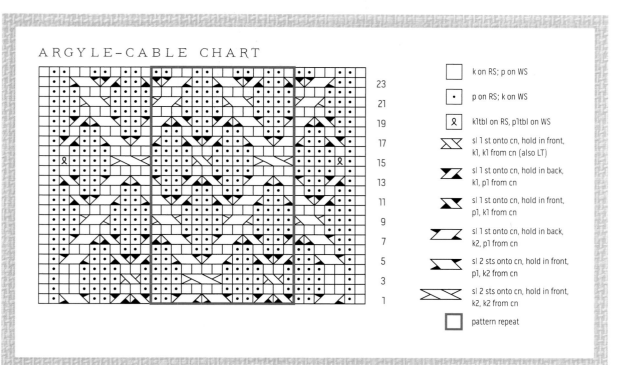

☐	k on RS; p on WS
•	p on RS; k on WS
℞	k1tbl on RS, p1tbl on WS
	sl 1 st onto cn, hold in front, k1, k1 from cn (also LT)
	sl 1 st onto cn, hold in back, k1, p1 from cn
	sl 1 st onto cn, hold in front, p1, k1 from cn
	sl 1 st onto cn, hold in back, k2, p1 from cn
	sl 2 sts onto cn, hold in front, p1, k2 from cn
	sl 2 sts onto cn, hold in front, k2, k2 from cn
☐	pattern repeat

place marker (pm), pick up and k 42 (54, 62, 66) sts along back neck edge, pm, 148 (152, 156, 158) sts along left front edge to lower edge.

ROW 1: (WS) P2, *k2, p2; repeat from * to end.

ROW 2: (RS) K2, *p2, k2; repeat from * to end.

Work Rows 1 and 2 twice more, then work Row 1 once more.

BUTTONHOLE ROW: (RS) K2, p2, k2, *BO 2 sts, work 9 (9, 13, 13) sts in patt; repeat from * 5 more times, continue in ribbing as established to end of row.

NEXT ROW: (WS) Work in rib as established, casting on 2 sts for each buttonhole.

SHORT-ROW COLLAR SHAPING

NEXT ROW: (RS) Work in rib to 2nd marker, turn. Yo, work to first marker, turn.

SHORT-ROW: Yo, work in rib to next yo, work yo tog with foll st, work 3 more sts in rib, turn.

Rep Short-row 13 more times— a total of 16 short-rows have been worked.

NEXT ROW: (RS) Yo, work to end of row, working yo tog with foll st.

Work 4 more rows in ribbing as established. BO all sts in patt.

Weave in all ends. Block collar and buttonband. Sew buttons to left front band opposite buttonholes.

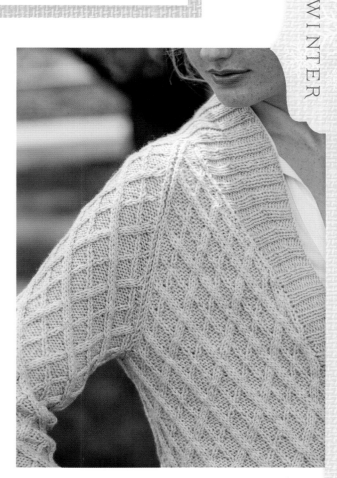

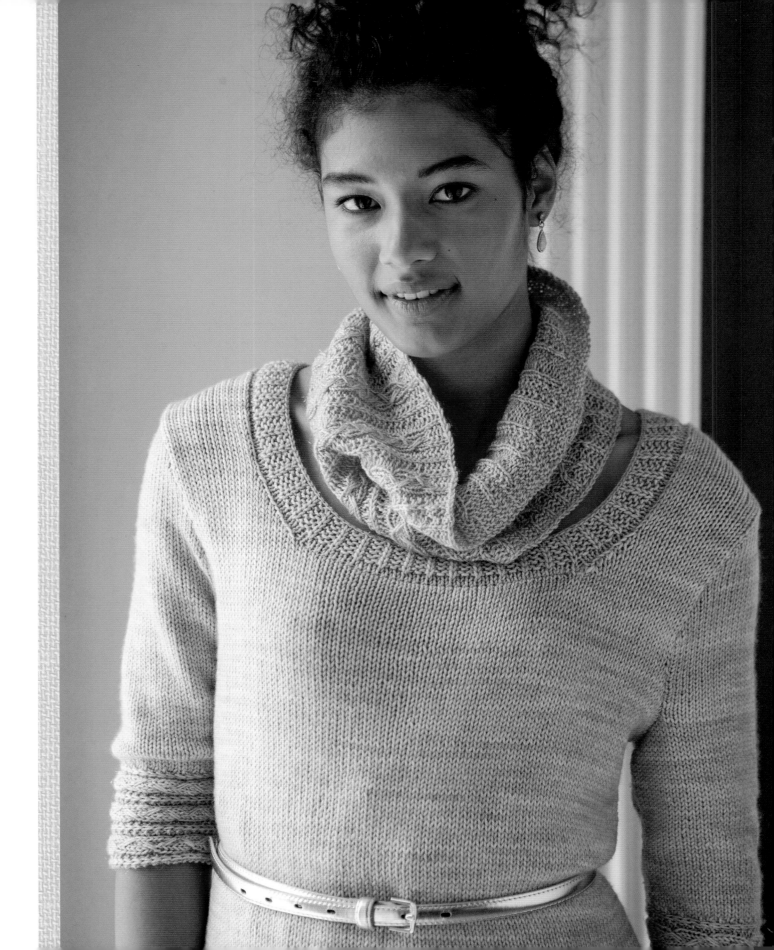

Zolena

COWL & PULLOVER SET

Zolena is a lovely winter sweater, great for pairing with jeans or a pretty skirt for a holiday cocktail party. The subtle sheen of Anzula's Nebula yarn adds just the right amount of glamour without being too glitzy. The separate cabled cowl matches the sweater's cuffs, and it's an optional cover-up for the open neckline.

FINISHED SIZE

Sweater: About 34¼ (37¾, 42¼ , 45¾ , 50¼)" (87 [96, 107.5, 116, 127.5] cm) bust circumference.

Project shown measures 34¼" (87 cm).

Cowl: About 22 (22, 22, 25, 25)" (56 [56, 56, 63.5, 63.5] cm) in circumference.

YARN

DK weight (#3 Light).

Shown here: Anzula Cricket (80% superwash merino wool, 10% cashmere, 10% nylon; 250 yd [229 m]/4 oz [115 g]), peach, 3 (4, 4, 5, 5) skeins (A). Anzula Nebula (86% superwash merino wool, 14% sparkling Stellina; 400 yd [366 m]/4 oz [115g]), peach, 1 skein (B).

NEEDLES

Size U.S. 5 (3.75 mm): 16" and 24" or 32" (40 and 61 or 81 cm) circular (cir).

NOTIONS

Markers (m); cable needle (cn); waste yarn; tapestry needle.

GAUGE

21 sts and 30 rows = 4" (10 cm) in St st after blocking.

NOTES

The cowl is worked separately in the round.

After sleeve cuffs are worked flat, sts are picked up along the cuff edge for the sleeves, which are also worked flat.

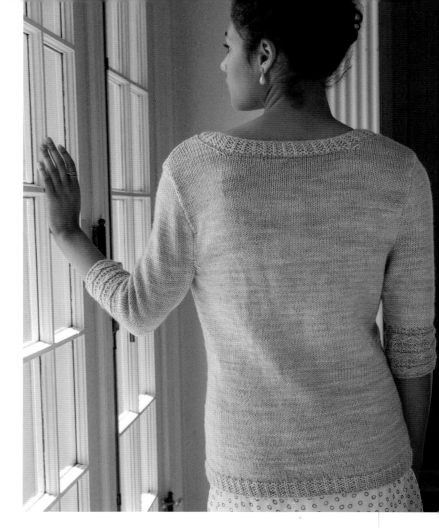

Body

With B, CO 180 (198, 222, 240, 264) sts using a long-tail cast-on (see Glossary). Join to work in the round, being careful not to twist sts, and place marker (pm) for beg of rnd. Place a 2nd marker at the halfway point for waist shaping. With A, work 12 rnds of Garter-Slip Rib, then work in St st (k every rnd) for 5 (5, 12, 12, 20) rnds.

WAIST SHAPING

DEC RND: *K1, ssk, k to 3 sts before m, k2tog, k1; repeat from * once more.

Rep Dec rnd every 12th rnd twice more—168 (186, 210, 228, 252) sts. Work 18 rnds even.

INC RND: *K1, M1, k to one st before m, M1, k1; repeat from * once more.

Rep Inc rnd every 12th rnd twice more—180 (198, 222, 240, 264) sts.

Cont in St st until body measures 15 (15, 16, 16, 17)" (38 [38, 40.5, 40.5, 43] cm), end last rnd 4 (4, 5, 5, 6) sts before beg-of-rnd marker.

NEXT RND: BO 4 (4, 5, 5, 6) sts, sl beg-of-rnd m, BO 4 (4, 5, 5, 6) sts, knit to 4 (4, 5, 5, 6) sts before side marker, BO 8 (8, 10, 10, 12) sts, knit to end of rnd—82 (91, 101, 110, 120) sts for each front and back. Turn to work back and forth over back sts, leaving sts for front on hold.

Back

BO 4 (6, 7, 8, 8) st at the beg of the foll 2 rows. Dec one st at each side every RS row twice—70 (75, 83, 90, 100) sts.

Work even until the armhole measures 7 (7, 7½, 7½, 8)" (18 [18, 19, 19, 20.5] cm), end with a WS row.

NECK AND SHOULDER SHAPING

NEXT ROW: (RS) K18 (20, 24, 26, 30), join 2nd ball of yarn and BO center 34 (35, 35, 38, 40) sts, k to end.

Working both sides at once, dec one st at each neck edge (one st in from edge) every RS row 4 times, *at the same time*, when armhole measures 8 (8, 8½, 8½, 9)" (20.5 [20.5, 21.5, 21.5, 23] cm), end with a WS row and BO 3 (4, 5, 5, 6) sts at beg of next 4 rows, 4 (4, 5, 6, 7) sts at beg of next 4 rows.

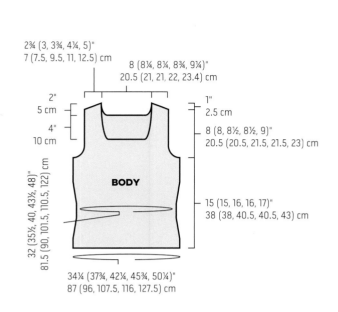

2¾ (3, 3¾, 4¼, 5)"
7 (7.5, 9.5, 11, 12.5) cm

8 (8¼, 8¼, 8¾, 9¼)"
20.5 (21, 21, 22, 23.4) cm

2"
5 cm

4"
10 cm

1"
2.5 cm

8 (8, 8½, 8½, 9)"
20.5 (20.5, 21.5, 21.5, 23) cm

BODY

32 (35½, 40, 43½, 48)"
81.5 (90, 101.5, 110.5, 122) cm

15 (15, 16, 16, 17)"
38 (38, 40.5, 40.5, 43) cm

34¼ (37¾, 42¼, 45¾, 50¼)"
87 (96, 107.5, 116, 127.5) cm

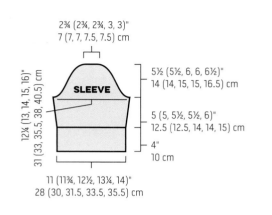

2¾ (2¾, 2¾, 3, 3)"
7 (7, 7, 7.5, 7.5) cm

SLEEVE

5½ (5½, 6, 6, 6½)"
14 (14, 15, 15, 16.5) cm

5 (5, 5½, 5½, 6)"
12.5 (12.5, 14, 14, 15) cm

4"
10 cm

12¾ (13, 14, 15, 16)"
31 (33, 35.5, 38, 40.5) cm

11 (11¾, 12½, 13¼, 14)"
28 (30, 31.5, 33.5, 35.5) cm

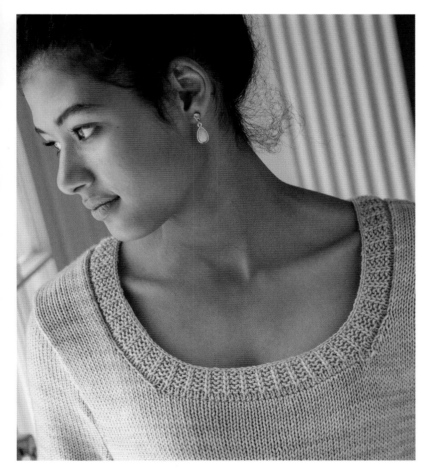

Front

Join A to sts on hold for front ready to work a WS row. BO 4 (6, 7, 8, 8) sts at the beg of the foll 2 rows. Dec one st at each side every RS row twice—70 (75, 83, 90, 100) sts.

Work even until the armhole measures 3 (3, 3½, 3½, 4)" (7.5 [7.5, 9, 9, 10] cm), end with a WS row.

NECK AND SHOULDER SHAPING

NEXT ROW: (RS) K18 (20, 24, 26, 30), join 2nd ball of yarn and BO center 34 (35, 35, 38, 40) sts, k to end.

Working both sides at once, dec one st at each neck edge (one st in from edge) every RS row 4 times—14 (16, 20, 22, 26) sts rem each side. Work even until armhole measures same as back to shoulder, end with a WS row. BO 3 (4, 5, 5, 6) sts at beg of next 4 rows, 4 (4, 5, 6, 7) sts at beg of next 4 rows.

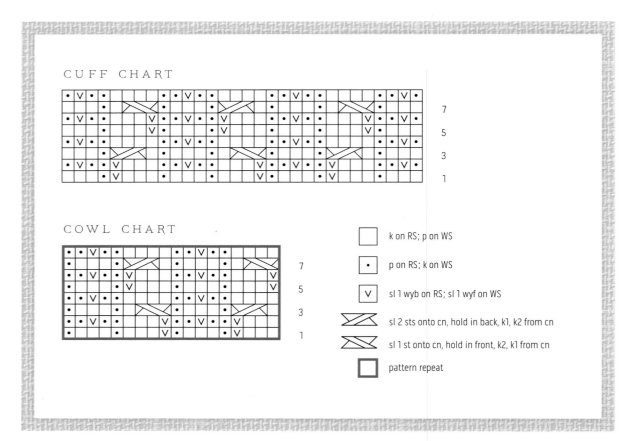

CUFF CHART

7
5
3
1

COWL CHART

7
5
3
1

☐ k on RS; p on WS

• p on RS; k on WS

V sl 1 wyb on RS; sl 1 wyf on WS

⧄ sl 2 sts onto cn, hold in back, k1, k2 from cn

⧄ sl 1 st onto cn, hold in front, k2, k1 from cn

☐ pattern repeat

Sleeves

With B, CO 30 sts. Work Cuff Chart until piece measures 11 (11¾, 12½, 13¼, 14)" (28 [30, 31.5, 33.5, 35.5] cm), end with a WS row. BO all sts. With RS facing, pick up and knit 58 (62, 66, 70, 74) sts along long edge of cuff. Work in St st, increase one st at each side every 8th row 3 (3, 4, 4, 5) times—64 (68, 74, 78, 84) sts. Work even in St st until sleeve measures 9 (9, 9½ , 9½ , 10)" (23 [23, 24, 24, 25.5] cm) from lower edge of cuff, end with a WS row.

SLEEVE CAP

BO 4 (4, 5, 5, 6) sts at the beg of the next 2 rows, 4 (6, 7, 8, 8) st at beg of foll 2 rows. Dec one st at each side on next row, then rep

dec row every other row 6 (6, 6, 6, 9) times, then every 4th row 5 (5, 6, 6, 5) times. Work 1 WS row. BO 2 sts at beg of next 2 rows, 3 sts at beg of next 2 rows. BO rem 14 (14, 14, 16, 16) sts.

Finishing

Sew shoulder seams. Set in sleeves and sew side and sleeve seams.

NECK RIBBING

With shorter cir and A, beg at right shoulder seam, pick up and k 16 sts along shaped right back neck edge, 34 (34, 34, 38, 38) along back neck edge, 16 sts along shaped left back neck, 36 sts along shaped left front neck edge, 33 (33, 33, 38, 38) sts along front neck edge, 36 sts along shaped

right front neck edge—171 (171, 171, 180, 180) sts. Join and pm for beg of rnd. Work 9 rnds of Garter-Slip Rib. With B, BO all sts.

Weave in all ends. Block to schematic.

Cowl

With B and shorter cir, CO 126 (126, 126, 144, 144) sts. Join to work in the round, being careful not to twist sts, and place marker (pm) for beg of rnd. Work 10 rnds of Garter-Slip Rib. Work Rnds 1–8 of Cowl Chart 10 times. Work 10 rnds of Garter-Slip Rib. BO loosely.

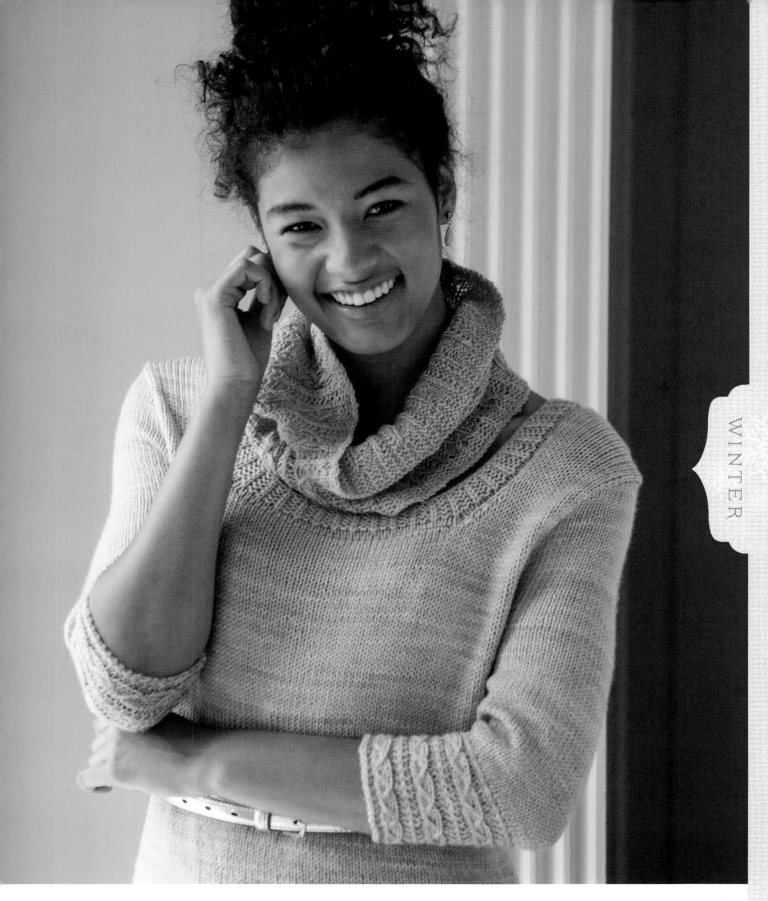

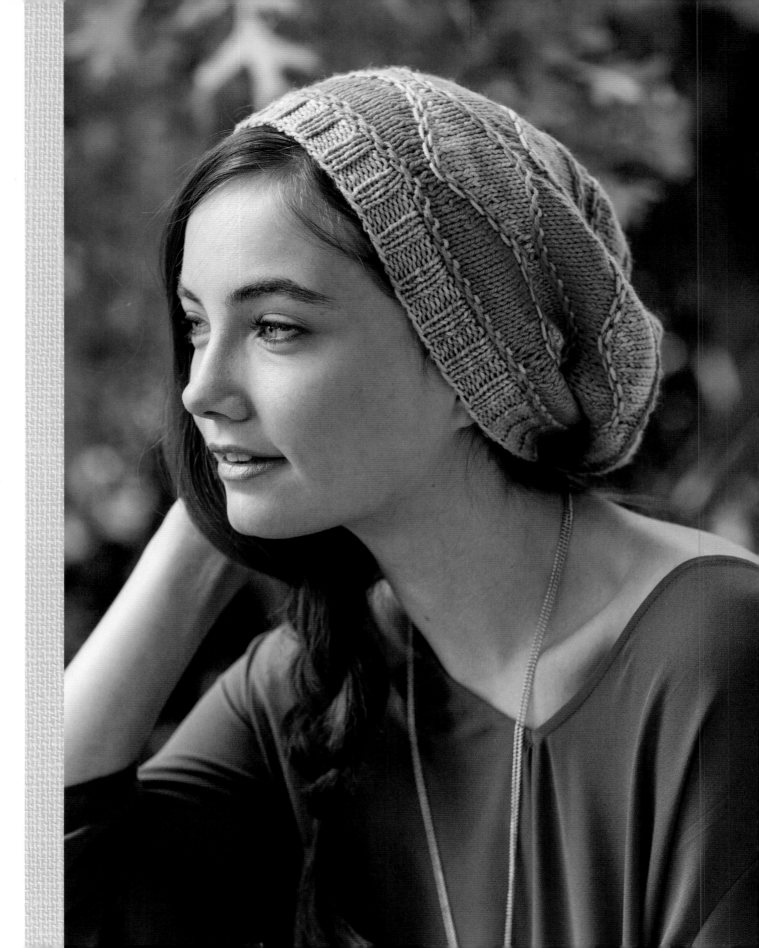

Weldon

WAVES HAT

This squishy slouch is just the thing to keep you warm on the chilly days that come no matter where you live. Knit it in shades of turquoise for a design reminiscent of ocean waves or pick your own two favorite hues for waves of cozy color.

FINISHED SIZE
About 18 (20)" (45.5 [51] cm) brim circumference.

Hat shown measures 20" (51 cm).

YARN
DK weight (#3 Light).

Shown here: Baah Yarn Sonoma (100% superwash merino wool; 234 yd [214 m]/3 1/2 oz [100 g]), Maldives (light turquoise, MC), mystique (medium turquoise, CC), 1 skein of each for both sizes.

NEEDLES
Size U.S. 6 (4 mm): 16" (40 cm) circular (cir) and set of 4 or 5 double-pointed (dpn).

Adjust needle size if necessary to obtain the correct gauge.

NOTIONS
Markers (m); tapestry needle.

GAUGE
21 sts and 26 rnds = 4" (10 cm) in St st.

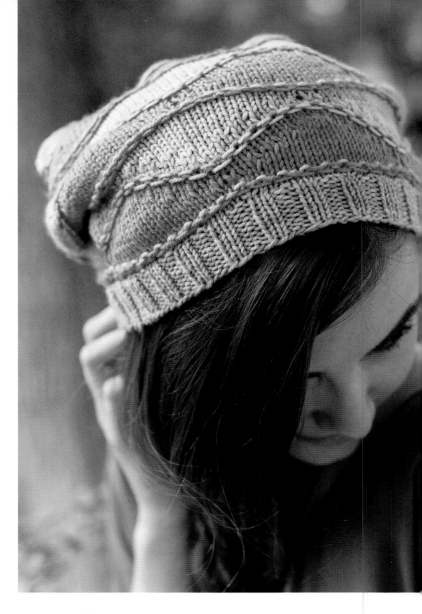

Brim

With cir needle and MC, CO 92 (108) sts. Join to work in the rnd, being careful not to twist sts, and place marker (pm) for beg of rnd.

RND 1: *K2, p2; rep from * around.

Rep Rnd 1 for k2, p2 rib for 9 more rnds.

NEXT RND: (inc rnd) [K10 (8), k1f&b] 8 (12) times, k4 (0)—100 (120) sts. Knit 1 rnd.

Short-Row Waves

With CC, work 2 rnds of Chain Stitch, then knit 1 rnd.

*With CC, work the short-row sequence as follows over the next 20 sts:

ROW 1: K19, wrap & turn (w&t; see Glossary).

ROW 2: P18, w&t.

ROW 3: K16, w&t.

ROW 4: P14, w&t.

ROW 5: K12, w&t.

ROW 6: P10, w&t.

ROW 7: K8, w&t.

ROW 8: P6, w&t.

ROW 9: K4, w&t.

ROW 10: P2, w&t.

ROW 11: K11, picking up all wraps.

Rep from * 4 (5) more times, working the short-row sequence over 20-st sections for a total of 5 (6) short-row waves in rnd. Knit 2 rnds even, picking up any remaining wraps.

With MC, work 2 rnds of Chain Stitch, then knit 1 rnd.

Knit 10 sts and place a 2nd marker to indicate an alternate beg of rnd.

**With MC, work the inverted short-row sequence as follows, picking up all wraps as the wrapped sts are worked:

ROW 1: K11, w&t.

ROW 2: P2, w&t.

ROW 3: K4, w&t.

ROW 4: P6, w&t.

ROW 5: K8, w&t.

ROW 6: P10, w&t.

ROW 7: K12, w&t.

ROW 8: P14, w&t.

ROW 9: K16, w&t.

ROW 10: P18, w&t.

ROW 11: K19, picking up any remaining wraps.

Rep from ** 4 (5) more times, working the inverted short-row sequence over 20-st sections for a total of 5 (6) short-row waves in rnd, ending at alternative beg of rnd. Knit 1 rnd, then work 1 more rnd, ending at the original beg-of-rnd marker.

Repeat the short-row wave sequences in each color, including the Chain Stitch and knit rnds, twice more—there will be 6 wave rnds, 3 in CC and 3 in MC.

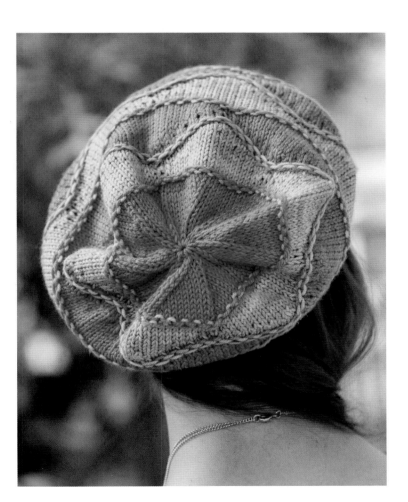

Crown

Note: Change to dpns when there are too few sts to work comfortably on cir needle.

With CC, work 2 rnds of Chain Stitch. Then work crown shaping as follows:

RND 1: (dec rnd) *K8, k2tog; rep from * around—90 (108) sts.

RND 2: Knit.

RND 3: (dec rnd) *K7, k2tog; rep from * around—80 (96) sts.

RND 4: Knit.

RND 5: (dec rnd) *K6, k2tog; rep from * around—70 (84) sts.

RND 6: Knit.

RND 7: (dec rnd) *K5, k2tog; rep from * around—60 (72) sts.

RND 8: Knit.

RND 9: (dec rnd) *K4, k2tog; rep from * around—50 (60) sts.

RND 10: (dec rnd) *K3, k2tog; rep from * around—40 (48) sts.

RND 11: (dec rnd) *K2, k2tog; rep from * around—30 (36) sts.

RND 12: (dec rnd) *K1, k2tog; rep from * around—20 (24) sts.

RND 13: (dec rnd) *K2tog; rep from * around—10 (12) sts.

Finishing

Cut yarn, leaving a long tail. Thread tail on tapestry needle, draw through rem sts, pull tight to close hole. Weave in all ends. Block lightly.

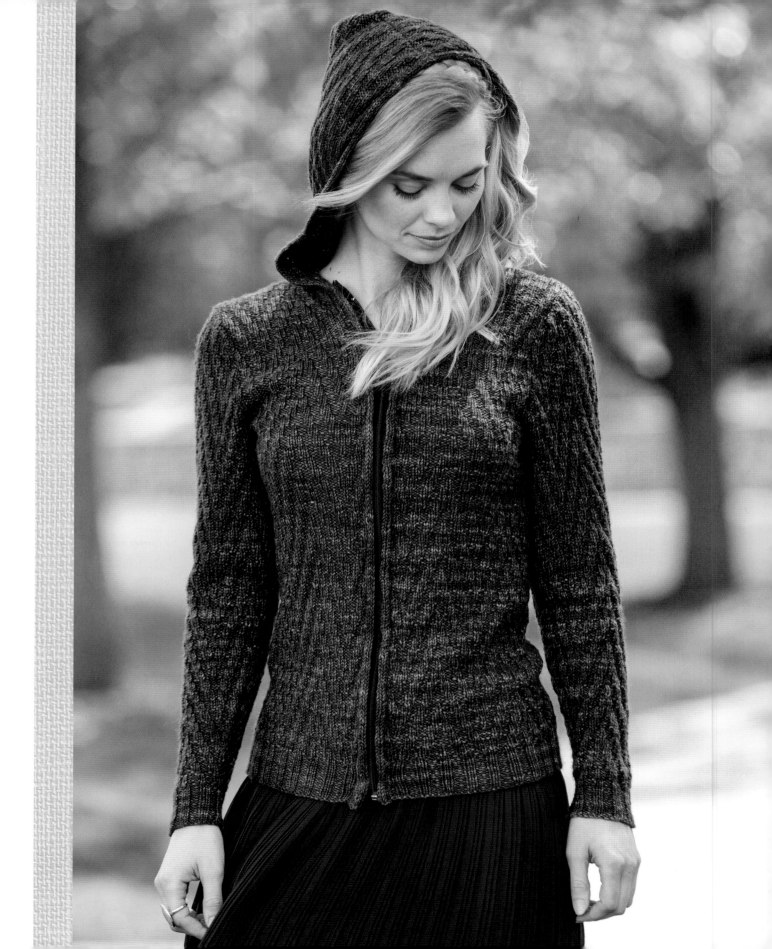

Lochlan

CHEVRON-STITCH HOODIE

Lochlan is the ideal casual cardigan for winter. The luxurious merino, silk, and cashmere blend yarn combined with the stretchy, easy-to-memorize chevron pattern create a light, cozy fabric. True comfort knitting!

FINISHED SIZE
About 30 (34, 37, 40, 43)" (76 [86.5, 94, 101.5, 109] cm) bust circumference.

Sweater shown measures 30" (76 cm).

YARN
DK weight (#3 Light).

Shown here: Shalimar Yarns Homage DK (80% merino wool, 10% cashmere, 10% silk; 255 yd [233 m]/3½ oz [100 g]), scarab (blue-green), 5 (6, 7, 7, 8) skeins.

NEEDLES
Size U.S. 6 (4 mm): 24" (61 cm) circular (cir) and set of 2 double-pointed (dpn) for applied I-cord.

Adjust needle size if necessary to obtain the correct gauge.

NOTIONS
Stitch holders or waste yarn; tapestry needle; zipper and sewing supplies.

GAUGE
24 sts and 34 rows = 4" (10 cm) in chevron pattern after blocking.

NOTE
Zipper shown is about 3" (7.5 cm) shorter than total sweater length.

Back

With cir needle, CO 82 (90, 98, 106, 114) sts. Do not join.

ROW 1: (RS) K2, *p2, k2; rep from * to end.

ROW 2: (WS) P2, *k2, p2; rep from * to end.

Rep last 2 rows 7 more times for k2, p2 rib, inc 10 (12, 12, 14, 14) sts evenly across last WS row—92 (102, 110, 120, 128) sts.

Work Chevron Chart as foll:

ROW 1: (RS) K1 (selvedge st), beg at indicated st, work chart to last st, k1 (selvedge st).

ROW 2: (WS) P1 (selvedge st), work chart as established to last st, p1 (selvedge st).

Cont to work chart in this way, working selvedge sts each side in St st, until piece measures 16 (16, 17, 17, 18)" (40.5 [40.5, 43, 43, 45.5] cm) from beg, end with a WS row.

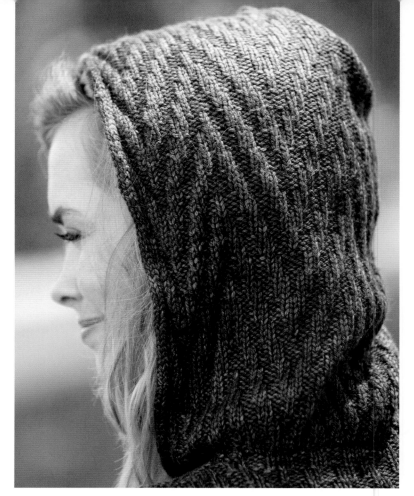

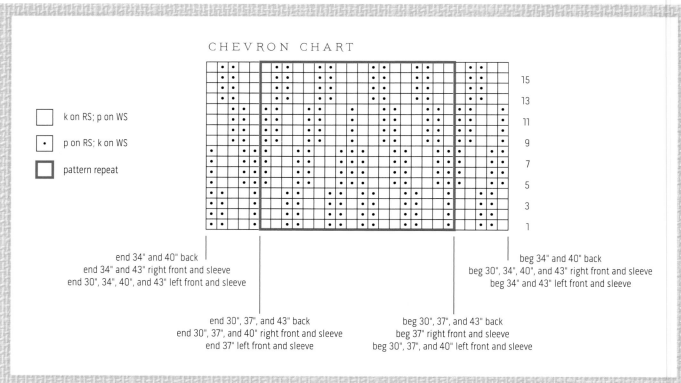

CHEVRON CHART

☐ k on RS; p on WS

• p on RS; k on WS

☐ pattern repeat

15
13
11
9
7
5
3
1

end 34" and 40" back
end 34" and 43" right front and sleeve
end 30", 34", 40", and 43" left front and sleeve

beg 34" and 40" back
beg 30", 34", 40", and 43" right front and sleeve
beg 34" and 43" left front and sleeve

end 30", 37", and 43" back
end 30", 37", and 40" right front and sleeve
end 37" left front and sleeve

beg 30", 37", and 43" back
beg 37" right front and sleeve
beg 30", 37", and 40" left front and sleeve

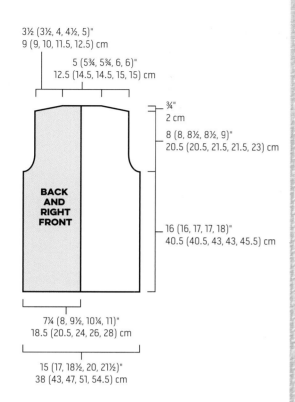

3½ (3½, 4, 4½, 5)"
9 (9, 10, 11.5, 12.5) cm

5 (5¾, 5¾, 6, 6)"
12.5 (14.5, 14.5, 15, 15) cm

¾"
2 cm

8 (8, 8½, 8½, 9)"
20.5 (20.5, 21.5, 21.5, 23) cm

**BACK
AND
RIGHT
FRONT**

16 (16, 17, 17, 18)"
40.5 (40.5, 43, 43, 45.5) cm

7¼ (8, 9½, 10¼, 11)"
18.5 (20.5, 24, 26, 28) cm

15 (17, 18½, 20, 21½)"
38 (43, 47, 51, 54.5) cm

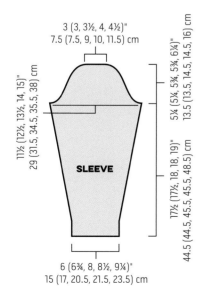

3 (3, 3½, 4, 4½)"
7.5 (7.5, 9, 10, 11.5) cm

5¼ (5¼, 5¾, 5¾, 6¼)"
13.5 (13.5, 14.5, 14.5, 16) cm

11½ (12½, 13½, 14, 15)"
29 (31.5, 34.5, 35.5, 38) cm

SLEEVE

17½ (17½, 18, 18, 19)"
44.5 (44.5, 45.5, 45.5, 48.5) cm

6 (6¾, 8, 8½, 9¼)"
15 (17, 20.5, 21.5, 23.5) cm

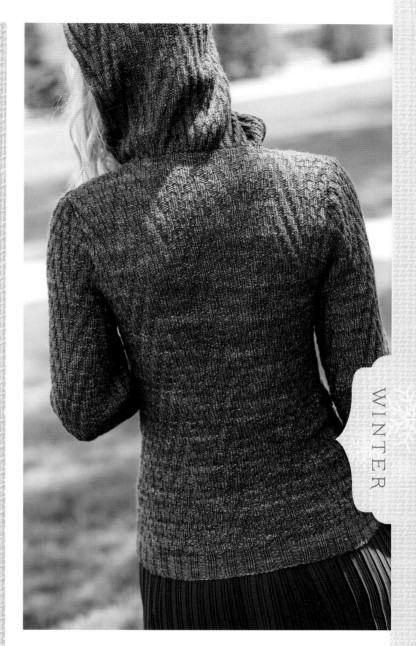

ARMHOLE SHAPING

BO 4 (5, 5, 5, 6) sts at the beg
of next 2 rows, 4 (6, 7, 8, 8) sts
at the beg of the foll 2 rows.
Dec one st at each side every RS
row twice—72 (76, 82, 90, 96)
sts. Cont in patt as established
until armhole measures 8 (8, 8½,
8½, 9)" (20.5 [20.5, 21.5, 21.5,
23] cm), end with a WS row.

SHAPE SHOULDERS

BO 7 (7, 8, 9, 10) sts at the beg of the next 6 rows—30 (34, 34, 36, 36) sts. BO all sts.

Right Front

With cir needle, CO 38 (42, 50, 54, 58) sts. Do not join. Work in k2, p2 rib as for back for 16 rows, inc 5 (6, 6, 7, 8) sts on last row—43 (48, 56, 61, 66) sts.

Work Chevron Chart as foll:

ROW 1: (RS) K1 (selvedge st), beg at indicated st, work chart to last st, k1 (selvedge st).

Cont to work chart in this way, working selvedge sts in St st, until front measures 16 (16, 17, 17, 18)" (40.5 [40.5, 43, 43, 45.5] cm) from beg, end with a RS row.

ARMHOLE SHAPING

BO 4 (5, 5, 5, 6) sts at the beg of next WS row, 4 (6, 7, 8, 8) sts at the beg of the foll WS row. Then dec one st at armhole edge every RS twice— 33 (35, 42, 46, 50) sts. Cont in patt as established until armhole measures 8 (8, 8½, 8½, 9)" (20.5 [20.5, 21.5, 21.5, 23] cm), end with a RS row.

SHOULDERS

BO 7 (7, 8, 9, 10) sts at the beg of the next 3 WS rows—12 (14, 18, 19, 20) sts. Place sts on waste yarn or st holder for hood.

Left Front

With cir needle, CO 38 (42, 50, 54, 58) sts. Do not join. Work in k2, p2 rib as for back for 16 rows, inc 5 (6, 6, 7, 8) sts on last row—43 (48, 56, 61, 66) sts.

Work Chevron Chart as foll:

ROW 1: (RS) K1 (selvedge st), beg at indicated st, work chart to last st, k1 (selvedge st).

Cont to work chart in this way, working selvedge sts in St st, until front measures 16 (16, 17, 17, 18)" (40.5 [40.5, 43, 43, 45.5] cm) from beg, end with a WS row.

ARMHOLES

BO 4 (5, 5, 5, 6) sts at the beg of the next RS row, then BO 4 (6, 7, 8, 8) sts at beg of foll RS row. Then dec one st at armhole edge every RS row twice—33 (35, 42, 46, 50) sts. Cont in patt as established until armhole measures 8 (8, 8½, 8½, 9)" (20.5 [20.5, 21.5, 21.5, 23] cm), end with a WS row.

SHOULDERS

BO 7 (7, 8, 9, 10) sts at beg of next 3 RS rows—12 (14, 18, 19, 20) sts. Place sts on st holder or waste yarn for hood.

Right Sleeve

With cir needle, CO 38 (42, 50, 54, 58) sts. Do not join. Work in k2, p2 rib as for back for 16 rows, inc 5 (6, 6, 7, 8) sts on last row—43 (48, 56, 61, 66) sts.

Work Chevron Chart as foll:

ROW 1: (RS) K1 (selvedge st), beg at indicated st, work chart to last st, k1 (selvedge st).

Cont to work chart in this way, inc one st each side every 10th row 13 (13, 12, 12, 12) times, working inc'd sts into chart patt—69 (74, 80, 85, 90) sts. Work even if necessary until sleeve measures 17½ (17½, 18, 18, 19)" (44.5 [44.5, 45.5, 45.5, 48.5] cm) or desired length, end with a WS row.

SLEEVE CAP

BO 4 (5, 5, 5, 6) sts at the beg of next 2 rows, 4 (6, 7, 8, 8) st at beg of foll 2 rows. Dec one st at each side every RS row 6 (6, 6, 6, 4) times, then every other RS row 6 (6, 7, 7, 9) times. BO 2 sts at the beg of the next 2 rows, 3 sts at the beg of the next 2 rows—19 (18, 20, 23, 26) sts. BO all remaining stitches.

Left Sleeve

Work as for right sleeve, working chart as indicated for left sleeve.

Seaming

Block to measurements. Sew shoulder seams. Set in sleeves. Sew side and sleeve seams.

Hood

Place 12 (14, 18, 19, 20) sts from right front on needle and join yarn ready to work a RS row. Work 12 (14, 18, 19, 20) sts in patt, then pick up and knit 42 (38, 38, 40, 50) sts along back neck edge, place 12 (14, 18, 19, 20) sts from left front on needle and work in patt—66 (66, 74, 78, 90) sts.

NEXT ROW: (WS) Work 15 (15, 21, 21, 15) sts in patt as established, [p1, p1f&b 1 (1, 1, 2, 1) times] 18 (18, 18, 12, 30) times, work in patt to end—84 (84, 92, 102, 120) sts.

Work Chevron Chart as foll:

ROW 1: (RS) K1 (selvedge st), work chart as established to last st, k1 (selvedge st).

Cont to work chart in this way, working selvedge sts in St st, until hood measures 12 (12, 13, 13, 14)" (30.5 [30.5, 33, 33,

35.5] cm) from neck edge, end with a WS row.

HOOD SHAPING

SHORT-ROW 1: (RS) Work 34 (34, 35, 40, 49) sts in patt, ssk, turn.

SHORT-ROW 2: (WS) Sl 1, work in patt to end.

Repeat last 2 rows 5 (5, 8, 8, 8) more times for right side shaping.

NEXT ROW: (RS) Work across entire row in patt. Note that unworked left side sts will be on different chart row than right side. Work short-rows for left side of hood as foll:

SHORT-ROW 1: (WS) Work 34 (34, 35, 40, 49) sts in patt, p2tog, turn.

SHORT-ROW 2: (RS) Sl 1, work in patt to end.

Repeat last 2 rows 4 (4, 7, 7, 7) more times, then work Row 1 once more—36 (36, 37, 42, 51) sts rem for each side of hood. Turn hood inside out and join using the three-needle bind-off method (see Glossary).

Finishing

With RS facing and dpn, beg at lower edge of right front, work applied I-cord (see Glossary) edging along right front, hood, and left front edges, ending at lower edge of left front.

Sew zipper in place along front edges behind I-cord edging. Weave in loose ends.

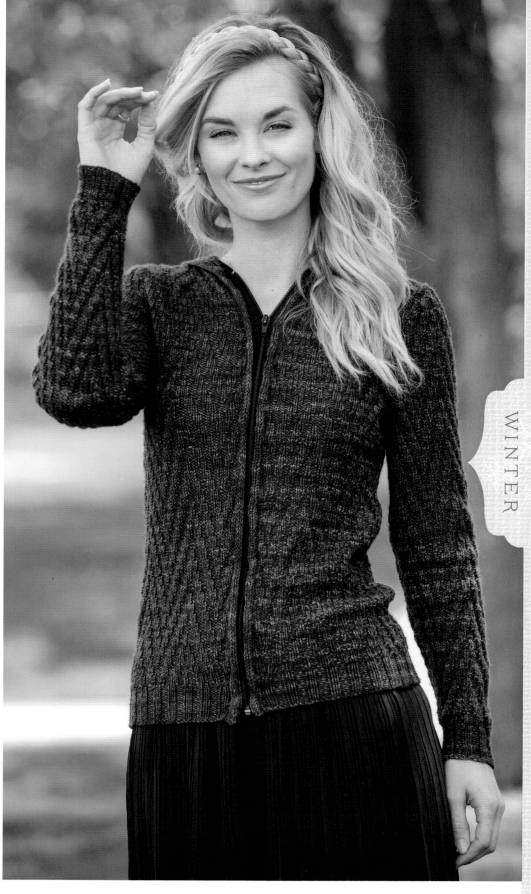

WINTER

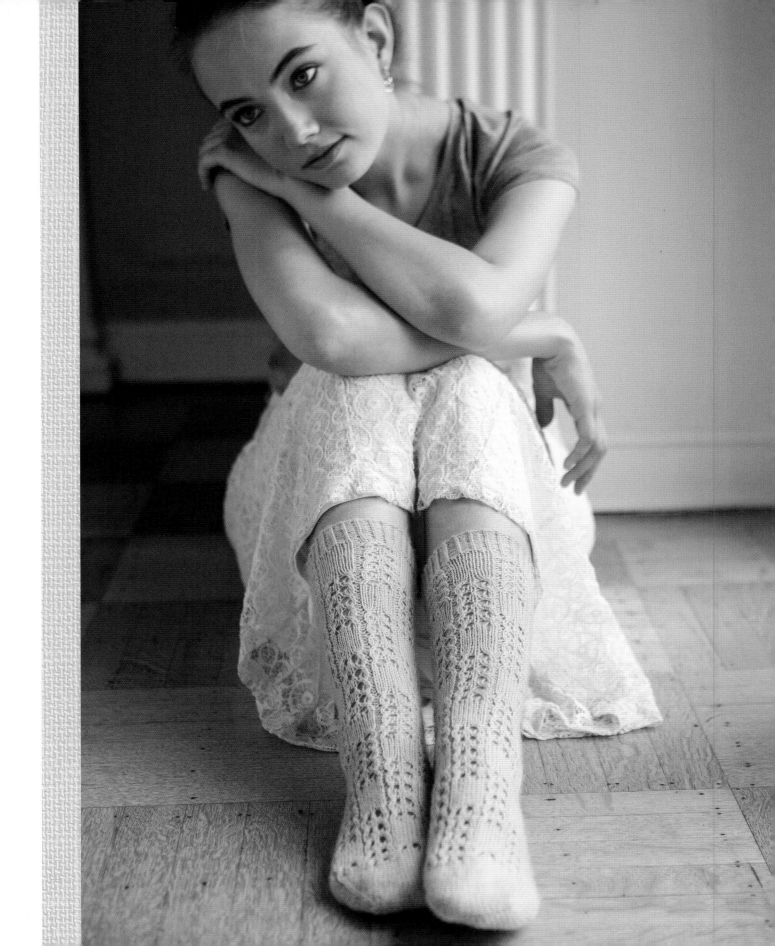

Williston

LACE SOCKS

Lightweight socks are perfect for chillier winter days. Working them in yarn with long color repeats highlights the lace columns. Knit them in this lovely peach hue or crazier colors for a fun-loving effect.

FINISHED SIZE

About 7½ (8½)" (19 [21.5] cm) foot circumference, 9½ (10)" (24 [25.5] cm) foot length from back of heel to toe, 11 (11¼)" (28 [28.5] cm) from cuff to base of heel.

Socks shown measure 7½" (19 cm) in foot circumference.

YARN

Fingering weight (#1 Super Fine).

Shown here: Crystal Palace Mini Mochi (80% merino wool, 20% nylon; 195 yd [178 m]/1¾ oz [50 g]), #327 Georgia peach, 2 balls.

NEEDLES

Size U.S. 1.5 (2.5 mm): 40" (100 cm) circular (cir) for magic loop method, or set of 4 or 5 double-pointed (dpn).

Adjust needle size if necessary to obtain the correct gauge.

NOTIONS

Tapestry needle.

GAUGE

30 sts and 36 rnds = 4" (10 cm) in St st.

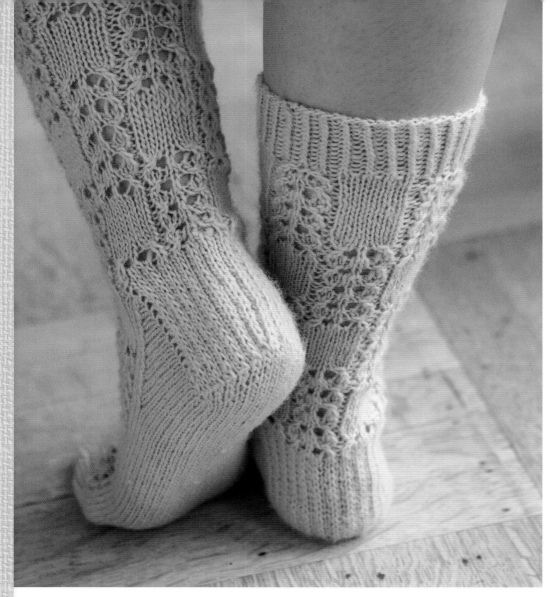

Leg

CO 64 (72) stitches. Join to work in the rnd, taking care not to twist sts.

RND 1: *P1, k1 tbl; rep from * around.

Rep Rnd 1 for p1, k1 tbl rib for 11 more rnds.

Work 16 (18)-st Lace Chart 4 times around, working the outlined sts for 8½" (21.5 cm) size only. Work chart through Rnd 34, then rep Rnds 7–34 until leg measures about 8½" (21.5 cm) from CO.

Heel

SIZE 7½" (19 CM) ONLY

Purl the first st onto previous needle so it is at the end of the rnd and will be held with instep sts. Work the heel flap over the next 31 (36) sts, rearranging needles as necessary.

HEEL FLAP

ROW 1: (RS) [Sl 1 wyb, k1] 15 (18) times, k1 (0), turn.

ROW 2: (WS) Sl 1 wyf, p to end.

Rep last 2 rows 15 (17) times, then work Row 1 once more.

TURN HEEL

ROW 1: (WS) Sl 1 wyf, p15 (18), p2tog, p1, turn.

ROW 2: Sl 1 wyb, k3, ssk, k1, turn.

ROW 3: Sl 1 wyf, p to 1 st before gap on previous row, p2tog (one st each side of gap), p1, turn.

ROW 4: Sl 1 wyb, k to 1 st before gap on previous row, ssk (one st each side of gap), k1, turn.

Rep Rows 3 and 4 until all heel sts have been worked, end with a Row 4 and do not turn at end of last row (for size 7½" [19 cm] only, omit k1 at end of last row)—17 (20) heel sts.

GUSSETS

NEXT RND: Pick up and knit 16 (18) sts along the side of the heel for left gusset (the slipped sts will make it easy to see where to pick up stitches), work Lace Chart as established over 33 (36) instep sts (for size 7½" [19 cm] only, purl added st at end of instep sts every rnd), pick up and knit 16 (18) sts along the other side of the heel for right gusset, knit heel and left gusset sts, work instep sts in patt, rearranging needles as necessary. Rnd now begins at right gusset sts.

RND 1: (dec rnd) K1, ssk, k to last 3 sts of left gusset, k2tog, k1, work instep sts in patt—2 sts dec'd.

RND 2: Knit gusset and heel sts, work instep sts in patt.

Rep last 2 rnds 8 (9) more times—64 (72) sts total, 33 (36) sts for instep and 31 (36) sts for sole.

Work even in patts as established until sock is about 8" (20.5 cm), or 1½ (2)" (3.8 [5] cm) shorter than desired length of the foot.

TOE SHAPING

**SET-UP RND FOR SIZE 7½"
(19 CM) ONLY:** K31 sole sts, k1,
ssk, k to last 3 instep sts, k2tog,
k1—62 sts total, 31 sts each for
instep and sole.

RND 1: (dec rnd) K1, ssk, k to last
3 sole sts, k2tog, k1, k1, ssk, k to
last 3 instep sts, k2tog, k1—4 sts
dec'd.

RND 2: Knit.

Rep Rnds 1 and 2 for toe 5 (7)
more times—38 (40) sts. Rep Rnd
1 only 3 (4) more times—26 (24)
sts. Cut yarn leaving a long tail.

Finishing

Thread tail on tapestry needle and
use Kitchener stitch (see Glos-
sary) to graft live sts tog. Weave
in ends. Block lightly if desired.

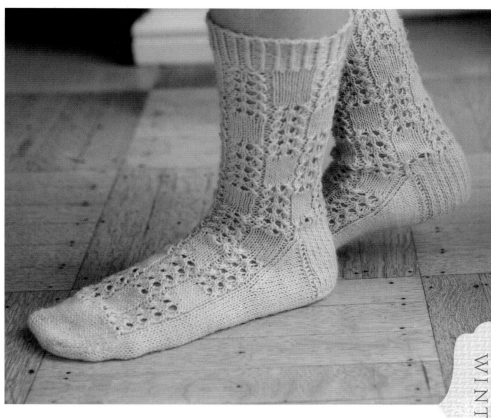

WINTER

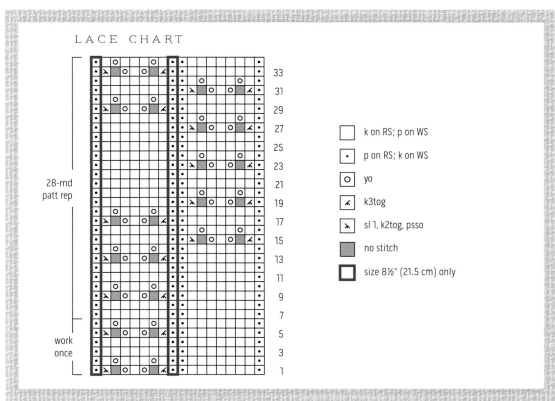

LACE CHART

28-rnd
patt rep

work
once

☐	k on RS; p on WS
•	p on RS; k on WS
○	yo
⋏	k3tog
⋌	sl 1, k2tog, psso
▦	no stitch
☐	size 8½" (21.5 cm) only

33
31
29
27
25
23
21
19
17
15
13
11
9
7
5
3
1

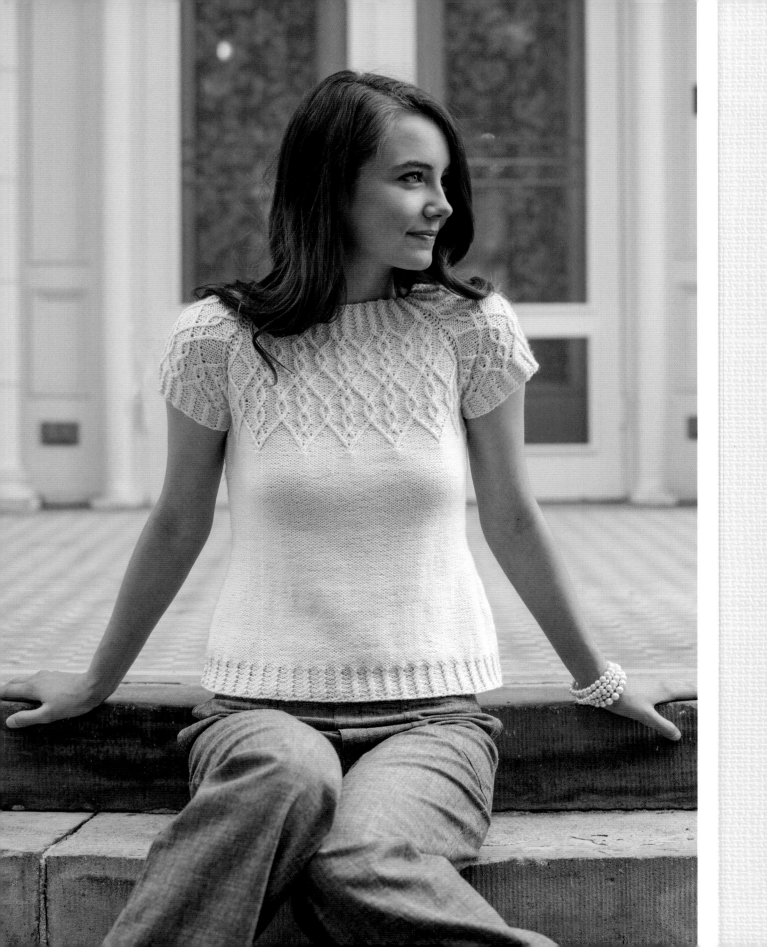

SPRINGTIME IS A fine time to peel off some layers and show a bit of skin. Short sleeves and sweet colors make for light hearts no matter how long the winter has lasted. A pair of short-sleeve pullovers in sportweight yarns anchors this spring collection.

Spring

There's also a fingering-weight cardigan and a pretty lace shawlette that are just right for covering up shoulders that are already itching to wear sundresses. For chillier spring days, throw in a candy-colored shawl in the simplest of colorwork patterns, and your spring wardrobe is complete.

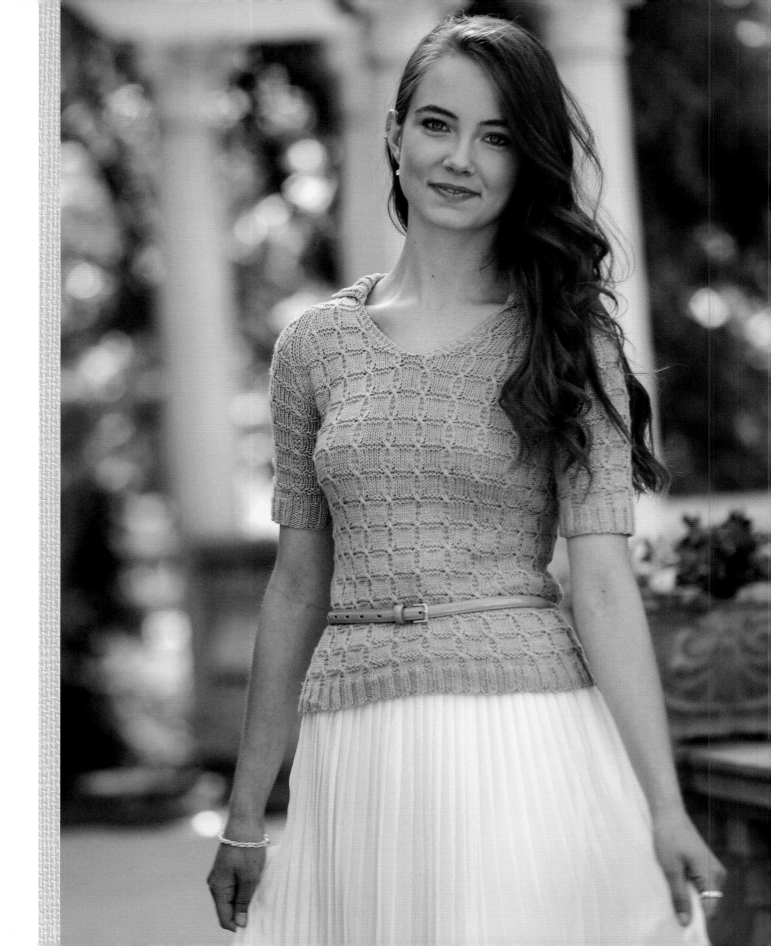

Teola

POLO-COLLAR TEE

Teola is a cool and comfy short-sleeve pullover with a lovely cable rib pattern that's much easier to work than it looks. In fact, the cables are so simple there's no need for a cable needle! The sweet lilac color welcomes spring, and the merino and viscose blend yarn makes the fabric wearable when it feels more like summer.

FINISHED SIZE
About 29½ (32, 34¾, 37½, 40, 42¾, 45½)" (75 [81.5, 88.5, 95, 101.5, 108.5, 115.5] cm) bust circumference.

Sweater shown measures 32" (81.5 cm).

YARN
Sportweight (#2 Sport).

Shown here: Lorna's Laces, Sportmate (70% superwash merino wool, 30% Outlast viscose; 270 yd [247 m]/3½ oz [100 g]), lilac 3 (3, 4, 4, 5, 5, 5) hanks.

NEEDLES
Size U.S. 5 (3.75 mm): 32" (81 cm) circulars (cir) and set of 4 or 5 double-pointed (dpn), or long circular for magic loop method.

Adjust needle size if necessary to obtain the correct gauge.

NOTIONS
Markers (m); stitch holders or spare circulars; waste yarn; tapestry needle.

GAUGE
24 sts and 36 rnds = 4" (10 cm) in Cable Rib Chart pattern.

NOTE
Waist shaping takes place over the center 2 sts of the knit blocks between cable columns. Use differently colored markers for shaping.

Jewel Cross Cable:
Drop first elongated st off needle to front, sl 2 sts, drop 2nd elongated st off needle to front, sl 2 sts back to left-hand needle, pick up 2nd dropped st with right-hand needle, sl 2 sts, pick up first dropped st with left-hand needle, sl 2 sts and 2nd dropped st back to left-hand needle, knit all 4 sts.

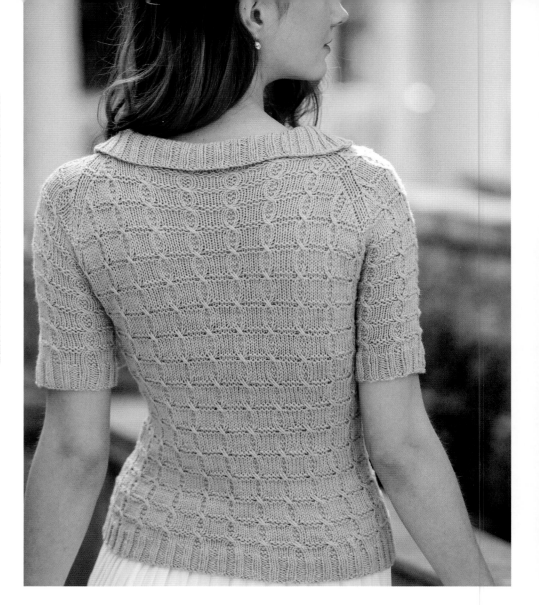

Body

With shorter cir needle, CO 88 (96, 104, 112, 120, 128, 136) sts, place marker (pm) for right side, CO 88 (96, 104, 112, 120, 128, 136), pm for beg of rnd and join to work in the rnd—176 (192, 208, 224, 240, 256, 272) sts.

RND 1: *P1, k2, p1; rep from * around.

Rep Rnd 1 for p2, k2 ribbing for 9 more rnds.

NEXT RND: Work Rnd 1 of 8-st rep of Cable Rib Chart 22 (24, 26, 28, 30, 32, 34) times around.

Cont in chart patt as established until 10 rnds of chart have been worked twice.

WAIST SHAPING

DEC RND 1: *K7, k2tog, place shaping marker, k to 9 sts before next marker, place shaping marker, ssk, k7; repeat from * once—172 (188, 204, 220, 236, 252, 268) sts.

Work 9 rnds even.

DEC RND 2: *K to first shaping marker, remove marker, k6, k2tog, place new shaping marker, k to 8 sts before second shaping marker, place new shaping marker, ssk, k to marker removing previous shaping marker; rep from * once—4 sts dec'd.

Continue in patt as established, rep Dec rnd 2 every 10th rnd twice more—160 (176, 192, 208, 224, 240, 256) sts.

Work 9 rnds even.

INC RND 1: *K to first shaping marker, M1, sl marker, k to next shaping marker, sl marker, M1, k to marker; rep from * once—164 (180, 196, 212, 228, 244, 260) sts.

Work 9 rnds even.

INC RND 2: *K to 8 sts before first shaping marker, M1, place new shaping marker, k to second shaping marker, remove marker, k8, place new shaping marker, M1, k to marker; rep from * once—4 sts inc'd.

Continue in patt as established, rep Inc rnd 2 every 10th rnd twice more—176 (192, 208, 224, 240, 256, 272) sts. Work even until 10 rnds of chart have been worked 12 (12, 12, 13, 13, 13, 14) times.

NEXT RND: Work to last 4 (4, 5, 5, 6, 6, 6) sts, BO 4 (4, 5, 5, 6, 6, 6) sts.

NEXT RND: BO 4 (4, 5, 5, 6, 6, 6) sts at beg of rnd, work to 4 (4, 5, 5, 6, 6, 6) sts before side marker, BO 8 (8, 10, 10, 12, 12, 12) sts, removing marker, work to end—160 (176, 188, 204, 216, 232, 248) sts, 80 (88, 94, 102, 108, 116, 124) sts each for front and back. Place body on waste yarn.

Sleeves

With dpn or longer cir needle, CO 56 (56, 64, 64, 72, 80, 80) sts, pm for beg of rnd and join to work in the round.

RND 1: *P1, k2, p1; repeat from * to end.

RNDS 2–8: Repeat Rnd 1.

NEXT RND: Work Rnd 1 of 8-st rep of Cable Rib Chart 7 (7, 8, 8, 9, 10, 10) times around.

Cont in chart patt as established until 10 rnds of chart have been worked 5 (5, 5, 6, 6, 7, 7) times.

NEXT RND: Work to last 4 (4, 5, 5, 6, 6, 6) sts, BO 4 (4, 5, 5, 6, 6, 6) sts.

NEXT RND: BO 4 (4, 5, 5, 6, 6, 6) sts, work to end of rnd—48 (48, 54, 54, 60, 68, 68) sts.

Raglan Yoke

Note: The beg of rnd will now be at center front. Yoke will begin with Rnd 3 of chart.

Slip first 40 (44, 47, 51, 54, 58, 62) front sts to a spare circular needle or stitch holder. Knit rem 40 (44, 47, 51, 54, 58, 62) sts of front, place raglan marker, then k48 (48, 54, 54, 60, 68, 68) sts of first sleeve, place raglan marker, k80 (88, 94, 102, 108, 116, 124) sts of back, place raglan marker, knit 48 (48, 54, 54, 60, 68, 68) sts of second sleeve, place raglan marker, knit 40 (44, 47, 51, 54, 58, 62) front sts from spare needle or stitch holder. Place distinct marker for new beg of rnd at center front—256 (272, 296, 312, 336, 368, 384) sts.

Work one rnd in patt as established.

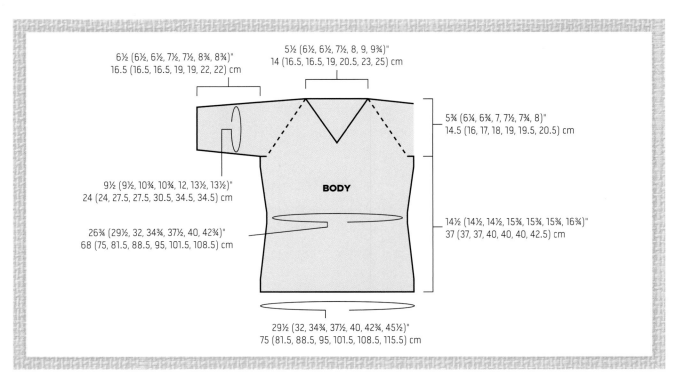

6½ (6½, 6½, 7½, 7½, 8¾, 8¾)"
16.5 (16.5, 16.5, 19, 19, 22, 22) cm

5½ (6½, 6½, 7½, 8, 9, 9¾)"
14 (16.5, 16.5, 19, 20.5, 23, 25) cm

5¾ (6¼, 6¾, 7, 7½, 7¾, 8)"
14.5 (16, 17, 18, 19, 19.5, 20.5) cm

9½ (9½, 10¾, 10¾, 12, 13½, 13½)"
24 (24, 27.5, 27.5, 30.5, 34.5, 34.5) cm

BODY

26¾ (29½, 32, 34¾, 37½, 40, 42¾)"
68 (75, 81.5, 88.5, 95, 101.5, 108.5) cm

14½ (14½, 14½, 15¾, 15¾, 15¾, 16¾)"
37 (37, 37, 40, 40, 40, 42.5) cm

29½ (32, 34¾, 37½, 40, 42¾, 45½)"
75 (81.5, 88.5, 95, 101.5, 108.5, 115.5) cm

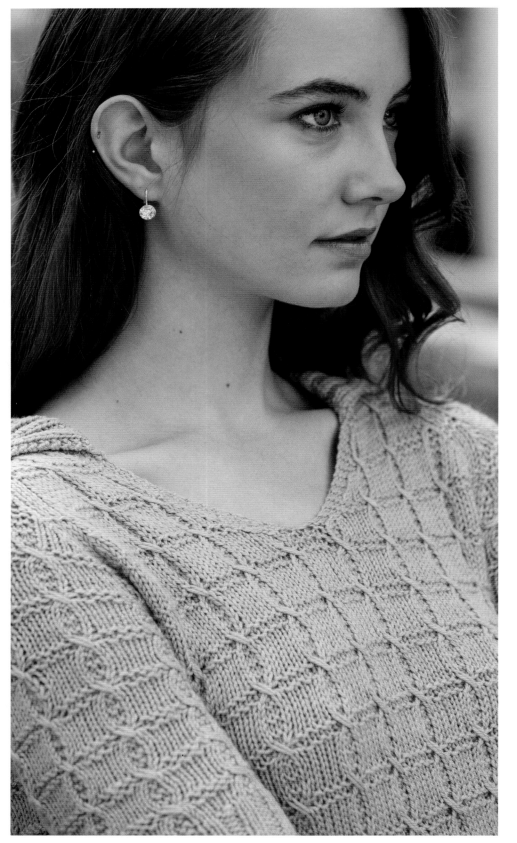

RAGLAN AND V-NECK SHAPING

Note: The Raglan decreases and V-Neck shaping happen at the same time. Be sure to read the next sections all the way through before proceeding.

RAGLAN DEC RND: [Work in patt to 3 sts before raglan marker, ssk, k1, sm, k1, k2tog] 4 times, work to end—8 sts dec'd.

Repeat Raglan Dec rnd on every 4th rnd 1 (2, 1, 2, 3, 3, 2) times, then every other rnd 22 (22, 26, 26, 26, 27, 30) times.

At the same time, when 1 (1, 1½, 1½, 2½, 1½, 2)" (2.5 [2.5, 3.8, 3.8, 6.5, 3.8, 5] cm) of raglan shaping has been worked, set up the V-Neck shaping as follows, beg on an odd-numbered rnd:

RND 1: K3, work in patt as established to last 3 sts, k3.

RND 2: P3, work to last 3 sts, p3.

Rep Rnds 1 and 2 once more.

Working back and forth in rows and continuing to work the raglan shaping as established on RS rows, work the V-Neck shaping as follows:

V-NECK DEC ROW: (RS) K3, ssk, work to last 5 sts, k2tog, k3—2 sts dec'd.

NEXT ROW: (WS) K3, work in patt to last 3 sts, k3.

Rep V-Neck Dec row every RS row 2 (3, 3, 4, 11, 15, 15) times, then every other RS row 8 (8, 8, 8, 4, 4, 4) times—42 (48, 48, 54, 64, 80, 80) sts when all shaping is complete. Work 1 WS row.

CABLE RIB CHART

			•	•					
			⟍⟋						9
	•	V	•	•	V	•	•		
		V			V				7
	•	V	•	•	V	•	•		
									5
			•	•					
									3
			•	•					
									1

☐ k on RS; p on WS

• p on RS; k on WS

V sl 1 wyb on RS; sl 1 wyf on WS

⟍⟋ jewel cross cable (see Stitch Guide)

☐ pattern repeat

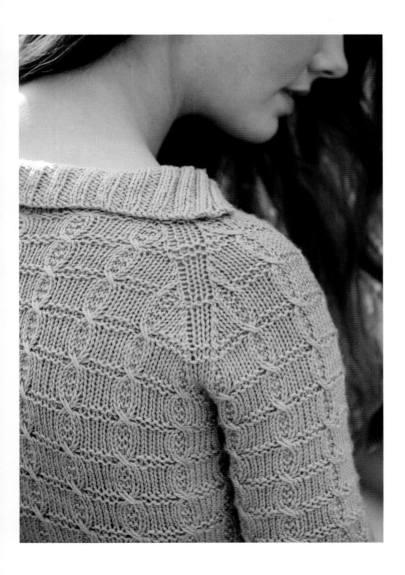

Collar

NEXT ROW: (RS) Knit to end of row, then pick up and knit 16 (17, 17, 18, 19, 21, 21) sts from the garter edge of the left front neckline.

Note: The next row will be a RS collar row so that the RS of the collar will show when turned back.

NEXT ROW: (RS) Knit to end of row, then pick up and knit 16 (17, 17, 18, 19, 21, 21) from the garter edge of the right front neckline—74 (82, 82, 90, 102, 122, 122) sts.

ROW 1: (WS) K2, *p2, k2; rep from * to end.

ROW 2: (RS) K2, *k2, p2; repeat from * to last 4 sts, k4.

Rep Rows 1 and 2 until collar measures about 2½" (6.5cm), end with a WS row. BO loosely.

Finishing

Block to measurements. Sew underarm seams. Weave in ends.

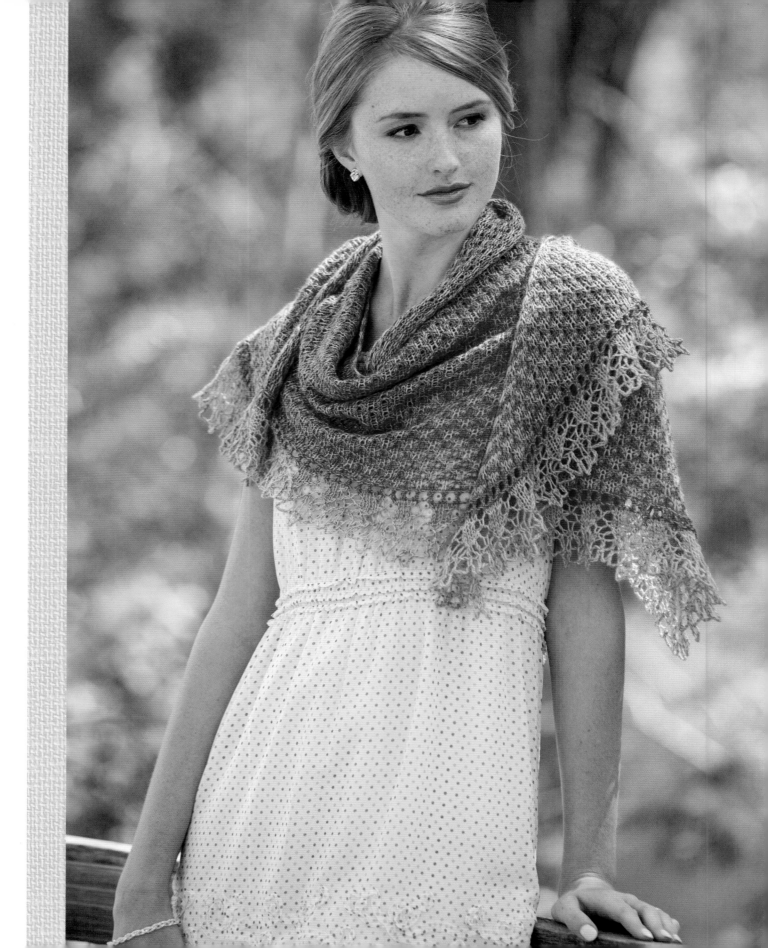

Mayella

ASYMMETRICAL WRAP

The shaping of this yummy candy-colored shawl allows the simple slip-stitch pattern to shine. Only one color is worked at a time on any given row, making it simple enough for a colorwork beginner.

SPRING

FINISHED SIZE
About 61" (155 cm) wide and 27" (68.5 cm) long from top edge to tip of lower point after blocking.

YARN
Fingering weight (#1 Super Fine)

Shown here: Knitted Wit Cashy Lite (80% merino wool, 10% cashmere, 10% nylon; 495 yd [453 m]/4 oz [115 g]), blush (MC) and salted caramel (CC), 1 skein of each.

NEEDLES
Size U.S. 6 (4 mm): 40" (100 cm) circular (cir).
Size U.S. G-6 (4 mm) crochet hook.
Adjust needle size if necessary to obtain the correct gauge.

NOTIONS
Tapestry needle.

GAUGE
16 sts and 20 rows = 4" (10 cm) in pattern stitch after blocking.

NOTES
This shawl is worked asymmetrically, beginning with a very small cast-on and increasing 2 sts at the beginning of every RS row.

The lace edging is applied after the two-color body is worked.

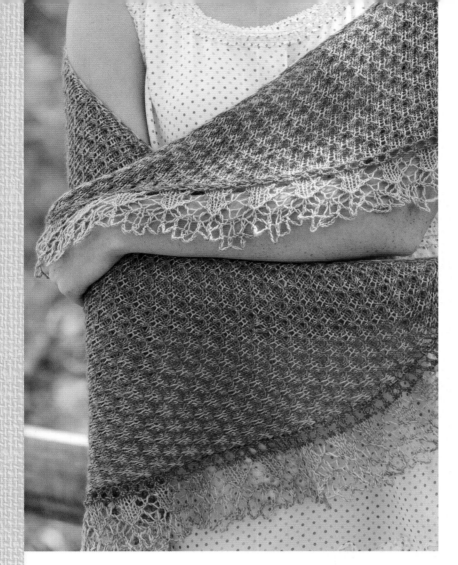

ROW 2: With CC, p4, *sl 3 wyf, p3; rep from * to last 4 sts, p3, k1 tbl.

ROW 3: With CC, sl 1, (k1, yo, k1) in next st, k4, *k2tog, sl 1 wyb, ssk, k1; rep from * to last 2 sts, k2.

ROW 4: With MC, p2, *sl 1 wyf, p3; rep from * to last 4 sts, sl 1 wyf, p2, k1 tbl.

ROW 5: With MC, sl 1, (k1, yo, k1) in next st, k1, *(k1, yo, k1) in next st, k3; rep from * to last 3 sts, (k1, yo, k1) in next st, k2.

ROW 6: With CC, p2, *sl 3 wyf, p3; rep from * to last 2 sts, p1, k1 tbl.

ROW 7: With CC, sl 1, (k1, yo, k1) in next st, k2, *k2tog, sl 1 wyb, ssk, k1; rep from * to end.

ROW 8: With MC, p4, *sl 1 wyf, p3; rep from * to last 2 sts, p1, k1 tbl.

Rep Rows 1–8 for pattern stitch 29 more times—250 sts.

Shawl

With MC and cir needle, CO 4 sts.

ROW 1: (RS) Sl 1, (k1, yo, k1) in next st, k2—6 sts.

ROW 2: P5, k1 tbl.

ROW 3: Sl 1, (k1, yo, k1) in next st, k1, (k1, yo, k1) in next st, k2—10 sts.

ROW 4: P2, sl 3 wyf, p4, k1 tbl.

BEG PATTERN STITCH
ROW 1: (RS) With MC, sl 1, (k1, yo, k1) in next st, *k3, (k1, yo, k1) in next st; rep from * to last 4 sts, k4.

EDGING CHART

(chart rows numbered 11, 9, 7, 5, 3, 1)

Legend:

- ☐ k on RS; p on WS
- · p on RS; k on WS
- ℧ k1tbl on RS and WS
- ○ yo
- ∨ sl 1 wyb on RS; sl 1 wyf on WS
- ╱ k2tog
- ╲ ssk
- ⅄ sl 1, k2tog, psso
- ↓ k1, yo, k1 in same st
- ▨ no stitch
- ☐ pattern repeat

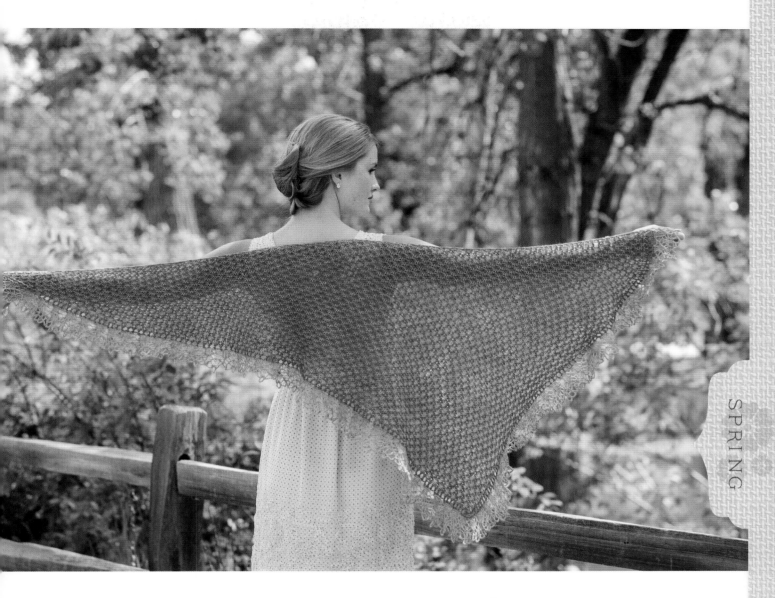

Work the transition rows in MC as follows:

ROW 1: (RS) Sl 1, (k1, yo, k1) in next st, k to end of row, then pick up 189 sts along the side edge (picking up one st in about 3 out of every 4 rows)—441 sts.

ROW 2: (WS) Knit.

ROW 3: Sl 1, (k1, yo, k1) in next st, k1, *yo, k2tog; repeat from * to end of row—443 sts.

ROW 4: Knit. Cut MC.

EDGING

With CC, work the 12-row Edging Chart.

With crochet hook, BO as follows: insert hook in group of 3 sts, yarn over and draw lp through sts, ch 6, *insert hook in group of 2 sts, yarn over and draw loop through all sts on hook, ch 6, insert hook in group of 3 sts, yarn over and draw loop through all sts on hook, ch 6; rep from * to end of row. Fasten off.

Finishing

Weave in ends, but do not trim. Block shawl using desired method, bringing out the points on the shawl edging. Trim ends.

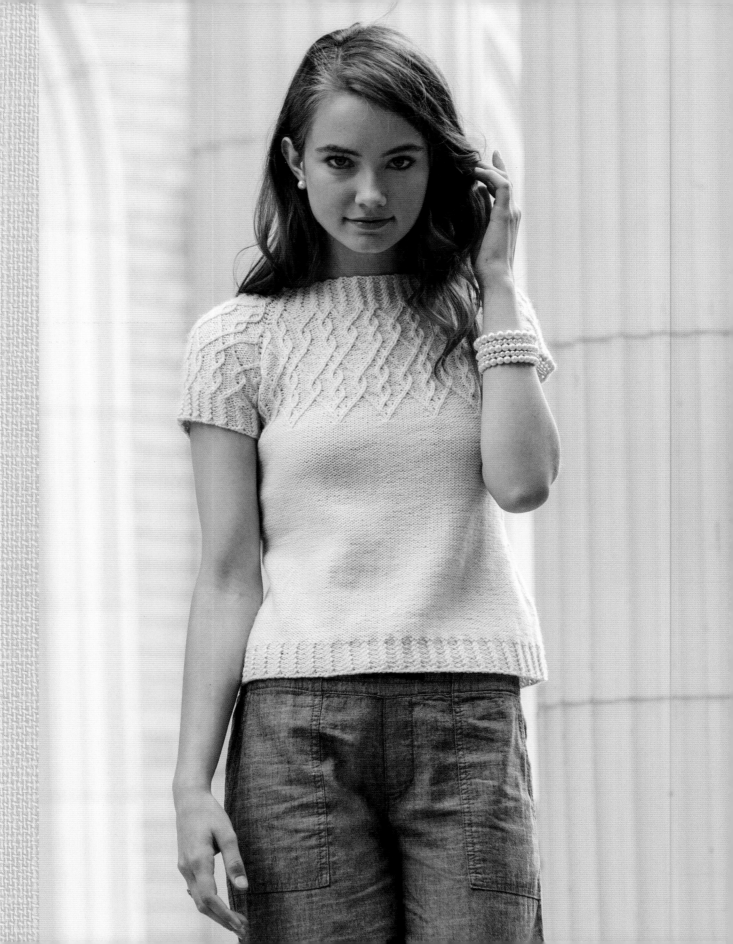

Coralue

SHORT-SLEEVE RAGLAN

Coralue is worked in reverse stockinette stitch with beautiful twisted cable detailing at the yoke. The cable pattern knits up like a dream in the wool and silk blend sportweight yarn, which is light and lofty enough for spring.

FINISHED SIZE
About 33½" (38¼, 41¾, 47½)" (85 [97, 106, 120.5] cm) bust circumference.

Sweater shown measures 33½" (85 cm).

YARN
Sportweight (#2 Fine).

Shown here: Stitch Sprouts Yellowstone (80% wool, 20% silk; 285 yd [260 m]/3½ oz [100 g]), snow, 3 (3, 4, 5) skeins.

NEEDLES
Size U.S. 5 (3.75 mm): 16" and 32" or 40" (40 and 81 or 100 cm) circular (cir) and set of 4 or 5 double-pointed (dpn).

Adjust needle size if necessary to obtain the correct gauge.

NOTIONS
Markers (m); cable needle (cn); stitch holders or waste yarn; tapestry needle.

GAUGE
23 sts and 32 rnds = 4" (10 cm) in reverse St st.

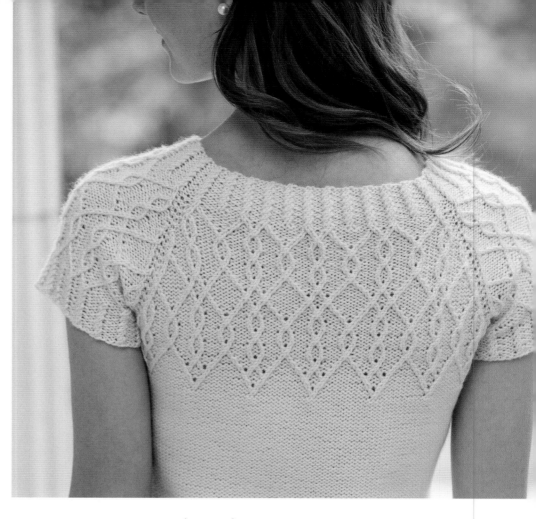

**TWISTED RIB
(MULTIPLE OF 4 STS)**

RND 1: *P2, K2tog, leaving sts on needle, k first st again; repeat from *.

RND 2: *P2, k2; repeat from *.

Rep Rnds 1 and 2 for pattern.

Yoke

With shorter cir needle, CO 144 (144, 152, 160) sts. Join to work in the rnd, being careful not to twist sts, and place marker (pm) for beg of rnd. Work 12 rnds in Twisted Rib.

Work set-up rnds as follows:

SIZES 33½" AND 38¼" (85 AND 97 CM) ONLY

RND 1: *P1f&b, place new marker for beg of rnd, p1f&b, work 46 sts in rib as established, p1f&b, pm, p1f&b, work 22 sts in rib, p1f&b, pm, p1f&b, work 46 sts in rib, p1f&b, pm, p1f&b, work 22 sts in rib, purl the final 2 sts before beg-of-rnd marker—152 sts.

RND 2: Work even in rib, purling the sts on either side of the markers.

SIZE 41¾" (106 CM) ONLY

RND 1: *Work 50 sts in rib, pm, work 26 sts in rib, pm; repeat from * once more.

RND 2: Work even in rib.

SIZE 47½" (120.5 CM) ONLY

Work 3 more rnds in rib as established, end last rnd one st before marker. Place new marker for beg of rnd (between the last 2 RT sts).

RND 4: Work 52 sts in rib as established, pm, work 28 sts in rib, pm, work 52 sts in rib, pm, work 28 sts in rib.

Beg with Rnd 1 (1, 1, 3), work Yoke Chart as follows:

RND 1 (1, 1, 3): [Work chart to rep line, work 12-st rep 4 times, work to end of chart, sl marker, work chart to rep line, work 12-st rep twice, work to end of chart, sl marker] twice.

Cont to work chart in this way through Row 24, then work Rows 1–14 (1–24, 1–24, 1–24) once more, then Rows 0 (0, 1–14, 1–24) once more—304 (344, 400, 440) sts.

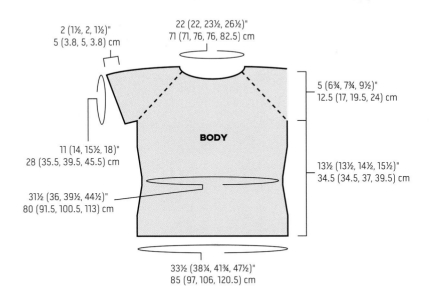

2 (1½, 2, 1½)"
5 (3.8, 5, 3.8) cm

22 (22, 23½, 26½)"
71 (71, 76, 76, 82.5) cm

5 (6¾, 7¾, 9½)"
12.5 (17, 19.5, 24) cm

BODY

13½ (13½, 14½, 15½)"
34.5 (34.5, 37, 39.5) cm

11 (14, 15½, 18)"
28 (35.5, 39.5, 45.5) cm

31½ (36, 39½, 44½)"
80 (91.5, 100.5, 113) cm

33½ (38¼, 41¾, 47½)"
85 (97, 106, 120.5) cm

YOKE CHART

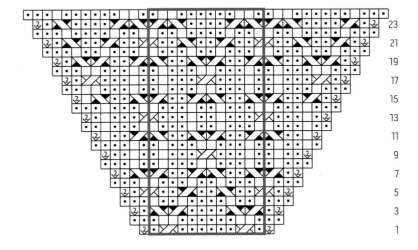

23
21
19
17
15
13
11
9
7
5
3
1

	k on RS; p on WS
·	p on RS; k on WS
⚓	purl into front and back of next st
⤡	sl 1 st onto cn, hold in back, k1, k1 from cn
⤢	sl 1 st onto cn, hold in back, k1, p1 from cn
⤢	sl 1 st onto cn, hold in front, p1, k1 from cn
	pattern repeat

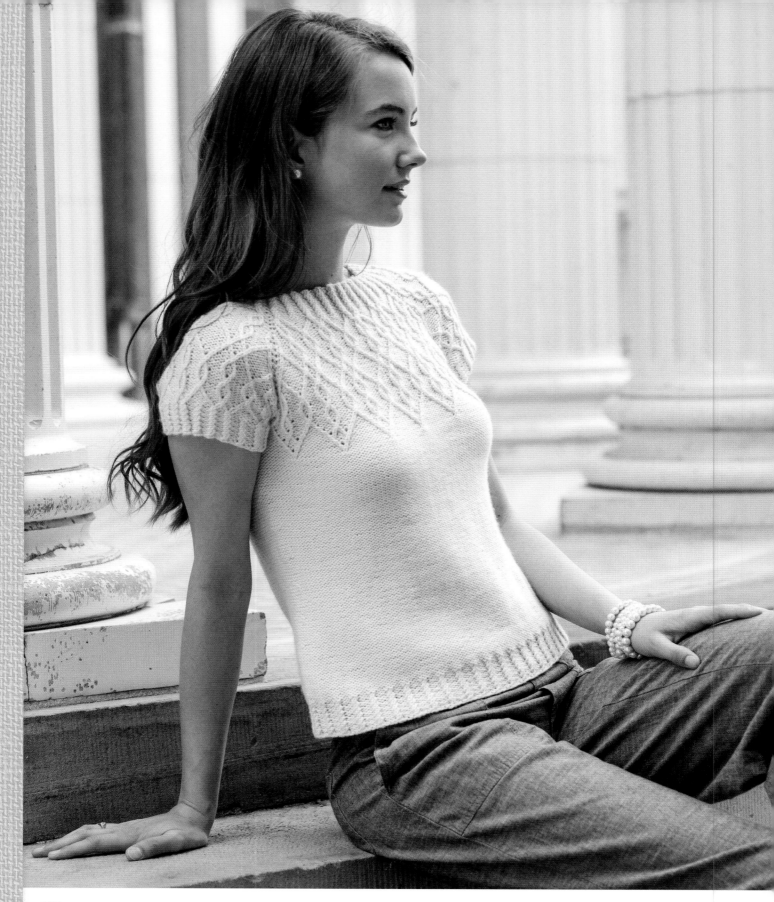

TRANSITION CHART A

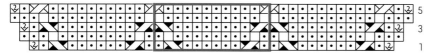

Legend:
- ☐ k on RS; p on WS
- · p on RS; k on WS
- purl into front and back of next st
- sl 1 st onto cn, hold in back, k1, k1 from cn
- sl 1 st onto cn, hold in back, k1, p1 from cn
- sl 1 st onto cn, hold in front, p1, k1 from cn
- ☐ pattern repeat

Chart A row numbers (right side): 15, 13, 11, 9, 7, 5, 3, 1

TRANSITION CHART B

Chart B row numbers (right side): 5, 3, 1

SIZES 33½" AND 41¾" (85 AND 106 CM) ONLY

Work Transition Chart A as follows:

RND 1: [Work 88 (112) sts in Transition Chart A , sl next 64 (88) sts to st holder or waste yarn for sleeve, CO 6 sts] twice.

Cont to work Transition Chart A through Row 15—192 (240) sts for body.

SIZES 38¼" AND 47½" (97 AND 120.5 CM) ONLY

Work Transition Chart B through Rnd 5—368 (464) sts.

NEXT RND: [Purl 104 (128) sts, sl next 80 (104) sts to st holder or waste yarn for sleeve, CO 6 (8) sts] twice—220 (272) sts for body.

ALL SIZES

Place new beg-of-rnd marker at center of underarm sts and 2nd shaping marker at center of opposite underarm sts. Work in reverse St st (purl every rnd) until body measures 3 (3, 4, 5)" (7.5 [7.5, 10, 12.5] cm) from underarm.

WAIST SHAPING

DEC RND: [P1, p2tog, p to 3 sts before next marker, p2tog, p1] twice—4 sts dec'd.

Rep Dec rnd every 8 rnds twice more—180 (208, 228, 260) sts. Work 8 rnds even.

INC RND: [P1, M1P, p to 1 st before next marker, M1P, p1] twice—4 sts inc'd.

Rep Inc rnd every 8 rnds twice more—192 (220, 240, 272) sts. Cont in rev St st until body measures about 12 (12, 13, 14)" (30.5 [30.5, 33, 35.5] cm) from underarm.

Work 12 rnds of Twisted Rib. Bind off loosely.

Sleeves

Place 64 (80, 88, 104) sts on dpns. Pick up 4 (4, 4, 8,) sts from the underarm and join, pm for beg of rnd—68 (84, 92, 112) sts.

SIZES 33½" AND 41¾" (85 AND 106 CM) ONLY

Cont to work Yoke Chart beg with Rnd 15, omitting increase sts at beg and end of rnds and incorporating cast-on underarm sts into chart patt. Cont to work chart in this way through Rnd 24.

ALL SIZES

Work in Twisted Rib for 10 rnds. BO loosely.

Finishing

Weave in all ends. Block to schematic measurements.

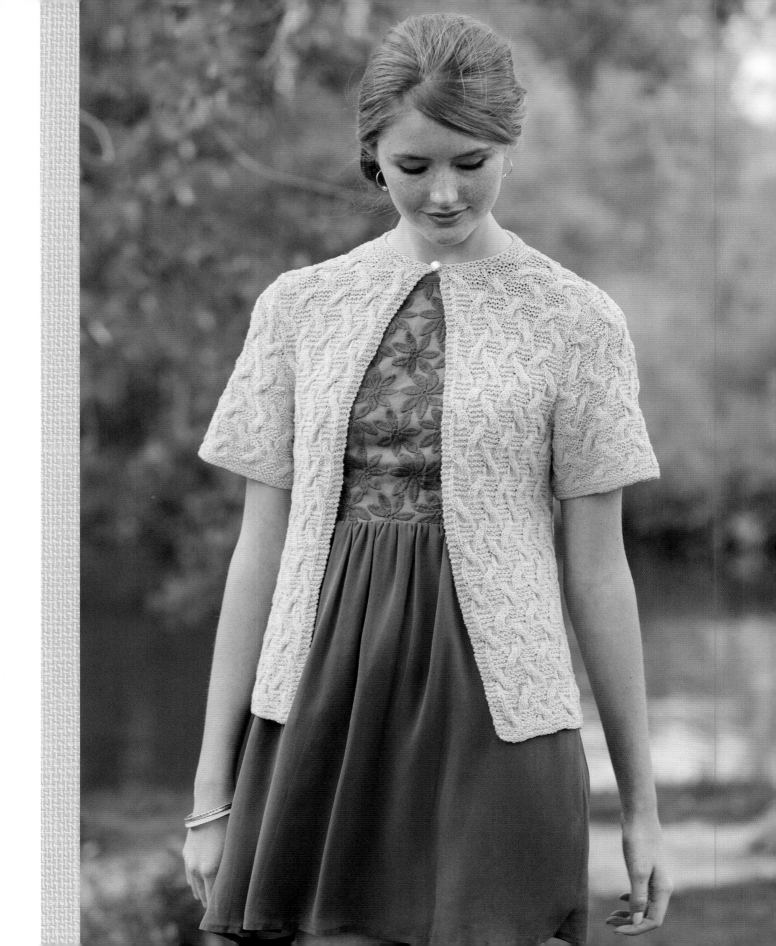

Jonetta

GARTER-CABLE CARDI

This sweater is just right when you need something to take the chill off on a spring evening. The simple construction and easy garter-cable pattern make it an ideal set-in-sleeve project for beginners.

FINISHED SIZE
About 34 (37, 40, 43, 46)" (86.5 [94, 101.5, 109, 117] cm) bust circumference.

Sweater shown measures 34" (86.5 cm).

YARN
Fingering weight (#1 Super Fine).

Shown here: Green Mountain Spinnery Forest (70% wool, 30% Tencel; 400 yd [366 m]/3½ oz [100 g]), sweet corn, 3 (3, 4, 4, 4) skeins.

NEEDLES
Size U.S. 5 (3.75 mm): 16" and 24" (40 and 61 cm) circular (cir).
Size U.S. F/5 (3.75 mm) crochet hook.

Adjust needle size if necessary to obtain the correct gauge.

NOTIONS
Cable needle (cn); stitch holder or waste yarn; one ⅜" (1 cm) button; tapestry needle.

GAUGE
26 sts and 34 rows = 4" (10 cm) in Garter Cable Chart pattern.

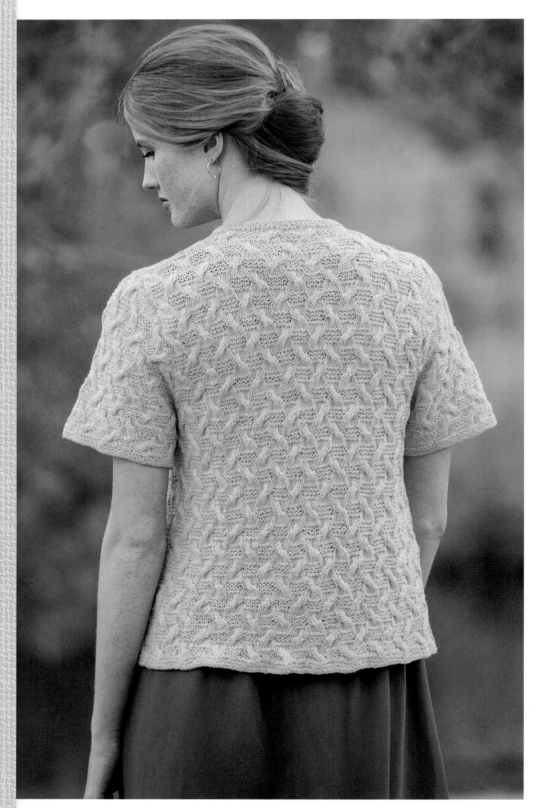

Back

CO 100 (109, 118, 127, 136) sts. Knit 4 rows.

INC ROW: (WS) [K7, k1f&b] 12 (13, 14, 15, 16) times, knit to end—112 (122, 132, 142, 152) sts.

Work in Garter Cable Chart until back measures 12½ (12½, 13, 13, 13½)" (31.5 [31.5, 33, 33, 34.5] cm) from lower edge, end with a WS row.

ARMHOLE SHAPING

BO 5 (5, 6, 6, 7) sts at the beg of next 2 rows, 4 (4, 5, 5, 6) sts at the beg of foll 2 rows. Dec one st at each side of the needle every RS row 3 (3, 4, 4, 5) times—88 (98, 102, 112, 116) sts. Work even until armhole measures 7½ (7½, 8, 8, 8½)" (19 [19, 20.5, 20.5, 21.5] cm), end with a WS row.

SHOULDER SHAPING

BO 8 (9, 9, 9, 10) sts at the beg of next 6 rows—40 (44, 48, 58, 56) sts. Place sts on stitch holder or waste yarn.

Right Front

CO 50 (56, 60, 64, 69) sts. Knit 4 rows.

INC ROW: (WS) [K7 (7, 9, 6, 9), k1f&b] 5 (6, 5, 8, 6) times, knit to end—55 (62, 65, 72, 75) st.

Work in Garter Cable Chart as foll:

ROW 1: (RS) K3, beg with st 1 (4, 1, 4, 1) of Garter Cable Chart, work chart to end.

ROW 2: (WS) Work Garter Cable Chart as established to last 3 sts, k3.

Cont in patt, working 3 sts at front edge in garter st, until front measures 12½ (12½, 13, 13, 13½)" (31.5 [31.5, 33, 33, 34.5] cm) from lower edge, end with a RS row.

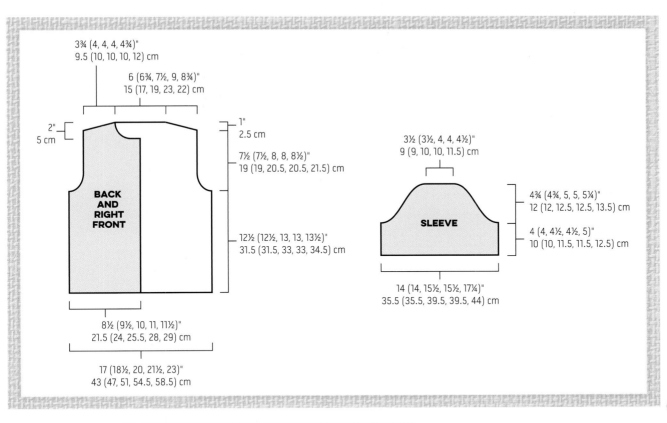

3¾ (4, 4, 4, 4¾)"
9.5 (10, 10, 10, 12) cm

6 (6¾, 7½, 9, 8¾)"
15 (17, 19, 23, 22) cm

2"
5 cm

1"
2.5 cm

7½ (7½, 8, 8, 8½)"
19 (19, 20.5, 20.5, 21.5) cm

BACK AND RIGHT FRONT

12½ (12½, 13, 13, 13½)"
31.5 (31.5, 33, 33, 34.5) cm

8½ (9½, 10, 11, 11½)"
21.5 (24, 25.5, 28, 29) cm

17 (18½, 20, 21½, 23)"
43 (47, 51, 54.5, 58.5) cm

3½ (3½, 4, 4, 4½)"
9 (9, 10, 10, 11.5) cm

SLEEVE

4¾ (4¾, 5, 5, 5¼)"
12 (12, 12.5, 12.5, 13.5) cm

4 (4, 4½, 4½, 5)"
10 (10, 11.5, 11.5, 12.5) cm

14 (14, 15½, 15½, 17¼)"
35.5 (35.5, 39.5, 39.5, 44) cm

ARMHOLE SHAPING

BO 5 (5, 6, 6, 7) sts at the beg of next WS row, 4 (4, 5, 5, 6) sts at beg of foll WS row. Dec one st at the armhole edge every RS row 3 (3, 4, 4, 5) times—43 (50, 50, 57, 57) sts. Work even until armhole measures 6½ (6½, 7, 7, 7½)" (14 16.5 [16.5, 18, 18, 19] cm), end with a WS row.

NECK & SHOULDER SHAPING

BO 9 (11, 11, 13, 13) sts at the beg of next RS row, 4 (5, 5, 8, 6) sts on foll RS row, then 3 (4, 4, 5, 4) sts on foll RS row. Dec one st at neck edge every RS row 3 (3, 3, 4, 4) times, *at the same time,* when armhole measures 7½ (7½, 8, 8, 8½)" (19 [19, 20.5, 20.5, 21.5] cm), shape shoulder as for back by binding off 8 (9, 9, 9, 10) sts at the beg of next 3 WS rows.

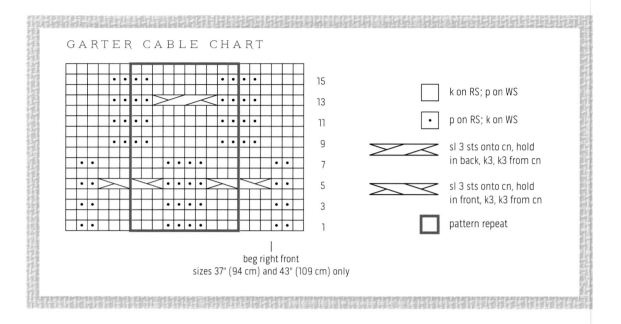

GARTER CABLE CHART

15
13
11
9
7
5
3
1

k on RS; p on WS

p on RS; k on WS

sl 3 sts onto cn, hold
in back, k3, k3 from cn

sl 3 sts onto cn, hold
in front, k3, k3 from cn

pattern repeat

beg right front
sizes 37" (94 cm) and 43" (109 cm) only

Left Front

CO 50 (56, 60, 64, 69) sts.
K 4 rows.

INC ROW: (WS) [K7 (7, 9, 6, 9),
k1f&b] 5 (6, 5, 8, 6) times, knit
to end—55 (62, 65, 72, 75) st.

Work in Garter Cable Chart
as foll:

ROW 1: (RS) Beg with first st,
work in Garter Cable Chart to
last 3 sts, k3.

ROW 2: (WS) K3, work chart
as established to end.

Cont in patt, working 3 sts at
front edge in garter st until
front measures 12½ (12½, 13,
13, 13½)" (31.5 [31.5, 33, 33,
34.5] cm) from lower edge, end
with a WS row.

ARMHOLE SHAPING

BO 5 (5, 6, 6, 7) sts at the beg of
next RS row, 4 (4, 5, 5, 6) sts at
beg of foll RS row. Dec one st at
the armhole edge every RS row 3
(3, 4, 4, 5) times—43 (50, 50, 57,
57) sts. Work even until armhole
measures 6½ (6½, 7, 7, 7½)" (16.5
[16.5, 18, 18, 19] cm), end with
a RS row.

NECK & SHOULDER SHAPING

BO 9 (11, 11, 13, 13) sts at the
beg of next WS row, 4 (5, 5, 8, 6)
sts on foll WS row, then 3 (4, 4, 5,
4) sts on foll WS row. Dec one
st at neck edge every RS row 3
(3, 3, 4, 4) times, *at the same time,*
when armhole measures 7½ (7½,
8, 8, 8½)" (19 [19, 20.5, 20.5,
21.5] cm), shape shoulder as for
back by binding off 8 (9, 9, 9, 10)
sts at the beg of next 3 RS rows.

Sleeves

CO 83 (83, 92, 92, 101) sts.
Knit 4 rows.

INC ROW: (WS) [K8, k1f&b] 9
(9, 10, 10, 11) times, knit to
end—92 (92, 102, 102, 112) sts.

Work in Garter Cable Chart
until sleeve measures 4 (4,
4½, 4½, 5)" (10 [10, 11.5, 11.5,
12.5] cm) from lower edge,
end with a WS row.

ARMHOLE & SLEEVE CAP
SHAPING

BO 5 (5, 6, 6, 7) sts at the beg of
the next 2 rows, 4 (4, 5, 5, 6) sts
on the foll 2 rows. Dec one st at
each side of needle every RS row
12 (12, 13, 13, 14) times. BO 2 sts
at beg of next 8 rows, then BO 3
sts at beg of next 4 rows—22
(22, 26, 26, 30) sts. BO all sts.

Finishing

Weave in all ends and block pieces to measurements. Sew shoulder seams and set in sleeves. Sew side and sleeve seams.

NECKBAND

With RS facing and shorter cir needle, beg at right front neck edge, pick and k19 (23, 23, 29, 27) sts to shoulder seam, k40 (44, 48, 58, 56) sts from back neck holder, pick up and k19 (23, 23, 29, 27) sts to left front neck edge—78 (90, 94, 116, 110) sts.

ROW 1: (WS) Knit, dec'ing 2 sts along each front neck edge and 4 sts along back neck edge—70 (82, 86, 108, 102) sts.

K 4 rows. BO all sts, leaving long tail at right front neck edge.

With crochet hook and tail, ch 6, sl st in right front neck edge to secure end of loop, turn and sc in each ch, sl st in neck edge once more. Fasten off.

Sew button to left front neck edge opposite loop. Weave in remaining ends.

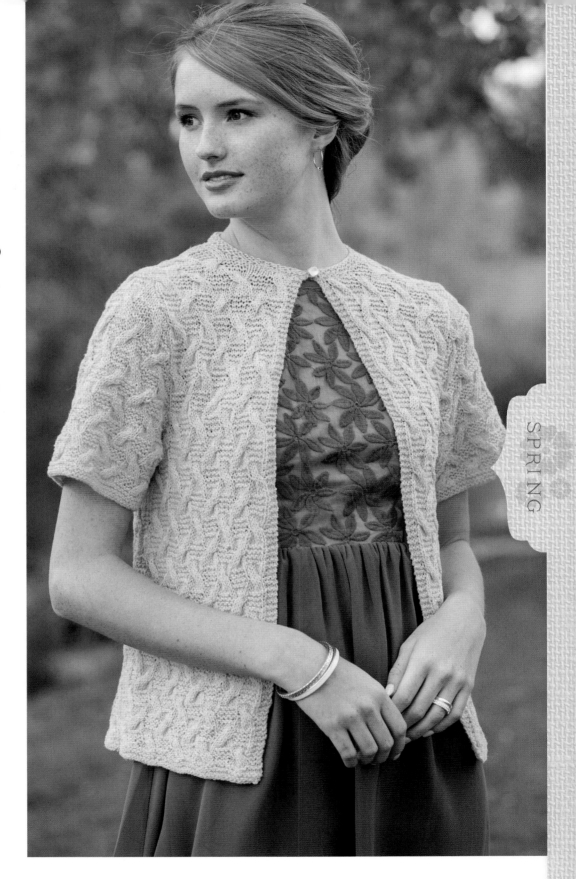

Fayola

LACE SHAWLETTE

This heart-shaped cover-up is light and ethereal, the ideal insubstantial something to dress up a sundress. Simple cables and lace make the most of luxurious silk and merino wool yarn in a gorgeous pale turquoise colorway.

FINISHED SIZE
About 60" (152.5 cm) wide and 19" (48.5 cm) long from center of top edge to tip of lower point after blocking.

YARN
Fingering weight (#1 Super Fine)

Shown here: Sweet Georgia Merino Silk Lace (50% silk, 50% merino wool; 765 yd [700 m]/3½ oz [100 g]), summer skin, 1 hank.

NEEDLES
Size U.S. 5 (3.75 mm): 40" (100 cm) circular (cir). Size U.S. F-5 (3.75 mm) crochet hook.

Adjust needle size if necessary to obtain the correct gauge.

NOTIONS
Markers (m); cable needle (cn); tapestry needle.

GAUGE
18 sts and 20 rows = 4" (10 cm) in Body Chart after blocking.

SET-UP CHART

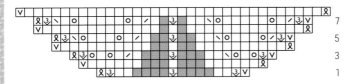

☐	k on RS; p on WS	☑ ↓ k1, yo, k1 in same st
☐ o	yo	☐ pattern repeat
☐ ∕	k2tog	▨ no stitch
☐ ＼	ssk	⤬ sl 2 sts onto cn, hold in back, k2, k2 from cn
☒	k1tbl on RS and WS	⤬ sl 2 sts onto cn, hold in front, k2, k2 from cn
☑	sl 1 wyf	

BODY CHART

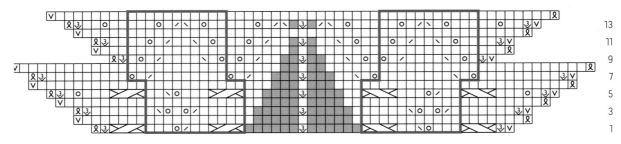

Shawl Body

CO 9 sts. Work Set-up Chart through Row 8—35 sts.

Note: On Rows 9–14 of Body Chart, the 11-st patt rep will be worked 1 additional time.

Work the 14-Row Body Chart 7 times—343 sts.

Shawl Edging

Note: On Rows 9–22 of Edging charts, the patt rep will be worked 1 additional time.

Work Edging charts as foll: work Row 1 of Right-Side Edging Chart to center st, then work Row 1 of Left-Side Edging Chart to end of row. Cont to work Edging charts in this way through Row 22.

CROCHET BIND-OFF

With crochet hook, BO 2 to 3 sts at a time using chart as a guide, working as foll: insert hook in group of 2 or 3 sts, yarn over and draw lp through sts, ch 6, *insert hook in group of 2 or 3 sts, yarn over and draw loop through all sts on hook, ch 6; rep from * to end of row. Fasten off.

Finishing

Weave in ends, but do not trim. Block shawl using desired method, bringing out the points on the shawl edging. Trim ends.

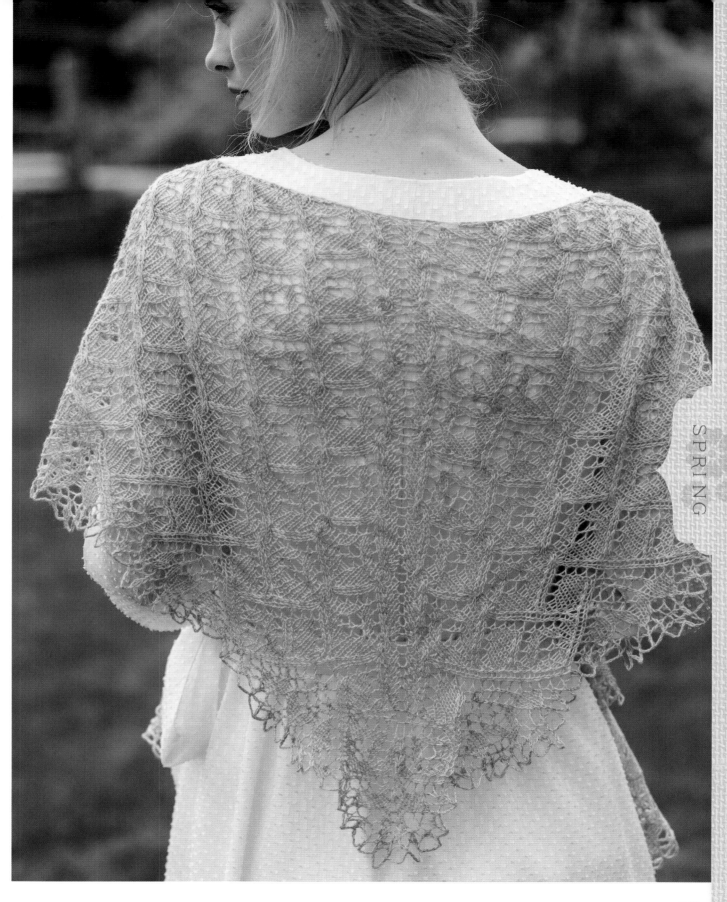

RIGHT SIDE EDGING CHART

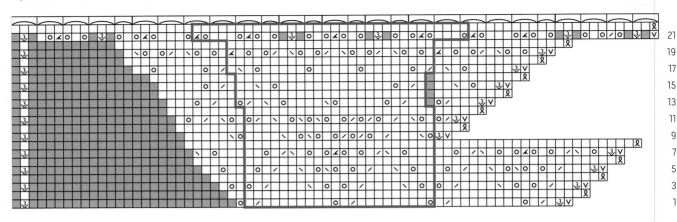

LEFT SIDE EDGING CHART

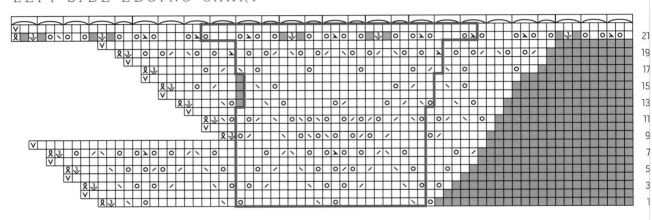

☐ k on RS; p on WS	⅄ sl 1, k2tog, psso
◉ yo	⅂ k1, yo, k1 in same st
╱ k2tog	☐ pattern repeat
╲ ssk	▨ no stitch
⅄ k1tbl on RS and WS	⤬ sl 2 sts onto cn, hold in back, k2, k2 from cn
⋁ sl 1 wyf	⤬ sl 2 sts onto cn, hold in front, k2, k2 from cn
⋏ k3tog	⌒ bind off using crochet hook

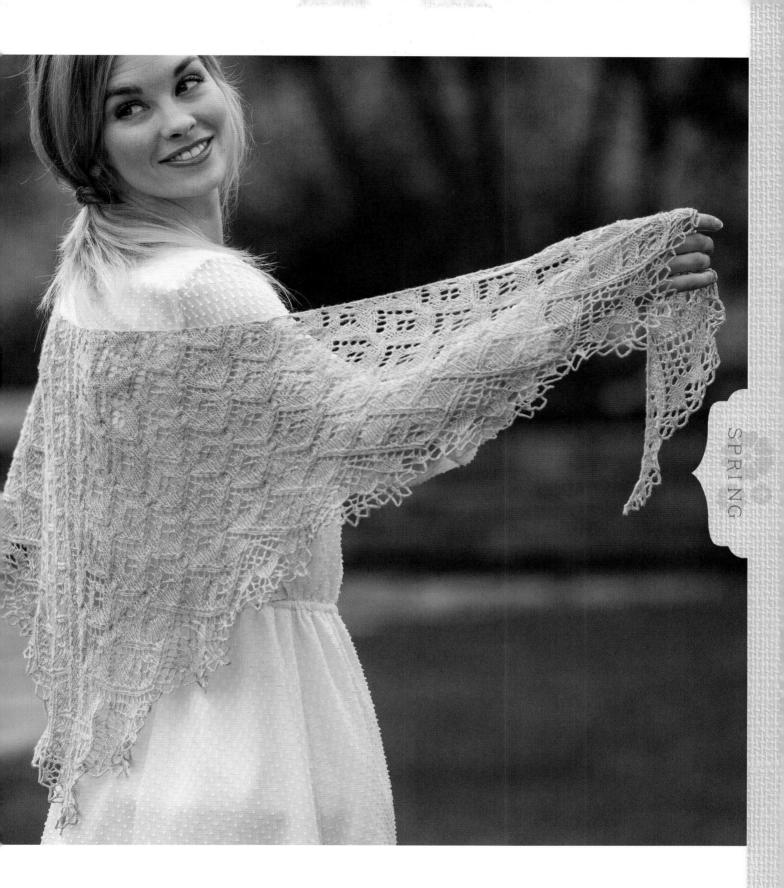

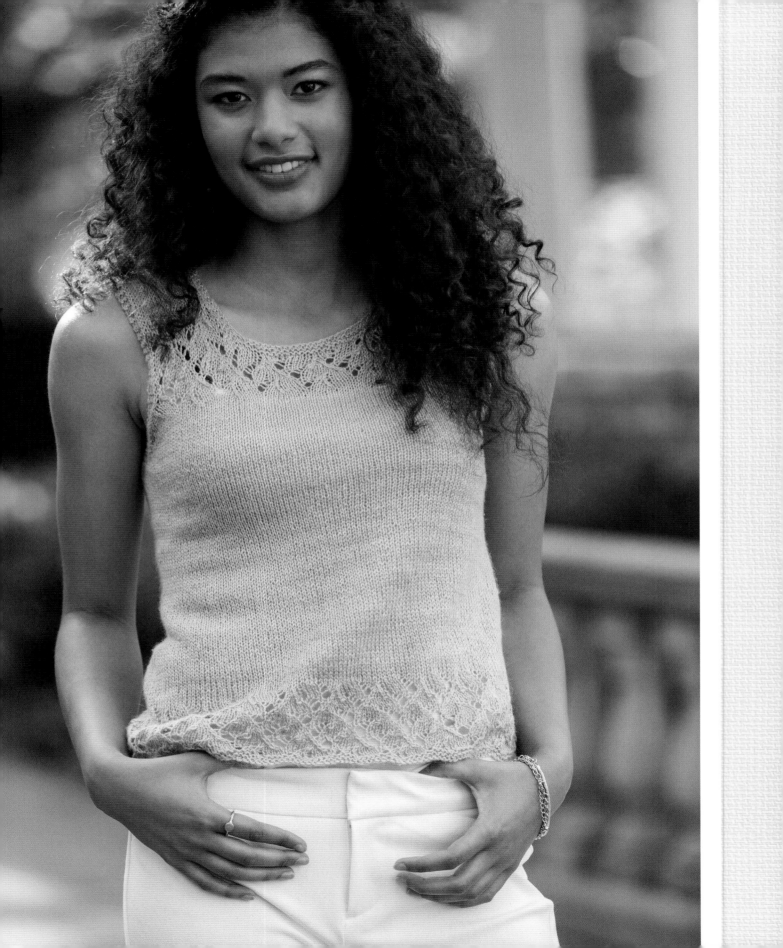

SUMMER MEANS the beach in these parts, and all of these summer projects would be lovely beachwear. The fibers are the lightest weights—nothing more than fingering and lace—worked up at loose tensions for breathable fabrics. There are lightweight tanks for everyday summer dressing and a lacy tunic for covering up a bit of skin.

Summer

A lace-trimmed cardigan takes the chill off your sun-kissed shoulders when the air conditioning inside is a bit too cold. Finally, knit an airy shawl to cover up for a late-night stroll with your toes in the sand.

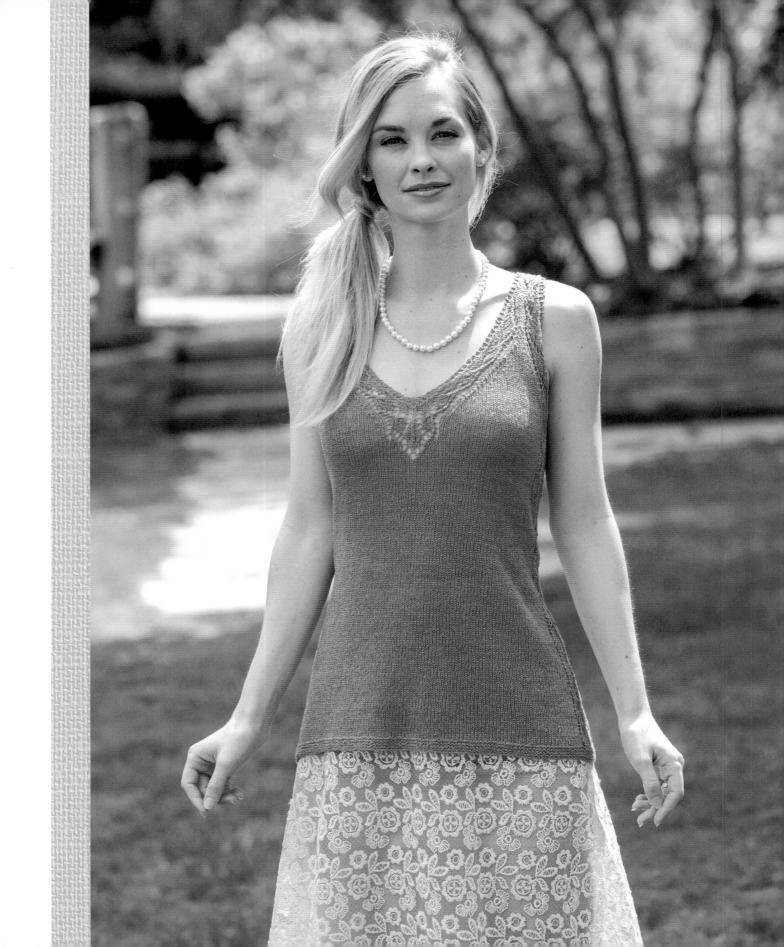

Leora

V-NECK TANK

Cool fingering-weight linen yarn creates a tank that's substantial enough to be worn alone but light enough to keep you comfortable in the summer sun. The wide straps of the tank cover bra straps and save you from that torture device called a strapless bra. Lace detailing gives it feminine charm.

FINISHED SIZE

About 35 (39, 43, 47, 51)" (89 [99, 109, 119.5, 129.5] cm) bust circumference.

Sweater shown measures 35" (89 cm).

YARN

Fingering weight (#1 Super Fine).

Shown here: Shibui Linen (100% linen; 246 yd [225 m]/1¾ oz [50 g]), poppy, 4 (4, 5, 5, 6) balls.

NEEDLES

Size U.S. 5 (3.75 mm): 32" or 40" (81 or 100 cm) circular (cir).

Adjust needle size if necessary to obtain the correct gauge.

NOTIONS

Markers (m); stitch holders or waste yarn; tapestry needle.

GAUGE

26 sts and 37 rnds = 4" (10 cm) in St st after blocking.

Body

CO 240 (266, 292, 318, 344) sts. Join to work in the rnd, being careful not to twist sts, and place marker (pm) for beg of rnd. Rnd begins at back left side edge.

RND 1: K15, pm, k105 (118, 131, 144, 157), pm, k15, pm, knit to end of rnd.

Beg with a purl rnd, work 7 rnds in garter stitch (purl 1 rnd, knit 1 rnd).

NEXT RND: [Work Lace Panel Chart over 15 sts, sl marker, k to marker, sl marker] twice.

Cont in patts as established, working chart through Rnd 12 and then rep Rnds 1–12, working rem sts in St st (k every rnd), until the body measures 3 (3, 4, 4, 5)" (7.5 [7.5, 10, 10, 12.5] cm) from the cast-on edge.

WAIST SHAPING

DEC RND: [Work Lace Panel Chart over 15 sts, sl marker, k1, k2tog, k to 3 sts before marker, ssk, k1, sl marker] twice—4 sts dec'd.

Cont in patts as established, rep Dec rnd every 8th rnd 8 more times—204 (230, 256, 282, 308) sts, 87 (100, 113, 126, 139) sts in St st for each front and back (note that total st count includes 15 sts for each lace panel, although actual count will vary depending on chart rnd).

Work in patts as established until the body measures about 14 (14, 15, 15, 16)" (35.5 [35.5, 38, 38, 40.5] cm) from the cast-on edge, ending with Rnd 12 of the Lace Panel Chart.

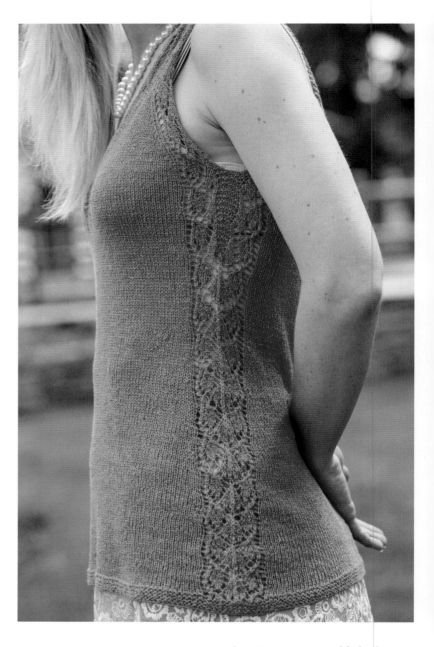

BUST INCREASES AND NECKLINE SET-UP

NEXT RND: Work Bust Increase Chart over 15 side lace panel sts, sl marker, k2tog 0 (1, 0, 1, 0) times, k32 (37, 45, 50, 58) sts, pm, work Front Neck Chart over 23 sts, pm, k to marker, sl marker, work Bust Increase Chart over 15 side lace panel sts, sl marker, k to end.

Cont in patts as established through Rnd 32 of Bust Increase and Front Neck Charts—229 (254, 281, 306, 333) sts, 26 in each side lace panel, 90 (102, 116, 128, 142) sts for front, 87 (100, 113, 126, 139) sts for back.

Slip the next 13 sts to the RH needle. Place next 116 (128, 142, 154, 168) sts for front on waste yarn or a stitch holder. Work back and forth on the rem 113 (126, 139, 152, 165) sts for back.

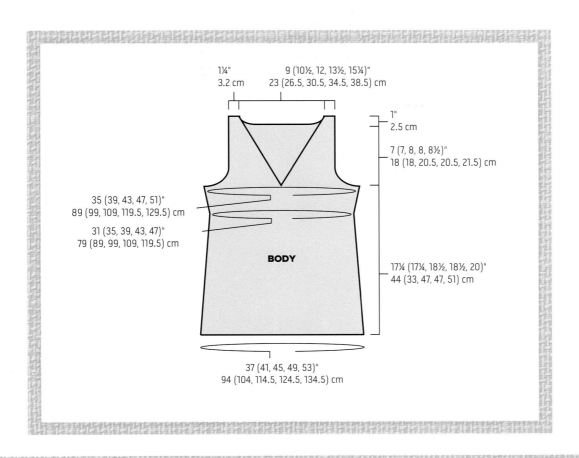

1¼"
3.2 cm

9 (10½, 12, 13½, 15¼)"
23 (26.5, 30.5, 34.5, 38.5) cm

1"
2.5 cm

7 (7, 8, 8, 8½)"
18 (18, 20.5, 20.5, 21.5) cm

35 (39, 43, 47, 51)"
89 (99, 109, 119.5, 129.5) cm

31 (35, 39, 43, 47)"
79 (89, 99, 109, 119.5) cm

BODY

17¼ (17¼, 18½, 18½, 20)"
44 (33, 47, 47, 51) cm

37 (41, 45, 49, 53)"
94 (104, 114.5, 124.5, 134.5) cm

LACE PANEL CHART

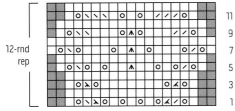

12-rnd rep

11
9
7
5
3
1

BUST INCREASE CHART

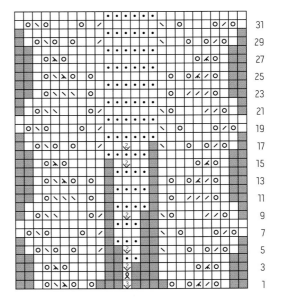

31
29
27
25
23
21
19
17
15
13
11
9
7
5
3
1

	k on RS; p on WS		sl 1, k2tog, psso
	p on RS; k on WS		sl 2 as if to k2tog, k1, p2sso
	yo		no stitch
	k1tbl on RS and WS		knit into front and back of next st
	k2tog		k1, yo, k1 in same st
	ssk		
	k3tog		

Back

DEC ROW: (RS) Work Right Lace Chart over 13 sts, sl marker, k1, k2tog, k to 3 sts before marker, ssk, k1, sl marker, work Left Lace Chart over 13 sts—2 sts dec'd.

NEXT ROW: (WS) Work Left Lace Chart to marker, sl marker, p to marker, sl marker, work Right Lace Chart to end.

Cont in patts as established, rep Dec row every other row 13 (15, 16, 18, 19) more times—59 (68, 79, 88, 99) sts in St st between markers.

Work even until armhole measures 7 (7, 8, 8, 8 ½)" (18 [18, 20.5, 20.5, 21.5] cm).

SHORT-ROW SHAPING FOR BACK NECK

Note: The back of the neck is shaped with short-rows. Make sure to keep the lace in pattern as established. After the turn, a yarnover is worked at the beginning of the next short-row. These yarnovers will be worked together with the foll st to close gaps and are not included in the stitch count.

ROW 1: (RS) Work Right Lace Chart to marker, sl marker, k16 (16, 20, 20, 24) turn.

ROWS 2, 4, 6, AND 8: (WS) Yo, purl to marker, sl marker, work in patt to end.

ROW 3: Work to marker, sl marker, k12 (12, 15, 15, 18) turn.

ROW 5: Work to marker, sl marker, k8 (8, 10, 10, 12) turn.

ROW 7: Work to marker, sl marker, k4 (4, 5, 5, 6) turn.

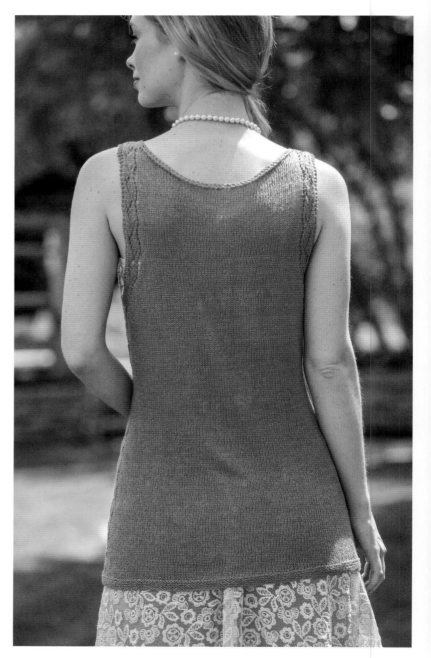

ROW 9: Work to marker, sl marker, knit to marker, knitting yo's together with foll st, sl marker, work Left Lace Chart to end.

ROW 10: Work to marker, sl marker, p16 (16, 20, 20, 24), turn.

ROWS 11, 13, 15, AND 17: Yo, knit to marker, sl marker, work in patt to end.

ROW 12: Work to marker, sl marker, p12 (12, 15, 15, 18), turn.

ROW 14: Work to marker, sl marker, p8 (8, 10, 10, 12), turn.

ROW 16: Work to marker, sl marker, p4 (4, 5, 5, 6), turn.

ROW 18: Work to marker, sl marker, purl to marker, purling yo's together with foll st, sl marker, work Right Lace Chart to end.

FRONT NECK CHART

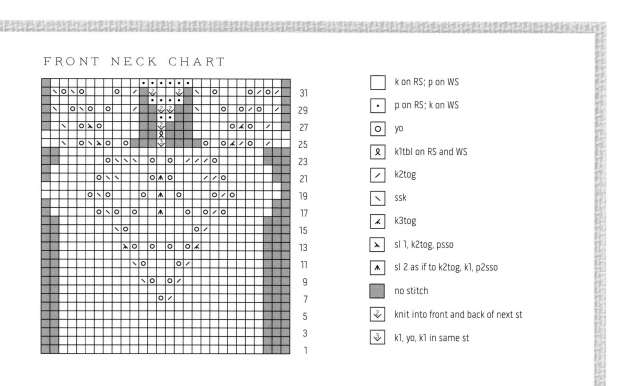

	Legend
☐	k on RS; p on WS
•	p on RS; k on WS
o	yo
℞	k1tbl on RS and WS
/	k2tog
\	ssk
⼂	k3tog
⅄	sl 1, k2tog, psso
⋀	sl 2 as if to k2tog, k1, p2sso
▨	no stitch
℣	knit into front and back of next st
⍋	k1, yo, k1 in same st

If necessary, work even to end on chart Row 4, 6, or 8—11 sts in chart patt each side, 59 (68, 79, 88, 99) sts between markers. Place back sts on waste yarn or stitch holder.

Fronts

Place the first 58 (64, 71, 77, 84) front sts on needle to work left front.

ROW 1: (RS) Work Right Lace Chart over 13 sts, sl marker, k1, k2tog, k to 3 sts before marker, ssk, k1, sl marker, work Left Lace Chart over 13 sts.

ROW 2: (WS) Work Left Lace Chart to marker, sl marker, p to marker, work Right Lace Chart to end.

FOR SIZES 47 AND 51 ONLY: Alternate double dec's at neck edge with single dec's until 4 (10) double dec's have been worked, then cont with single dec's only.

Rep last 2 rows 13 (15, 16, 18, 19) more times, then work dec at neck edge only every RS row 2 (4, 9, 7, 6) more times, when all shaping is complete work 8 (0, 0, 0, 0) rows even, end with Row 4 of charts—24 sts, 2 sts in St st rem between markers.

NEXT ROW: (RS) Work Left Strap Chart over 24 sts.

Cont to work chart as established through Row 24—14 sts. Working in patt as established (rep Rows 13–24 of chart, omitting neck edge dec's), work 12 (12, 4, 4, 12) more rows. Place rem 14 sts on waste yarn or stitch holder.

Place rem 58 (64, 71, 77, 84) front sts on needle to work right front. Join yarn ready to work a RS row and complete as for left front, reversing chart placement and all shaping.

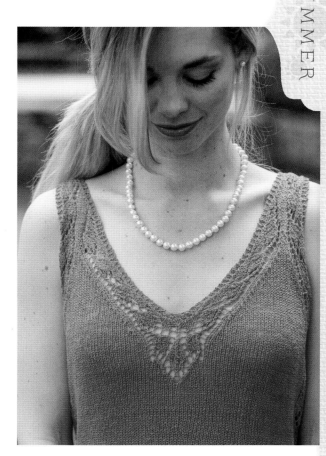

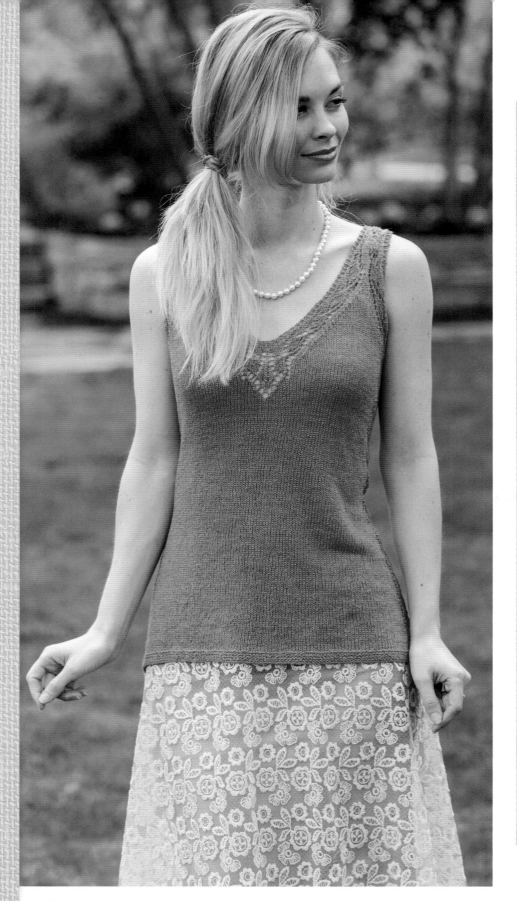

LEFT LACE CHART

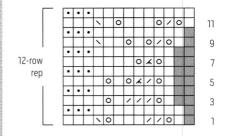

12-row rep

Rows labeled: 11, 9, 7, 5, 3, 1

RIGHT LACE CHART

12-row rep

Rows labeled: 11, 9, 7, 5, 3, 1

	
□	k on RS; p on WS
•	p on RS; k on WS
O	yo
�15	k1tbl on RS and WS
╱	k2tog
╲	ssk
⋏	k3tog
⋏	sl 1, k2tog, psso
⋏	sl 2 as if to k2tog, k1, p2sso
▨	no stitch
⇓	knit into front and back of next st
⇓	k1, yo, k1 in same st

LEFT STRAP CHART

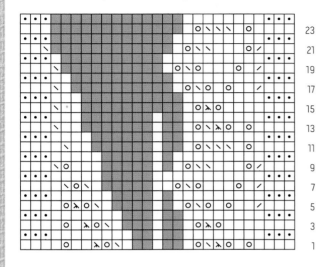

RIGHT STRAP CHART

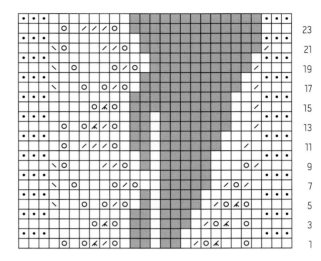

Neck Edging

With RS touching and WS facing outward, use the three-needle bind-off method (see Glossary) to BO 11 sts at each shoulder edge tog, leaving 3 sts at each front neck edge and 59 (68, 79, 88, 99) sts for back neck on hold. Place 3 rem sts at right front neck edge on needle and join back sts with garter st edging as foll:

ROW 1: (RS) K2, ssk the last st together with the next st from the back.

ROW 2: (WS) Sl 1, k2.

Rep Rows 1 and 2 until all the back neck sts have been joined to garter edging. Using Kitchener stitch (see Glossary), graft last row to 3 sts on hold at left front neck edge.

Finishing

Weave in all ends. If necessary, use some of the ends to tighten up the areas under the arms and at the V-neck where there might be small gaps. The linen yarn responds well to handwashing and a short tumble in the dryer on low heat. Use a steam iron to smooth out the lace.

SUMMER

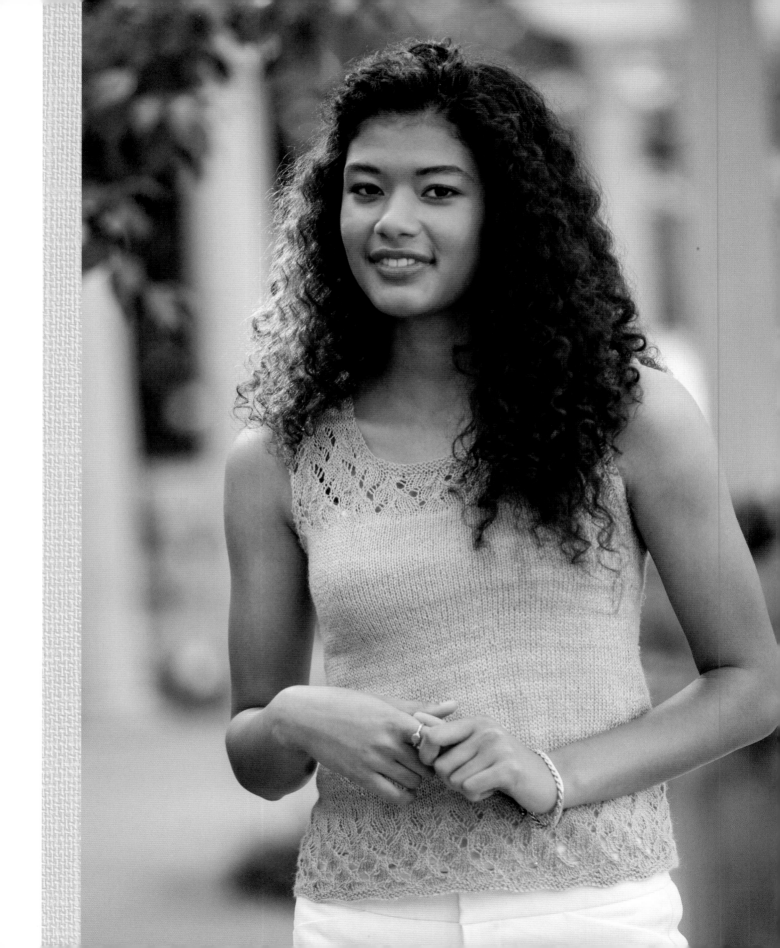

Dorthelia

LACE-EDGED TANK

Wear this feminine tank
with white shorts or capris
for casual summer flair
or pair it with a skirt for
an evening out. The touches
of lace are placed
to show just the right
amount of skin.

FINISHED SIZE
About 31 (34, 36, 39,
42½)" (79 [86.5, 91.5,
99, 108] cm) bust
circumference.

Sweater shown measures
31" (79 cm).

YARN
Fingering weight
(#1 Super Fine).

Shown here: The Fibre
Company Meadow (40%
merino wool, 25% llama,
20% silk, 15% linen; 545 yd
[498 m]/3½ oz [100 g]),
pennyroyal (pale blue-
green), 1 (2, 2, 2, 2) skeins.

NEEDLES
U.S. 5 (3.75 mm): 32"
or 40" (81 or 100 cm)
circular (cir).

*Adjust needle size
if necessary to obtain
the correct gauge.*

NOTIONS
Markers (m); stitch
holders or waste yarn;
tapestry needle.

GAUGE
25 sts and 34 rnds = 4"
(10 cm) in St st after
blocking.

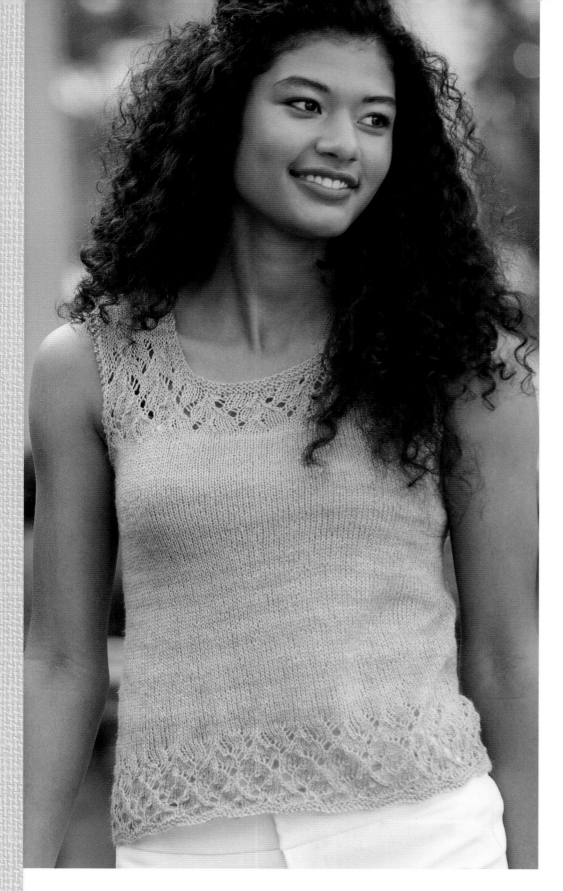

Body

CO 99 (108, 117, 126, 135) sts, place marker (pm) for side, CO 99 (108, 117, 126, 135) sts—198 (216, 234, 252, 270) sts. Join to work in the rnd, being careful not to twist sts, and pm for beg of rnd.

Work 6 rnds in garter st (knit 1 rnd, purl 1 rnd).

Work Rnds 1–24 of Lace Chart.

Work 4 rnds in St st (knit every rnd).

WAIST SHAPING

DEC RND: *K1, ssk, k to 3 sts before marker, k2tog, k1; repeat from * once more—4 sts dec'd.

Rep Dec rnd every 12th rnd 3 (3, 4, 4, 3) times—182 (200, 214, 232, 254) sts.

Work even for 8 rnds.

INC RND: *K1, m1, k to one st before next marker, m1, k1; repeat from * once more—4 sts inc'd.

Rep Inc rnd every 12 rnds twice more—194 (212, 226, 244, 266) sts.

Work even in St st until body measures 12 (12, 13, 13, 14)" (30.5 [30.5, 33, 33, 35.5] cm).

ARMHOLE SET-UP

RND 1: Knit.

RND 2: P3, k to 3 sts before side marker, p6, k to last 3 sts, p3.

Repeat Rnds 1 and 2 twice more.

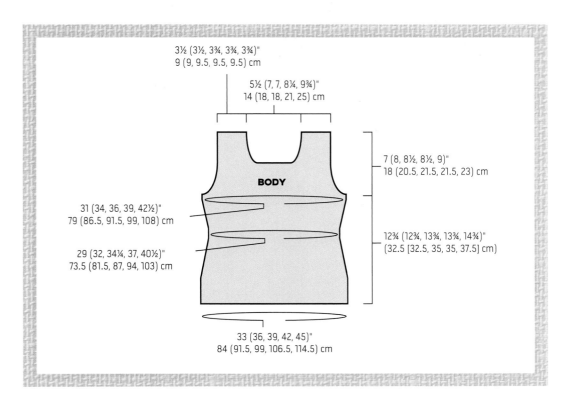

3½ (3½, 3¾, 3¾, 3¾)"
9 (9, 9.5, 9.5, 9.5) cm

5½ (7, 7, 8¼, 9¾)"
14 (18, 18, 21, 25) cm

BODY

7 (8, 8½, 8½, 9)"
18 (20.5, 21.5, 21.5, 23) cm

31 (34, 36, 39, 42½)"
79 (86.5, 91.5, 99, 108) cm

29 (32, 34¼, 37, 40½)"
73.5 (81.5, 87, 94, 103) cm

12¾ (12¾, 13¾, 13¾, 14¾)"
(32.5 [32.5, 35, 35, 37.5] cm)

33 (36, 39, 42, 45)"
84 (91.5, 99, 106.5, 114.5) cm

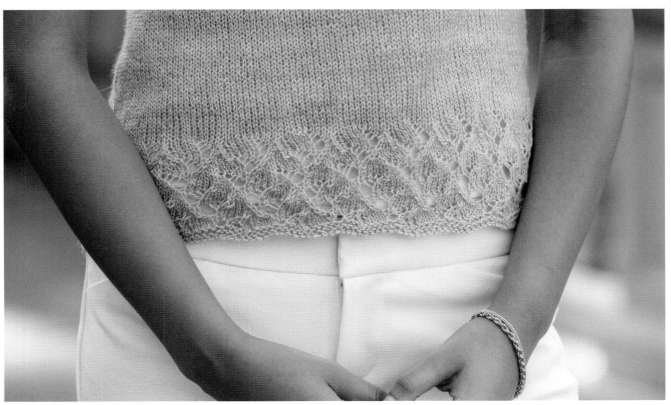

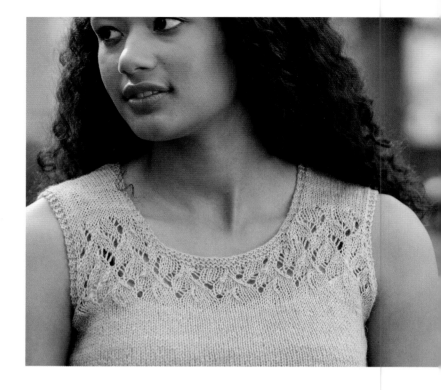

LACE CHART

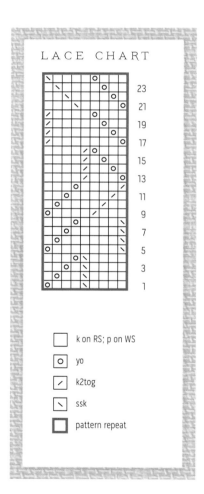

| | | | | | | | | | | |
23
21
19
17
15
13
11
9
7
5
3
1

☐ k on RS; p on WS

◉ yo

⟋ k2tog

⟍ ssk

▢ pattern repeat

Front

NEXT RND: K3, ssk, k to 5 sts before side marker, k2tog, k3, turn. Place remaining 97 (106, 113, 122, 133) sts on waste yarn or stitch holder for back.

NEXT ROW: (WS) K3, p to last 3 sts, k3.

Keeping the first and last 3 sts in garter as established, dec one st inside garter sts at each armhole edge every RS row 5 (5, 7, 7, 8) more times—85 (94, 97, 106, 115) sts. Place markers for center 72 (81, 81, 90, 99) sts.

Note: For 31" and 34" sizes, markers will be one st off center with extra st at left side.

NEXT ROW: (RS) K3, ssk, k to marker, work Lace Chart to marker, k to last 5 sts, k2tog, k3—2 sts dec'd.

Cont in patts as established, dec one st inside garter sts at each armhole edge every RS row twice more—79 (88, 91, 100, 109) sts.

For sizes 31" and 34" (79 and 86.5 cm) only, dec one more st inside garter sts at beg of foll RS row—78 (87) sts.

For all sizes, cont in patts through Row 12 of Lace Chart.

NECKLINE SET-UP

ROW 1: (RS) K3, k0 (0, 2, 2, 2), work 18 sts in Lace Chart, k36 (45, 45, 54, 63), work 18 sts in Lace Chart, k0 (0, 2, 2, 2), k3.

ROW 2: (WS) K3, p0 (0, 2, 2, 2), work 18 sts in Lace Chart, k36 (45, 45, 54, 63), work 18 sts in Lace Chart, p0 (0, 2, 2, 2), k3.

Rep Rows 1 and 2 once, then rep Row 1 once more.

ROW 6: K3, p0 (0, 2, 2, 2), work 18 sts in Lace Chart, k3, BO 30 (39, 39, 48, 57) sts, k3, work 18 sts in Lace Chart, p0 (0, 2, 2, 2), k3—24 (24, 26, 26, 26) sts rem on each side.

FRONT STRAPS

Work left strap first as foll:

NEXT ROW: (RS) K3, k0 (0, 2, 2, 2), work in Lace Chart to last 5 sts, k2tog, k3—one st dec'd.

NEXT ROW: (WS) K3, work in Lace Chart to marker, p0 (0, 2, 2, 2), k3.

Rep last 2 rows once more—22 (22, 24, 24, 24) sts.

Work in patt until Lace Chart is complete, then work even in St st with 3-st garter st edges until armhole measures 7 (8, 8½, 8½, 9)" (18 [20.5, 21.5, 21.5, 23] cm). Place sts on waste yarn or stitch holder.

Join yarn to 24 (24, 26, 26, 26) sts for right strap, ready to work a RS row and complete as for left strap, reversing shaping at neck edge.

Back

Place 97 (106, 113, 122, 133) sts for the back on needle. Join yarn ready to work a RS row.

NEXT ROW: (RS) K3, ssk, k to last 5 sts, k2tog, k3—2 sts dec'd.

NEXT ROW: (WS) K3, p to last 3 sts, k3.

Rep last 2 rows 8 (8, 10, 10, 11) times—79 (88, 91, 100, 109) sts.

For sizes 31" and 34" (79 and 86.5 cm) only, dec one more st inside garter sts at beg of foll RS row—78 (87) sts. Work 1 WS row.

For all sizes, work even in St st with 3-st garter edges for 4 (4, 6, 6, 6) rows, end with a WS row.

NECKLINE SET-UP

ROW 1: (RS) K21 (21, 23, 23, 23), pm, k36 (45, 45, 54, 63), pm, k to end.

ROW 2: K3, p18 (18, 20, 20, 20), k to marker, p18 (18, 20, 20, 20), k3.

ROW 3: Knit.

Rep Rows 2 and 3 once more.

ROW 6: K3, p18 (18, 20, 20, 20), k3, BO 30 (39, 39, 48, 57) sts, k to marker, p18 (18, 20, 20, 20), k3—24 (24, 26, 26, 26) sts rem on each side.

BACK STRAPS

Work right strap first as foll:

NEXT ROW: (RS) K3, k last 5 sts, k2tog, k3—one st dec'd.

NEXT ROW: (WS) K3, p to last 3 sts, k3.

Rep last 2 rows once more—22 (22, 24, 24, 24) sts.

Work even until armhole measures same as front. Place sts on waste yarn or stitch holder.

Join yarn to 24 (24, 26, 26, 26) sts for left strap ready to work a RS row and complete as for right strap, reversing shaping at neck edge.

Finishing

With RS touching and WS facing outward, use the three-needle bind-off method (see Glossary) to BO 24 (24, 26, 26, 26) sts at each shoulder edge tog. Weave in all ends. If necessary, use some of the ends to tighten up the areas under the arms and at the neckline where there might be small gaps. Block to schematic measurements.

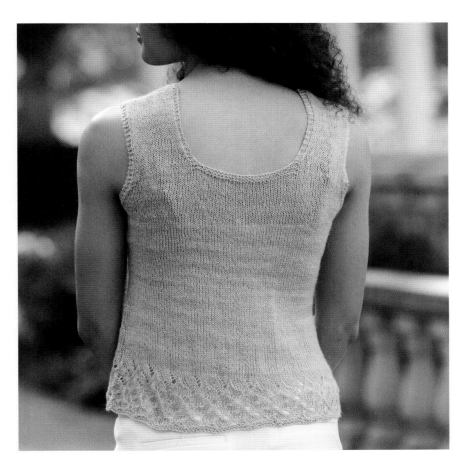

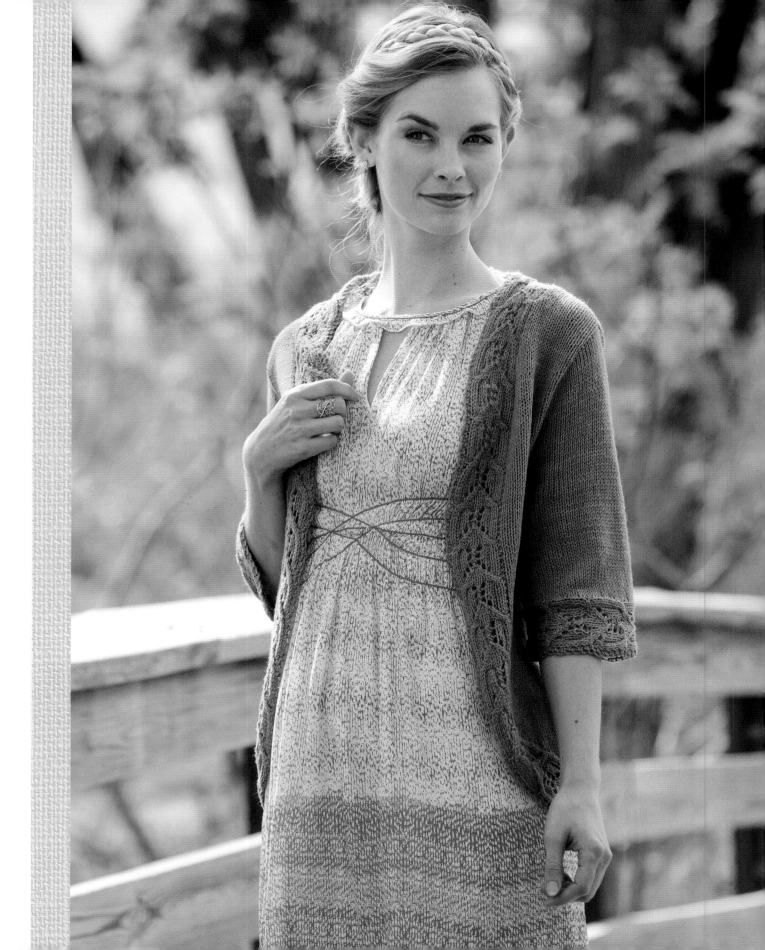

Temple

CABLE-EDGED CARDIGAN

This light and sheer cardigan sits like a whisper over your favorite sundresses and sleeveless tops. Worked up in lace-weight merino wool at an airy gauge, it will become your go-to summer cover-up.

FINISHED SIZE
About 34 (37, 41, 44½, 48)" (86.5 [94, 104, 113, 122] cm) bust circumference.
Sweater shown measures 34" (86.5 cm).

YARN
Laceweight (#0 Lace).

Shown here: Dream In Color Baby (100% merino wool; 700 yd [640 m]/4 oz [115 g]), Prince William, 2 (2, 2, 2, 3) skeins.

NEEDLES
Size U.S. 6 (4 mm).

Adjust needle size if necessary to obtain the correct gauge.

NOTIONS
Markers (m); stitch holders or waste yarn; tapestry needle.

GAUGE
22 sts and 30 rows = 4" (10 cm) in St st.

NOTES
Bust measurements are given with about a 1" (2.5 cm) gap between fronts.

When picking up along edges of chart patterns, pick up with right side of work facing along garter side edge so that yarnovers are at the outer edge.

Back

CO 16 sts. Work 12 rows of Left and Back Border Chart 10 (11, 12, 13, 14) times, then work through Row 2 (4, 6, 6, 8) once more—piece measures about 16 (17¾, 19¾, 21¼, 23)" (40.5 [45, 50, 54, 58.5] cm) from beg. BO.

With RS facing and working along garter side edge, pick up and knit about 3 sts for every 4 rows—92 (102, 112, 122, 132) sts. Beg with a WS row, work in St st (k on RS, p on WS) until piece measures 5 (5, 5½, 5½, 6)" (12.5 [12.5, 14, 14, 15] cm) from lower edge.

WAIST SHAPING

Dec 1 st at each side on next row, then every 6th row twice more—86 (96, 106, 116, 126) sts. Work 7 rows even. Inc one st at each side on next row, then every 6th row twice more—92 (102, 112, 122, 132) sts. Continue to work in St st until back measures 15 (15, 16, 16, 17)" (38 [38, 40.5, 40.5, 43] cm), end with a WS row.

ARMHOLE SHAPING

BO 4 (5, 5, 5, 6) sts at beg of next 2 rows, then BO 4 (6, 7, 8, 8) sts at beg of next 2 rows. Dec one st at each side every RS row twice—72 (76, 84, 92, 100) sts. Continue in St st until armhole measures 8 (8, 8½, 8½, 9)" (20.5 [20.5, 21.5, 21.5, 23] cm), end with a WS row.

SHOULDER SHAPING

BO 7 (6, 6, 8, 10) sts at beg of next 2 rows, 7 (5, 7, 8, 9) sts at beg of next 2 rows. BO 0 (5, 7, 8, 9) sts at beg of next 2 rows—44 sts. Place sts on holder or waste yarn for back neck.

Right Front

CO 16 sts. Work 12 rows of Right Border Chart 3 (3, 4, 5, 5) times, then work through Row 5 (11, 5, 1, 7) once more. Place the 16 sts on holder or waste yarn.

With RS facing and working along garter side edge, pick up and knit about 3 sts for every 4 rows—30 (35, 40, 45, 50) sts. Work short-row shaping for front curve starting on a WS row as follows:

ROW 1: (WS) Purl to last 16 sts, wrap and turn (w&t; see Glossary).

ROW 2 (AND ALL RS ROWS): Knit.

ROW 3: Purl to last 13 sts, picking up and purling wrap with foll st on this and all foll WS rows, w&t.

ROW 5: Purl to last 10 sts, w&t.

ROW 7: Purl to last 8 sts, w&t.

ROW 9: Purl to last 6 sts, w&t.

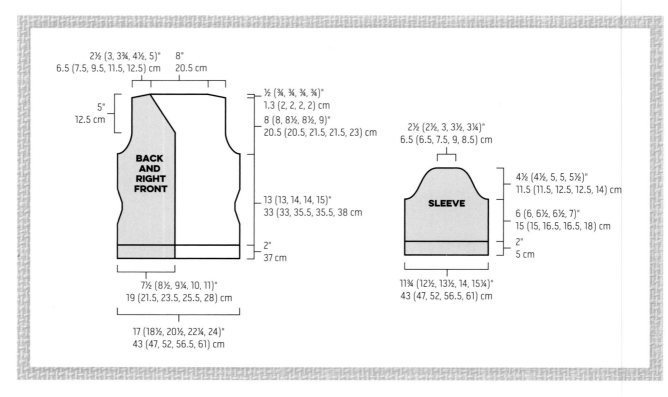

2½ (3, 3¾, 4½, 5)"
6.5 (7.5, 9.5, 11.5, 12.5) cm

8"
20.5 cm

5"
12.5 cm

½ (¾, ¾, ¾, ¾)"
1.3 (2, 2, 2, 2) cm

8 (8, 8½, 8½, 9)"
20.5 (20.5, 21.5, 21.5, 23) cm

BACK AND RIGHT FRONT

13 (13, 14, 14, 15)"
33 (33, 35.5, 35.5, 38) cm

2"
37 cm

7½ (8½, 9¼, 10, 11)"
19 (21.5, 23.5, 25.5, 28) cm

17 (18½, 20½, 22¼, 24)"
43 (47, 52, 56.5, 61) cm

2½ (2½, 3, 3½, 3¼)"
6.5 (6.5, 7.5, 9, 8.5) cm

SLEEVE

4½ (4½, 5, 5, 5½)"
11.5 (11.5, 12.5, 12.5, 14) cm

6 (6, 6½, 6½, 7)"
15 (15, 16.5, 16.5, 18) cm

2"
5 cm

11¾ (12½, 13½, 14, 15¼)"
43 (47, 52, 56.5, 61) cm

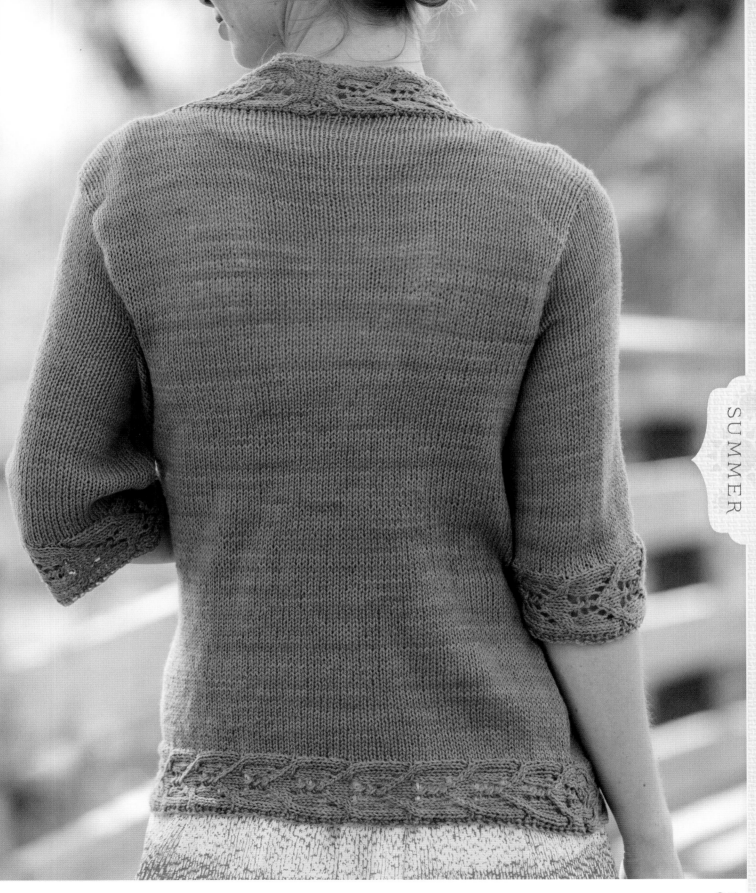

LEFT AND BACK BORDER CHART

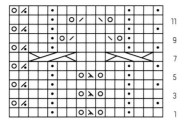

RIGHT BORDER CHART

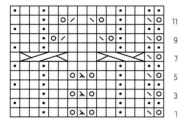

⬜	k on RS; p on WS
•	p on RS; k on WS
O	yo
╱	k2tog
╲	ssk
⟋	k2tog on WS
⋋	sl 1, k2tog, psso
⧓	sl 2 sts onto cn, hold in front, k3, k2 from cn
⧓	sl 3 sts onto cn, hold in back, k2, k3 from cn

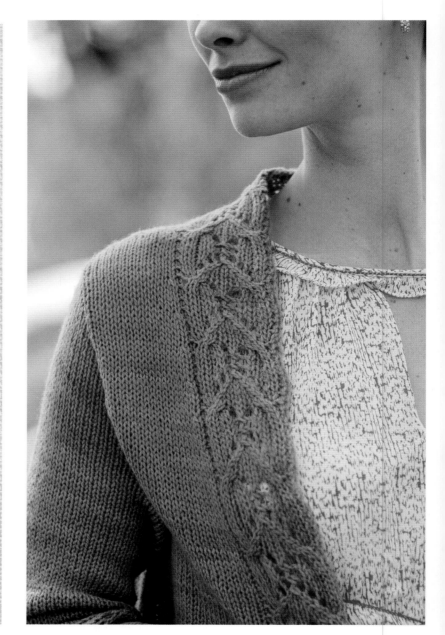

ROW 11: Purl to last 4 sts, w&t.

ROW 13: Purl to last 2 sts, w&t.

ROW 15: Purl to end of row, place marker (pm), then work Row 6 (12, 6, 2, 8) of Right Border Chart over 16 sts on hold—46 (51, 56, 61, 66) sts.

Continue working Right Border Chart as established and rem sts in St st until the front measures 5 (5, 5½, 5½, 6)" (12.5 [12.5, 14, 14, 15] cm) from lower edge, measured at side edge.

WAIST SHAPING

Dec one st at side edge on next row, then every 6th row twice more—43 (48, 53, 58, 63) sts. Work 7 rows even. Inc one st at side edge on next row, then every 6th row twice more—46 (51, 56, 61, 66) sts. Continue to work in patts as established until front measures 15 (15, 16, 16, 17)" (38 [38, 40.5, 40.5, 43] cm) from lower edge, measured at side edge, end with a RS row.

ARMHOLE AND V-NECK SHAPING

BO 4 (5, 5, 5, 6) sts at beg of next WS row, then BO 4 (6, 7, 8, 8) sts at beg of foll WS row. Dec one st at the armhole edge every RS row twice—36 (38, 42, 46, 50) sts. Work even until armhole measures 3 (3, 3½, 3½, 4)" (7.5 [7.5, 9, 9, 10] cm), dec one st at the neck edge on armhole side of marker on next RS row, then every 6th row 5 times more—30 (32, 36, 40, 44) sts.

SHOULDER SHAPING

When armhole measures 8 (8, 8½, 8½, 9)" (20.5 [20.5, 21.5, 21.5, 23] cm), BO 7 (6, 6, 8, 10) sts at beg of next WS row, then BO 7 (5, 7, 8, 9) sts at beg of next WS row. BO 0 (5, 7, 8, 9) sts at beg of next WS row—16 sts remain in Right Border Chart. Place sts on waste yarn or holder, making note of last chart row worked.

Left Front

CO 16 sts. Work 12 rows of Left and Back Border Chart 3 (4, 4, 5, 5) times, then work through Row 6 (0, 6, 2, 8) once more. Place the 16 sts on holder or waste yarn.

With RS facing and working along garter side edge, pick up and knit about 3 sts for every 4 rows—30 (35, 40, 45, 50) sts. Purl 1 row.

Work short-row shaping for front curve starting on a RS row as follows:

ROW 1: (RS) Knit to last 16 sts, w&t.

ROW 2 (AND ALL RS ROWS): Purl.

ROW 3: Knit to last 13 sts, picking up and knitting wrap with foll st on this and all foll RS rows, w&t.

ROW 5: Knit to last 10 sts, w&t.

ROW 7: Knit to last 8 sts, w&t.

ROW 9: Knit to last 6 sts, w&t.

ROW 11: Knit to last 4 sts, w&t.

ROW 13: Knit to last 2 sts, w&t.

ROW 15: Knit to end of row, pm, then work row 7 (1, 7, 3, 9) of Left and Back Border Chart over 16 sts on hold—46 (51, 56, 61, 66) sts.

Continue working Left and Back Border Chart as established and rem sts in St st until the front measures 5 (5, 5½, 5½, 6)" (12.5 [12.5, 14, 14, 15] cm) from lower edge, measured at side edge.

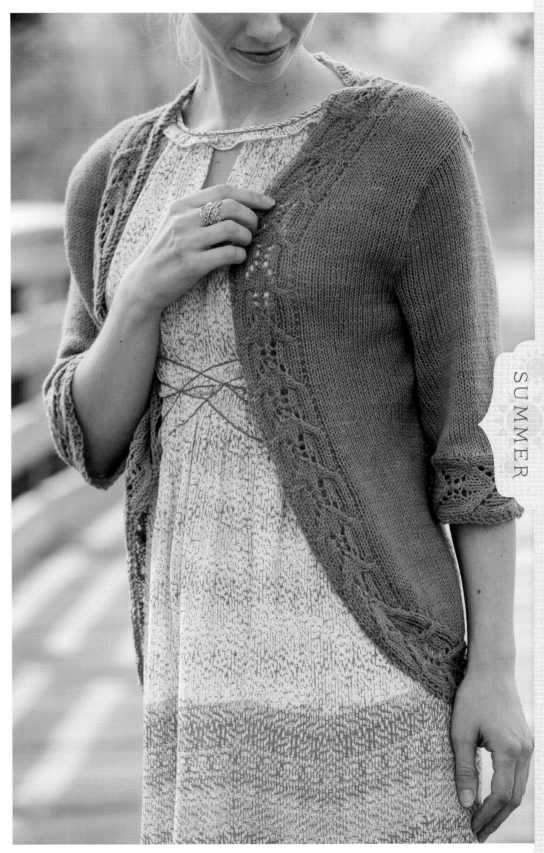

SUMMER

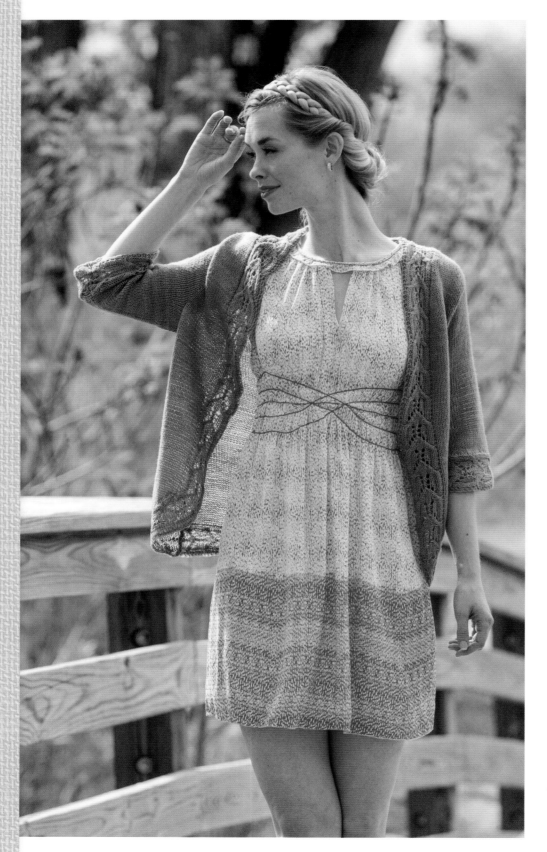

WAIST SHAPING

Dec one st at side edge on next row, then every 6th row twice more—43 (48, 53, 58, 63) sts. Work 7 rows even. Inc one st at side edge on next row, then every 6th row twice more—46 (51, 56, 61, 66) sts. Continue to work in patts as established until front measures 15 (15, 16, 16, 17)" (38 [38, 40.5, 40.5, 43] cm) from lower edge, measured at side edge, end with a WS row.

ARMHOLE AND V-NECK SHAPING

BO 4 (5, 5, 5, 6) sts at beg of next RS row, then BO 4 (6, 7, 8, 8) sts at beg of foll RS row. Dec one st at the armhole edge every RS row twice—36 (38, 42, 46, 50) sts. Work even until armhole measures 3 (3, 3½, 3½, 4)" (7.5 [7.5, 9, 9, 10] cm), dec one st at the neck edge on armhole side of marker on next RS row, then every 6th row 5 times more—30 (32, 36, 40, 44) sts.

SHOULDER SHAPING

When armhole measures 8 (8, 8½, 8½, 9)" (20.5 [20.5, 21.5, 21.5, 23] cm), BO 7 (6, 6, 8, 10) sts at beg of next RS row, then BO 7 (5, 7, 8, 9) sts at beg of next RS row. BO 0 (5, 7, 8, 9) sts at beg of next RS row—16 sts remain in Left and Back Border Chart. Place sts on waste yarn or holder, making note of last chart row worked.

Right Sleeve

CO 16 sts. Work 12 rows of Left and Back Border Chart 7 (7, 8, 8, 9) times, then work through Row 2 (6, 2, 8, 4) once more. BO.

With RS facing and working along garter side edge, pick up and knit about 3 sts for every 4

rows—64 (68, 74, 78, 84) sts. Beg with a WS row, work in St st until sleeve measures 8 (8, 8½, 8½, 9)" (20.5 [20.5, 21.5, 21.5, 23] cm) from lower edge, end with a WS row.

BO 4 (5, 5, 5, 6) sts at beg of next 2 rows, 4 (6, 7, 8, 8) st at beg of foll 2 rows. Dec one st at each end every RS row 2 (5, 5, 6, 7) times, then every 4th row 4 (2, 3, 4, 3) times, then every RS row 1 (4, 4, 1, 4) times. BO 2 sts at the beg of the next 4 (2, 2, 2, 2) rows, 3 sts at the beg of the next 4 (2, 2, 2, 2) rows—14 (14, 16, 20, 18) sts. BO.

Left Sleeve
Work as for right sleeve, using Right Border Chart for cuff.

Finishing
Weave in all ends and block pieces to measurements. Sew shoulder seams. Set in sleeves. Sew side and sleeve seams.

Place 16 right front edge sts on needle. Join yarn at shoulder ready to work a WS row. Work 1 WS row in patt. Place 22 sts from right half of back neck on LH needle, then join edge to back sts as foll:

ROW 1: (RS) Work chart patt to last st, ssk last st of edge with next back st on LH needle.

ROW 2: (WS) Sl 1, work in patt to end.

Rep last 2 rows until edging is joined to center back neck. BO loosely.

Place 22 sts from left half of back neck on RH needle. Place 16 left front edge sts on LH needle. Join yarn at shoulder ready to work a RS row over edge sts. Work 1 RS

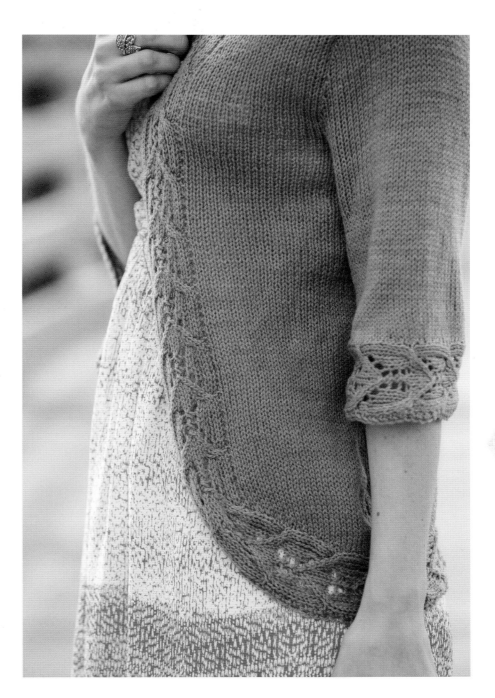

row in patt, then join edge to back sts as foll:

ROW 1: (WS) Work chart patt to last st, ssk last st of edge with next back st on LH needle.

ROW 2: (RS) Sl 1, work in patt to end.

Rep last 2 rows until edging is joined to center back neck. BO loosely.

Seam back neck and weave in remaining ends. Steam block the neck edging or re-block the entire sweater if desired.

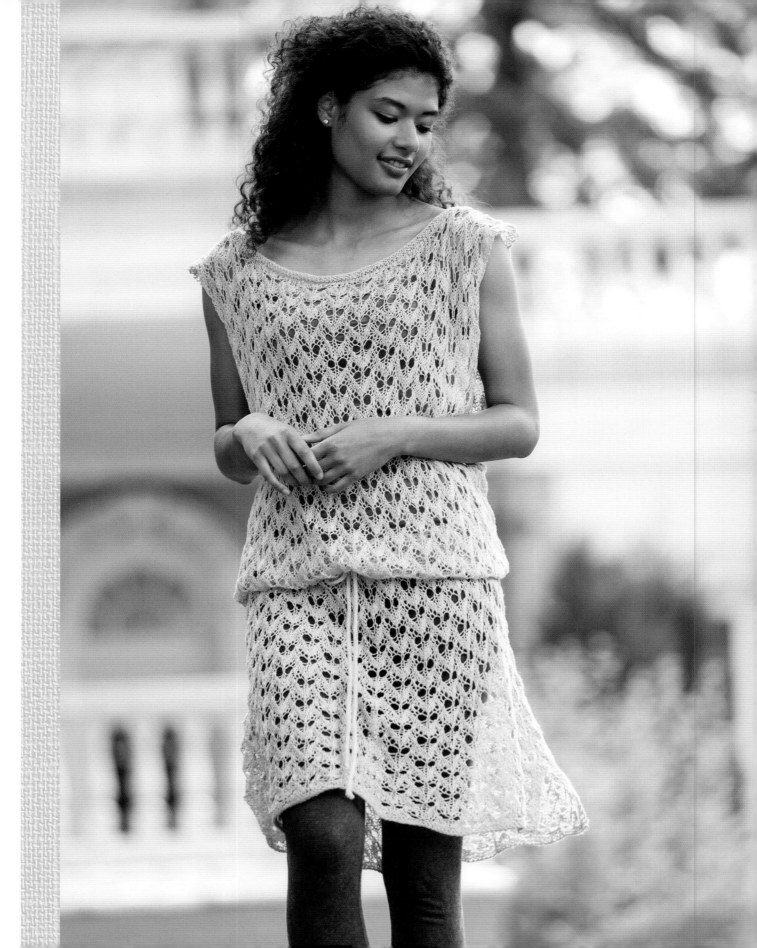

Alliemay

LACE TUNIC

Alliemay is a loose-fitting tunic that's perfect for throwing over a tank and leggings, swimsuit, or a simple fitted sundress. Changing the position of the I-cord belt gives you three different silhouettes: empire waist, true waist, or a comfortable drop waist.

FINISHED SIZE
About 33 (37, 41)" (84 [94, 104] cm) bust circumference.

Tunic shown measures 37" (94 cm).

YARN
Laceweight (#0 Lace)

Shown here: Anzula Breeze (65% silk, 35% linen; 755 yd [690 m]/4 oz [115 g]), keylime, 1 (2, 2) hanks.

NEEDLES
Size U.S. 6 (4 mm): 32" (81 cm) circular (cir).

Adjust needle size if necessary to obtain the correct gauge.

NOTIONS
Markers (m) (different color for beg of rnd); spare needle in same size as main needle for three-needle bind-off; stitch holders or waste yarn; tapestry needle.

GAUGE
22 sts and 23 rows/rnds = 4" (10 cm) in blocked lace pattern.

NOTES
This tunic is worked up in a very forgiving, stretchy fabric, but it is intended to be worn loosely. If in doubt, go with the smaller size.

An I-cord maker will make short work of the long I-cord for the waist tie.

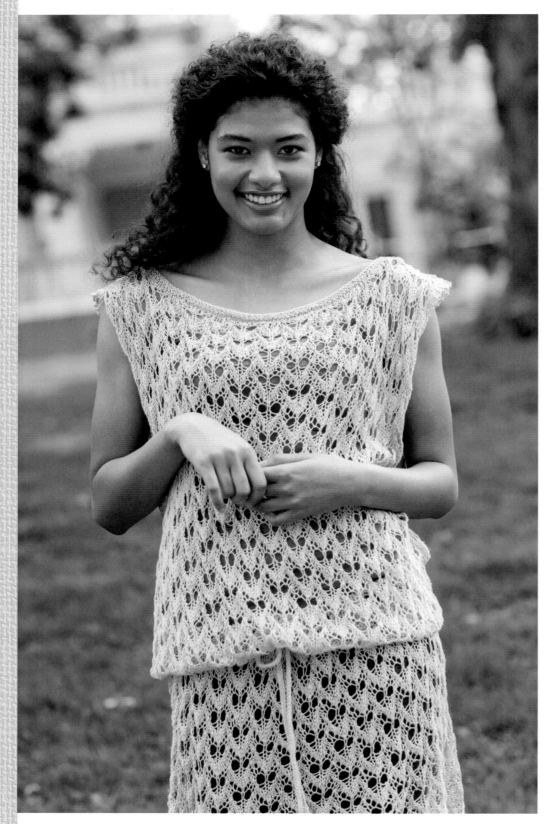

Front

CO 91 (103, 115) sts. Work 5 rows in garter stitch (knit every row).

NEXT ROW: (RS) K3 for garter st edge, work row 1 of 12-st Front Panel Chart rep 7 (8, 9) times, k1, k3 for garter st edge.

NEXT ROW: (WS) K3, p1, work in patt to last 3 sts, k3.

Cont chart patt and edge sts as established until piece measures 3" (7.5 cm) from CO, end with a WS row. Place sts on waste yarn or st holder.

Back

CO 91 (103, 115) sts. Work 5 rows in garter stitch.

NEXT ROW: (RS) K3 for garter st edge, work Row 1 of 12-st Back Panel Chart rep 7 (8, 9) times, k1, k3 for garter st edge.

NEXT ROW: (WS) K3, p1, work in patt to last 3 sts, k3.

Cont chart patt and edge sts as established until piece measures 3" (7.5 cm) from CO, end with same WS row as front.

JOIN TO WORK BODY IN THE ROUND

Place front sts on needle.

JOINING RND: (RS) Work 91 (103, 115) front sts in patt, place marker (pm) for right side, work 91 (103, 115) back sts in patt, pm in color for beg of rnd and join for working in rnds—182 (206, 230) sts; rnd begins at left side of body, at beg of front sts.

NEXT RND: [P3 for garter st edge, work patt as established to 4 sts before side marker, k1, p3 for garter st edge] twice.

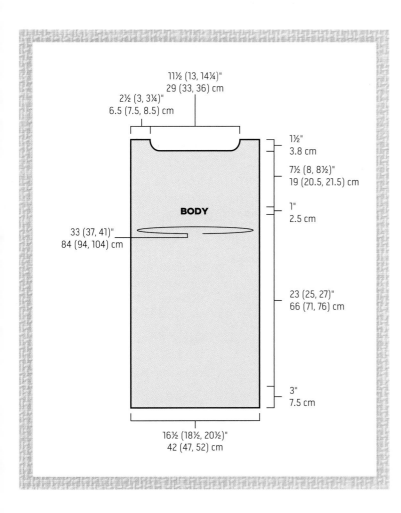

11½ (13, 14¼)"
29 (33, 36) cm

2½ (3, 3¼)"
6.5 (7.5, 8.5) cm

1½"
3.8 cm

7½ (8, 8½)"
19 (20.5, 21.5) cm

1"
2.5 cm

BODY

33 (37, 41)"
84 (94, 104) cm

23 (25, 27)"
66 (71, 76) cm

3"
7.5 cm

16½ (18½, 20½)"
42 (47, 52) cm

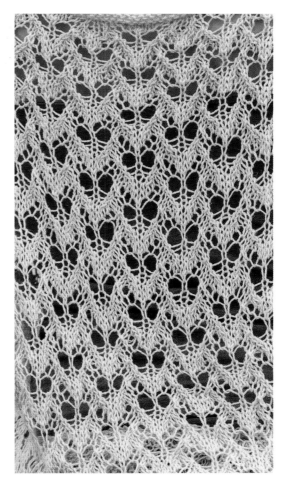

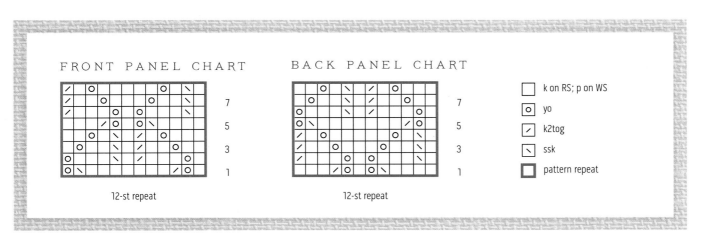

FRONT PANEL CHART

7

5

3

1

12-st repeat

BACK PANEL CHART

7

5

3

1

12-st repeat

☐ k on RS; p on WS

⊙ yo

⟋ k2tog

⟍ ssk

☐ pattern repeat

Work 3 rnds in patts as established, working 6 sts each side in garter st (knit 1 rnd, purl 1 rnd), end with an odd-numbered rnd.

NEXT RND: P3, place new marker in color for beg of rnd, work to 4 sts before side marker, p2tog, p5, work to 4 sts before original beg-of-rnd marker, p2tog, p5, removing original beg-of-rnd marker—180 (204, 228) sts.

Note: The 6 edge sts at each side will now be worked in chart patt, allowing patt to line up over all sts in rnd.

NEXT RND: Work 12-st rep of Front Panel Chart patt 15 (17, 19) times around.

Cont in patt as established until piece measures 26 (28, 30)" (66 [71, 76] cm) from CO, or desired length to underarms less 1" (2.5cm), end 3 sts before end of an even-numbered rnd.

Note: The 6 edge sts at each side will be worked once more in garter st. Work Front Panel and Back Panel Charts to maintain patts as established.

NEXT RND: Place new marker in color for beg of rnd, [k3 for garter-st edge, work chart patt as established to 3 sts before marker, k1f&b, k2, sl m] twice—182 (206, 230) sts. Remove previous beg-of-rnd marker, rnd begins at left side of body as before.

NEXT RND: [P3 for garter-st edge, work patt as established to 4 sts before marker, k1, p3 for garter-st edge] twice.

Work 4 rnds in patts as established, end with an even-numbered rnd.

DIVIDE FOR FRONT AND BACK

NEXT ROW: (RS) Work 91 (103, 115) front sts in patt, turn. Place rem 91 (103, 115) sts for back on waste yarn or stitch holder.

Work back and forth in rows on 91 (103, 115) front sts only until armhole measures 7½ (8, 8½)" (19 [20.5, 21.5] cm), end with a WS row.

NECK SHAPING

NEXT ROW: (RS) Work 18 (20, 22) sts in patt, BO 55 (63, 71) sts, work in patt to end.

Working 18 (20, 22) sts of right shoulder only, work 9 rows in patt, dec'ing one st at neck edge every RS row—14 (16, 18) sts. Place sts on waste yarn or st holder.

Rejoin yarn with WS facing at neck edge and work 18 (20, 22) sts of left shoulder in the same way—14 (16, 18) sts. Place sts on waste yarn or st holder.

Return 91 (103, 115) sts for back to needle. Rejoin yarn with RS facing and complete as for front.

Finishing

With RS touching and WS facing outward, use the three-needle bind-off method (see Glossary) to BO the 14 (16, 18) front and back shoulder sts tog at each side.

NECK EDGING

With RS facing, beg at left shoulder seam, pick up and knit 67 (75, 83) sts evenly spaced along front neck, 67 (75, 83) sts evenly spaced along back neck—134 (150, 166) sts. Join and pm for beg of rnd. Work 4 rnds in garter st (knit 1 rnd, purl 1 rnd). BO all sts.

Weave in all ends. Block lightly to schematic measurements.

Make a 48 (52, 56)" (122 [132, 142] cm) four-stitch I-cord (see Glossary). Weave through the eyelets in the lace at any desired point to create an empire waist, true waist, or drop waist, as photographed.

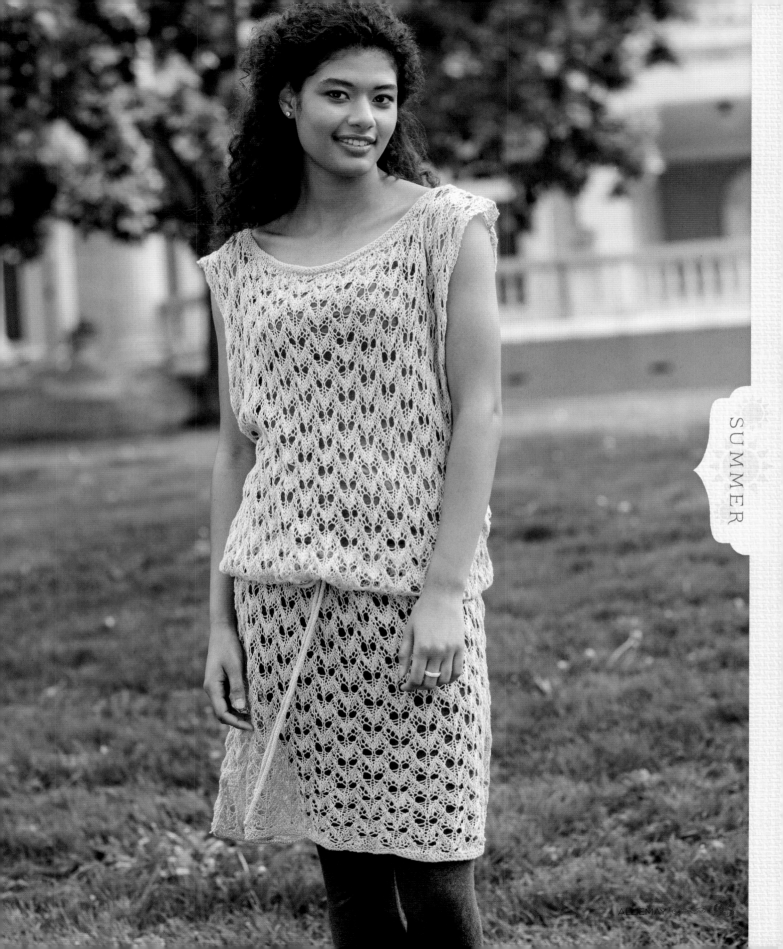

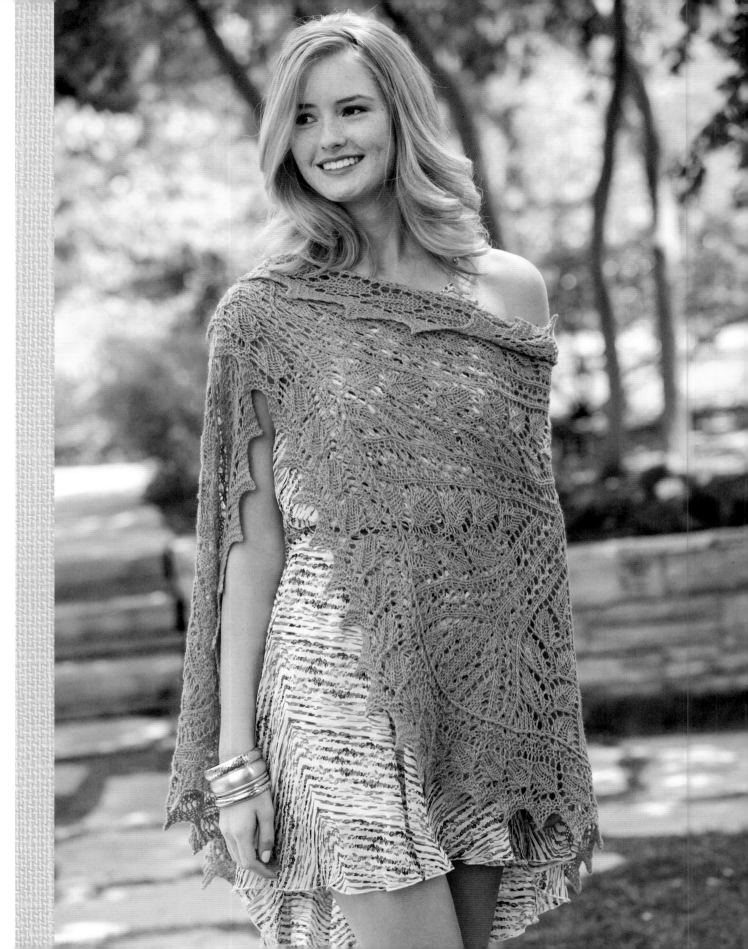

Junius

SHAPED SHAWL

Junius doesn't look like
much when laid out flat, but
when it's draped over your
shoulders you realize what
a great layering piece it is.
The clever increases create
shoulder lines that allow
the shawl to stay on
even without a pin
or other closure.

FINISHED SIZE
About 60" (152.5 cm) wide
across top edge and 36"
(91.5 cm) long from center
of top edge to tip of lower
point after blocking.

YARN
Sportweight (#2 Fine).

Shown here: Dream In
Color Perfectly Posh Sport
(70% merino wool, 10%
cashmere, 10% silk, 10%
baby fine mohair; 320 yd
[293 m]/3½ oz [100 g]),
amberglass (gold), 3 skeins.

NEEDLES
Size U.S. 8 (5 mm): 40"
(100 cm) circular (cir).

NOTIONS
Markers (m);
tapestry needle.

GAUGE
15 sts and 20 rows = 4"
(10 cm) in Chart A
after blocking.

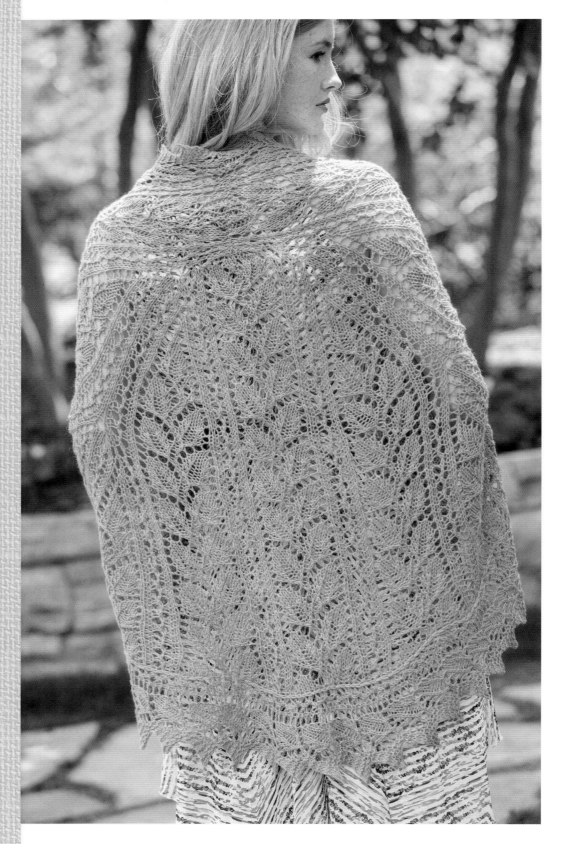

Set-Up

CO 70 sts. Work the Set-Up Charts as foll: Work Right-Side Set-Up Chart, then Center and Left-Side Set-Up Chart. Cont to work charts in this way through Row 10, placing markers as indicated on Row 10—98 sts.

Body

Work the Body Chart as foll: Work to marker, [work Chart A once, Chart B once] twice, work Chart A once, work to end of Body Chart. Cont to work charts in this way through Row 40—178 sts.

Work the Body Chart as foll: Work to marker, work Chart A twice, work Chart B once, work Chart A 3 times, work Chart B once, work Chart A twice, work to end of Body Chart. Cont to work charts in this way through Row 40—258 sts.

Work the Body Chart as foll: Work to marker, work Chart A 3 times, work Chart B once, work Chart A 5 times, work Chart B once, work Chart A 3 times, work to end of Body Chart. Cont to work charts in this way through Row 20—306 sts.

RIGHT-SIDE SET-UP CHART

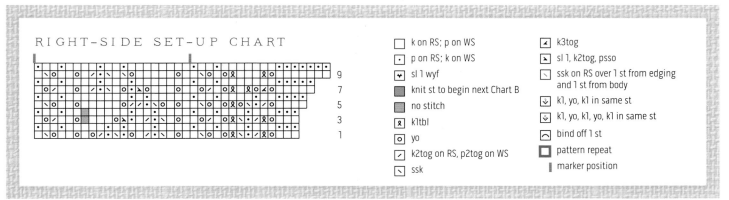

□ k on RS; p on WS	◪ k3tog
· p on RS; k on WS	⬂ sl 1, k2tog, psso
⊻ sl 1 wyf	◲ ssk on RS over 1 st from edging and 1 st from body
▨ knit st to begin next Chart B	⬇ k1, yo, k1 in same st
▨ no stitch	⬇ k1, yo, k1, yo, k1 in same st
⊠ k1tbl	⌒ bind off 1 st
○ yo	☐ pattern repeat
⊿ k2tog on RS, p2tog on WS	▮ marker position
⊾ ssk	

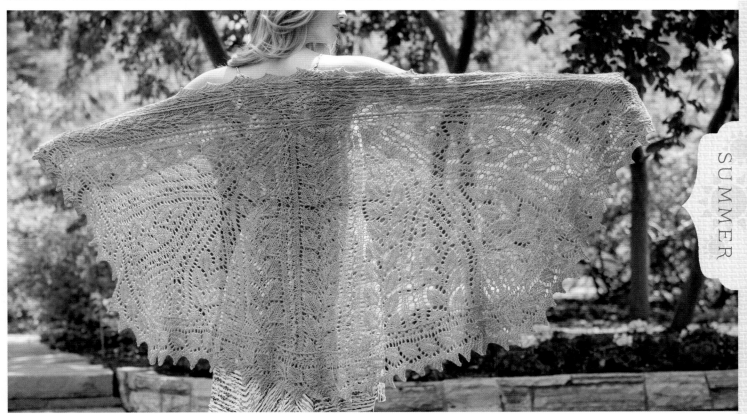

CENTER AND LEFT-SIDE SET-UP CHART

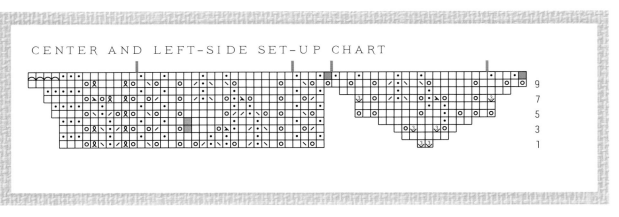

CHART A

CHART B

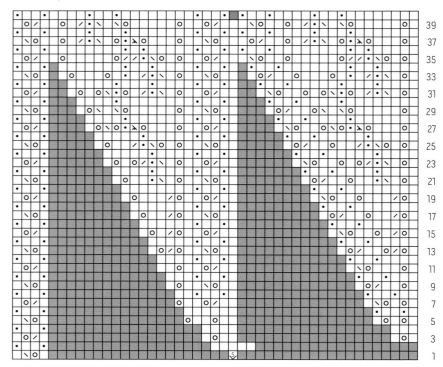

☐	k on RS; p on WS
•	p on RS; k on WS
⊻	sl 1 wyf
■	knit st to begin next Chart B
▨	no stitch
ደ	k1tbl
o	yo
╱	k2tog on RS, p2tog on WS
╲	ssk
⋋	k3tog
⋏	sl 1, k2tog, psso
⌐	ssk on RS over 1 st from edging and 1 st from body
↓	k1, yo, k1 in same st
↓	k1, yo, k1, yo, k1 in same st
⌒	bind off 1 st
☐	pattern repeat
▌	marker position

BODY CHART

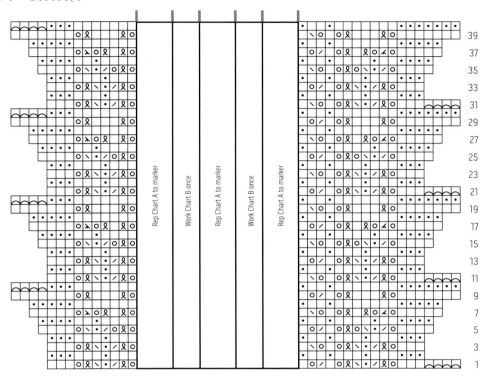

EDGING CHART

Edging

Work Edging Chart over first 18 sts, joining edging sts to body sts on needle with an ssk at the end of every RS row. Rep Rows 1–10 of Edging Chart until 14 sts rem from opposite edge, end with Row 4 of chart—14 sts. Graft last row to rem 14 sts.

Finishing

Sew cast-on edge together. Weave in all ends, but do not trim. Block using pins or wires to bring out points and block the shawl into a rounded rectangle shape. Trim ends.

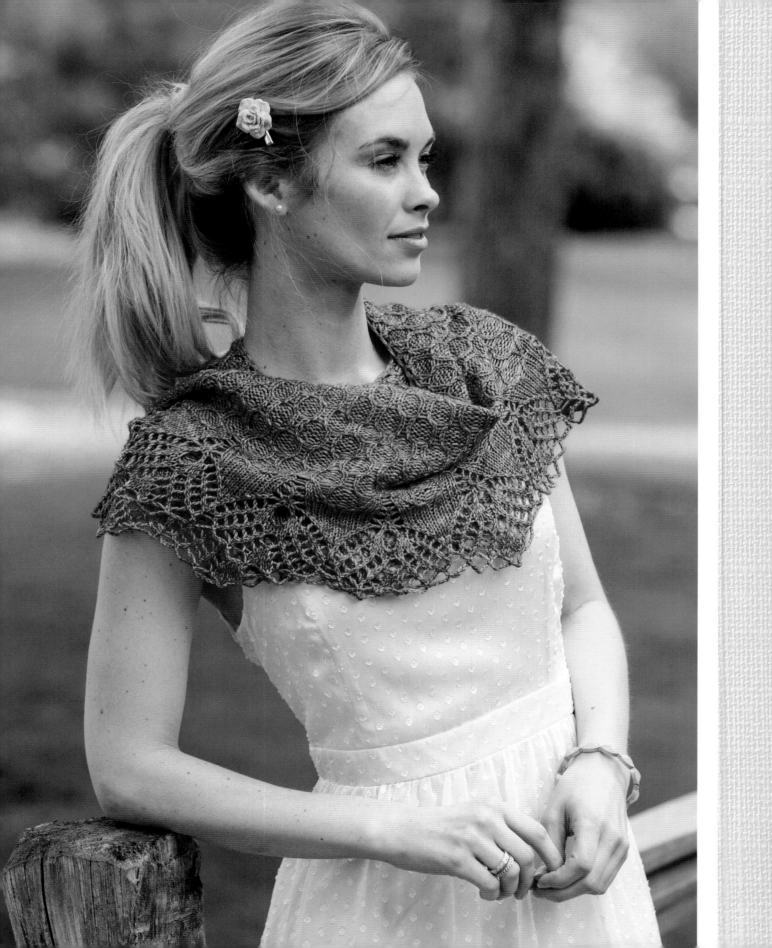

FALL MEANS transitions, and even if the temperatures haven't dropped much in these parts, we still like to change up our wardrobes. No matter how short or long the fall season runs where you are, these pieces will give your closet a much-needed boost.

Fall

Two fingering-weight shawls in very autumnal colors help to fake the season even if the leaves haven't changed quite yet. A duo of lightweight layering cardigans in fine yarns promotes that back-to-school feel. And a yoked pullover for any chilly days will carry over easily into a winter wardrobe.

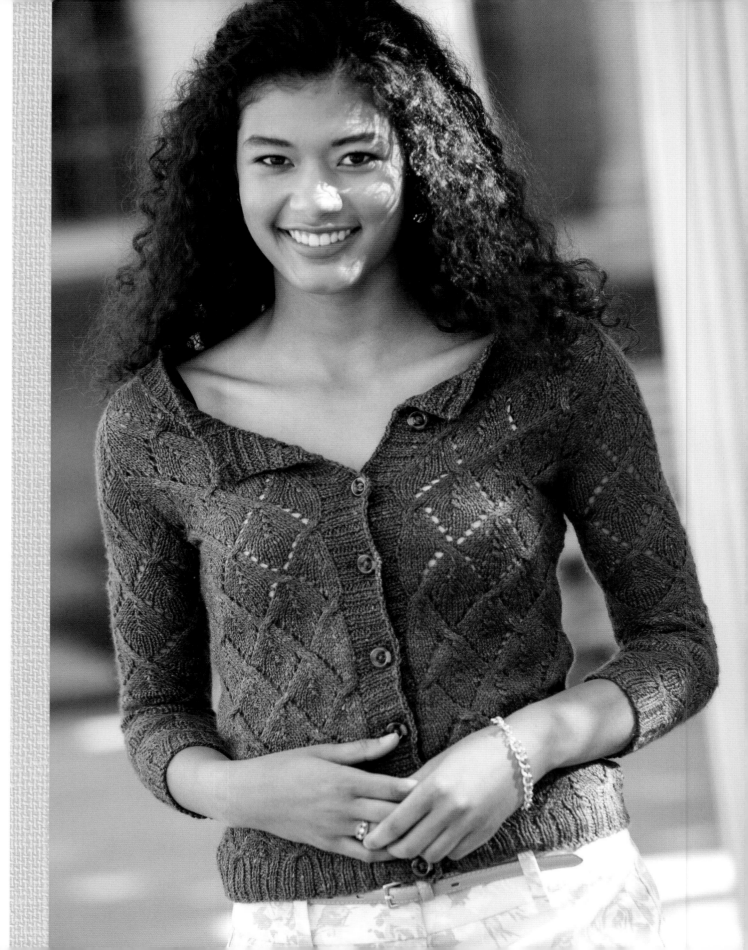

DIAMOND-LACE CARDIGAN

An easy layering piece for fall or any season, Darl is a simple cabled cardigan with enough openwork to keep it from being too warm. The merino wool, silk, and alpaca blend yarn is easy on the hands and soft on the skin.

FINISHED SIZE
About 29 (34½, 37, 42, 47)" (73.5 [87.5, 94, 106.5, 119.5] cm) in circumference.

Sweater shown measures 29" (73.5 cm).

YARN
Sportweight (#2 Sport).

Shown here: The Fibre Company Acadia (60% merino wool, 20% baby alpaca, 20% silk; 145 yd [133 m]/1¾ oz [50 g]), wild onion, 6 (7, 8, 10, 12) skeins.

NEEDLES
Size U.S. 6 (4 mm).

NOTIONS
Cable needle (cn); tapestry needle; eight ⅝" (1.5 cm) buttons.

GAUGE
22 sts and 32 rows = 4" (10 cm) in chart pattern after blocking.

NOTES
Sizes 29" and 42" use separate A Charts for back and each front. Sizes 34½", 42", and 47" use Chart B for the back and both fronts. All sizes use Chart B for the sleeves.

When shaping into chart patterns, if there are not enough stitches to work both a decrease and its companion yarnover, work the sts in St st.

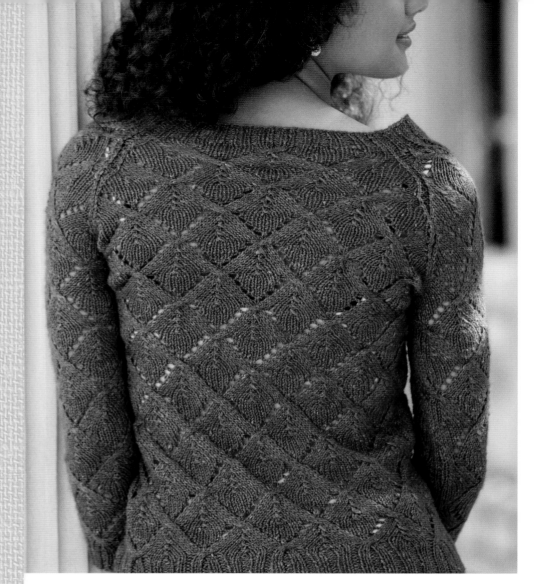

Back

CO 68 (79, 91, 104, 115) sts.

ROW 1: (RS) K3, *p1, k2; repeat from * to last 2 (1, 1, 2, 1) sts, p1 (0, 0, 1, 0), k1.

ROW 2: (WS) K the knit sts and p the purl sts.

Cont in rib as established for 10 more rows.

Work set-up Rows 1 and 2 of Chart A (B, B, A, B)—77 (91, 105, 119, 133) sts.

Work Rows 1–20 of Chart A (B, B, A, B) a total of 5 (5, 5, 5, 6) times, then work Rows 0 (0, 1–10, 1-10, 0) once more.

RAGLAN SHAPING

Note: Work raglan decreases one st in from edge.

Cont in patt as established, BO 4 (4, 5, 6, 7) sts at the beg of the next 2 rows. Dec one st each side of next row, then rep dec row every 4th row 1 (0, 0, 0, 0) times, then every other row 17 (24, 29, 34, 39) times—31 (33, 35, 37, 39) sts. BO all sts.

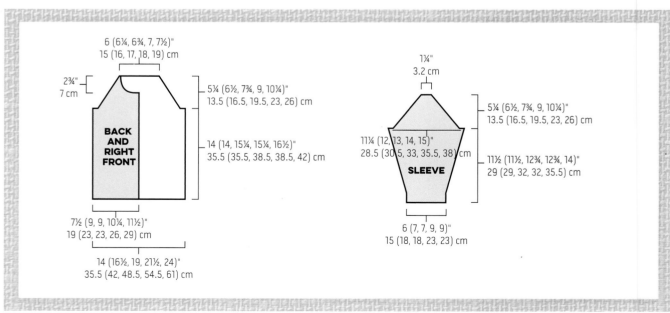

6 (6¼, 6¾, 7, 7½)"
15 (16, 17, 18, 19) cm

2¾"
7 cm

5¼ (6½, 7¾, 9, 10¼)"
13.5 (16.5, 19.5, 23, 26) cm

BACK AND RIGHT FRONT

14 (14, 15¼, 15¼, 16½)"
35.5 (35.5, 38.5, 38.5, 42) cm

7½ (9, 9, 10¼, 11½)"
19 (23, 23, 26, 29) cm

14 (16½, 19, 21½, 24)"
35.5 (42, 48.5, 54.5, 61) cm

1¼"
3.2 cm

5¼ (6½, 7¾, 9, 10¼)"
13.5 (16.5, 19.5, 23, 26) cm

11¼ (12, 13, 14, 15)"
28.5 (30.5, 33, 35.5, 38) cm

SLEEVE

11½ (11½, 12¾, 12¾, 14)"
29 (29, 32, 32, 35.5) cm

6 (7, 7, 9, 9)"
15 (18, 18, 23, 23) cm

Right Front

CO 37 (43, 43, 49, 55) sts.

ROW 1: (RS) K3, *p1, k2; repeat from * to last st, k1.

ROW 2: (WS) K the knit sts and p the purl sts.

Cont in rib as established for 10 more rows.

Work set-up Rows 1 and 2 of Chart A (B, B, A, B)—42 (49, 49, 56, 63) sts.

Work Rows 1–20 of Chart A (B, B, A, B) a total of 5 (5, 5, 5, 6) times, then work Rows 1 (1, 1–11, 1-11, 1) once more.

RAGLAN SHAPING AND NECK

Note: Work raglan decreases one st in from edge.

Cont in patt as established, BO 4 (4, 5, 6, 7) sts at the beg of the next WS row. Dec one st at armhole edge on next row, then rep dec every 4th row 1 (0, 0, 0, 0) times, then every other row 17 (24, 29, 34, 39) times.

At the same time, when 30 (31, 25, 26, 27) sts rem, BO 10 (11, 8, 9, 10) sts on the next RS row. Dec one st at the neck edge on next RS row, then every other row 1 (1, 0, 0, 0) time, then every 4th row 4 (4, 3, 3, 3) times—3 (3, 2, 2, 2) sts when all shaping is complete. BO all sts.

Left Front

CO 37 (43, 43, 49, 55) sts.

ROW 1: (RS) K3, *p1, k2; repeat from * to last st, k1.

ROW 2: (WS) K the knit sts and p the purl sts.

Cont in rib as established for 10 more rows.

Work set-up Rows 1 and 2 of Chart A (B, B, A, B)—42 (49, 49, 56, 63) sts.

Work Rows 1–20 of Chart A (B, B, A, B) a total of 5 (5, 5, 5, 6) times, then work Rows 0 (0, 1–10, 1-10, 0) once more.

RAGLAN SHAPING AND NECK

Note: Work raglan decreases one st in from edge.

Cont in patt as established, BO 4 (4, 5, 6, 7) sts at the beg of the next RS row. Dec one st at armhole edge on next RS row, then rep dec every 4th row 1 (0, 0, 0, 0) times, then every other row 17 (24, 29, 34, 39) times.

At the same time, when 30 (31, 25, 26, 27) sts rem, BO 10 (11, 8, 9, 10) sts on the next WS row. Dec one st at the neck edge on next row, then every other row 1 (1, 0, 0, 0) time, then every 4th row 4 (4, 3, 3, 3) more times—3 (3, 2, 2, 2) sts when all shaping is complete. BO all sts.

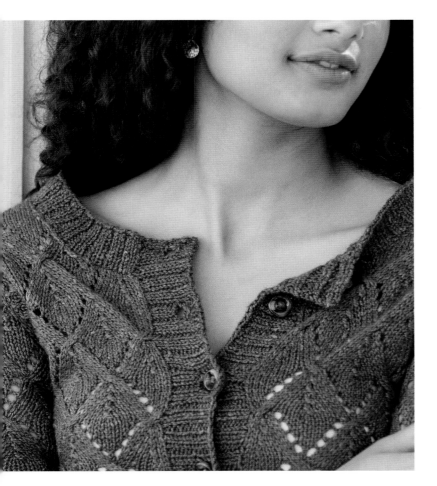

CHART A BACK

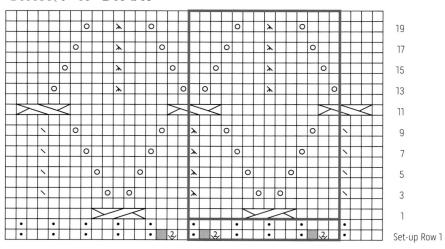

19
17
15
13
11
9
7
5
3
1
Set-up Row 1

CHART A LEFT FRONT

19
17
15
13
11
9
7
5
3
1
Set-up Row 1

□	k on RS; p on WS
•	p on RS; k on WS
o	yo
\	ssk
⋏	sl 1, k2tog, psso
⅋	knit into front and back of next st
▧	no stitch
⧄⧅	sl 3 sts onto cn, hold in back, k2, k3 from cn
⧄⧅	sl 2 sts onto cn, hold in front, k3, k2 from cn
☐	pattern repeat

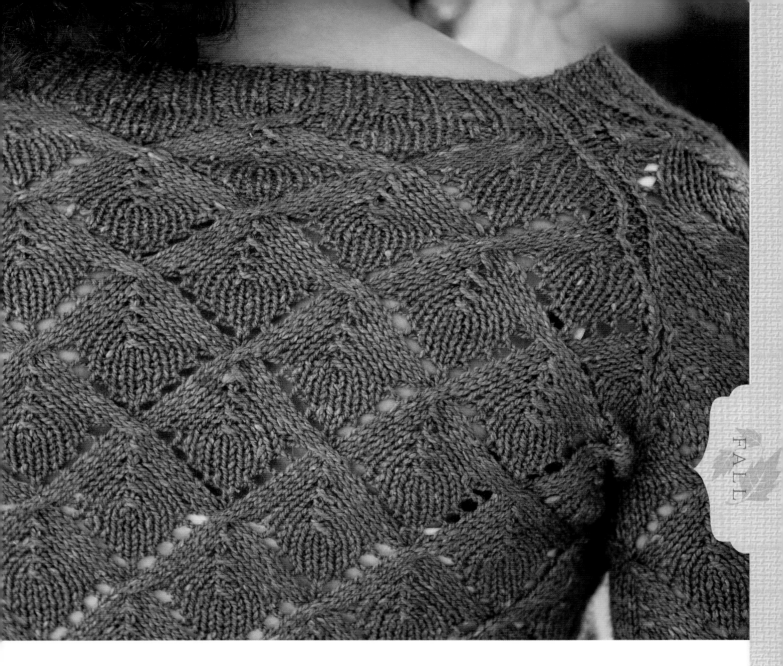

Sleeves

CO 36 (43, 43, 55, 55) sts.

ROW 1: (RS) K2 (3, 3, 3, 3), *p1, k2; repeat from * to last st, p1 (k1, k1, k1, k1).

ROW 2: (WS) K the knit sts and p the purl sts.

Cont in rib as established for 10 more rows.

Work set-up Rows 1 and 2 of Chart B—42 (49, 49, 63, 63) sts.

Note: For size 29", omit the first and last cables on Row 1 of chart until there are sufficient sts to work cables.

Work Rows 1–20 of Chart B a total of 4 (4, 4, 4, 5) times, then work Rows 0 (0, 1–10, 1-10, 0) once more, at the same time, inc one st each side every 6th (8th, 8th, 10th, 10th) row 10 (8, 11, 7, 10) times, working inc'd sts into chart patt—62 (67, 71, 77, 83) sts.

RAGLAN SHAPING

Working in pattern as established, BO 4 (4, 5, 6, 7) sts at the beg of the next 2 rows. Dec one st at each armhole edge on next row, then dec 2 sts at each armhole edge every other row 4 (0, 0, 0, 0) times, then one st at each armhole edge every 4th row 0 (0, 3, 6, 9) times, then every other row 15 (24, 23, 22, 21) times—6 (7, 7, 7, 7) sts rem. BO all sts.

CHART A RIGHT FRONT

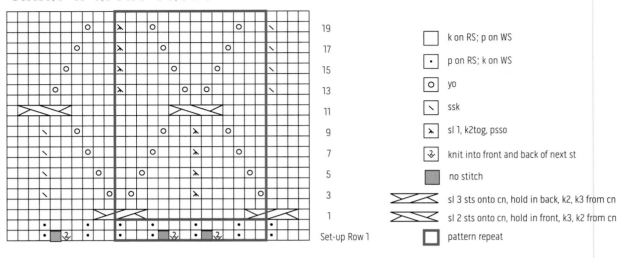

☐	k on RS; p on WS
·	p on RS; k on WS
○	yo
＼	ssk
⋏	sl 1, k2tog, psso
⤓	knit into front and back of next st
▨	no stitch
⧄	sl 3 sts onto cn, hold in back, k2, k3 from cn
⧄	sl 2 sts onto cn, hold in front, k3, k2 from cn
☐	pattern repeat

CHART B

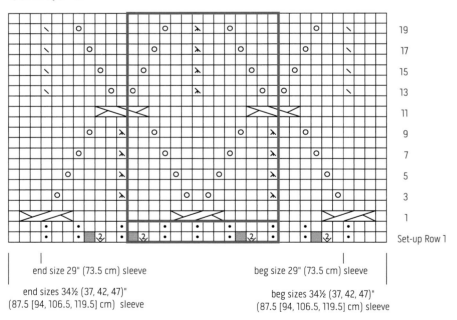

end size 29" (73.5 cm) sleeve beg size 29" (73.5 cm) sleeve

end sizes 34½ (37, 42, 47)"
(87.5 [94, 106.5, 119.5] cm) sleeve

beg sizes 34½ (37, 42, 47)"
(87.5 [94, 106.5, 119.5] cm) sleeve

Finishing

Block pieces to measurements. Sew raglan seams. Sew side and sleeve seams.

NECK EDGING

With RS facing, beg at right front neck edge, pick up and knit 109 (109, 112, 112, 115) sts along neck edge.

ROW 1: (WS) P1, *p2, k1; rep from * to last 3 sts, p3.

ROW 2: (RS) K1, *k2, p1; rep from * to last 3 sts, k3.

Cont in rib as established for 7 more rows.

BO all sts in rib.

BUTTONBANDS

With RS facing, beg at edge of neck edging, pick up and knit 98 (98, 104, 104, 110) sts along the left front edge.

ROW 1: (WS) P2, *k1, p2; rep from * to end.

ROW 2: (RS) K2, *p1, k2; rep from * to end.

Cont in rib as established for 9 more rows.

BO all sts in rib.

With RS facing, beg at lower edge, pick up and knit 98 (98, 104, 104, 110) sts along the right front edge.

ROW 1: (WS) P2, *k1, p2; rep from * to end.

ROW 2: (RS) K2, *p1, k2; rep from * to end.

Cont in rib as established for 3 more rows.

BUTTONHOLE ROW: (RS) Work 3 (3, 2, 2, 2) sts in rib, [BO 2 sts, work 11 (11, 12, 12, 13) sts in rib] 7 times, BO 2 sts, work last 2 (2, 2, 2, 1) sts.

NEXT ROW: (WS) Work in rib as established, casting on 2 sts over each buttonhole.

Work 4 rows more in rib. BO all sts in rib.

Weave in all remaining ends and block neck and buttonband. Sew buttons to buttonband opposite buttonholes.

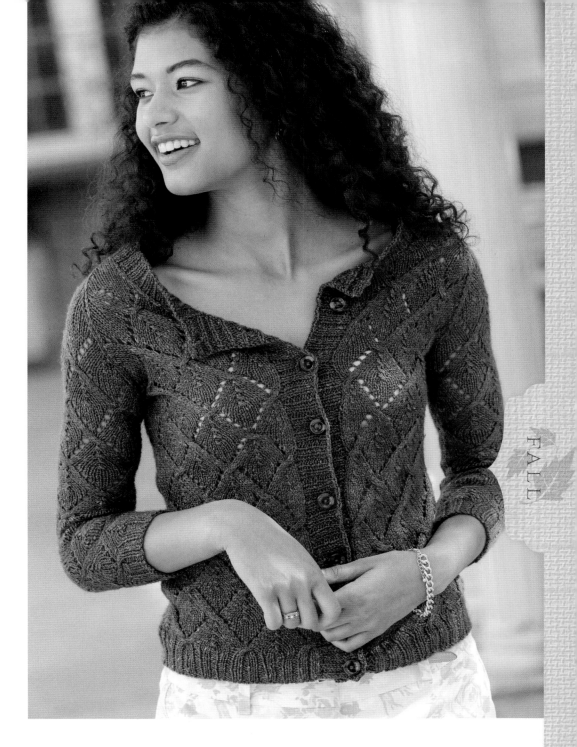

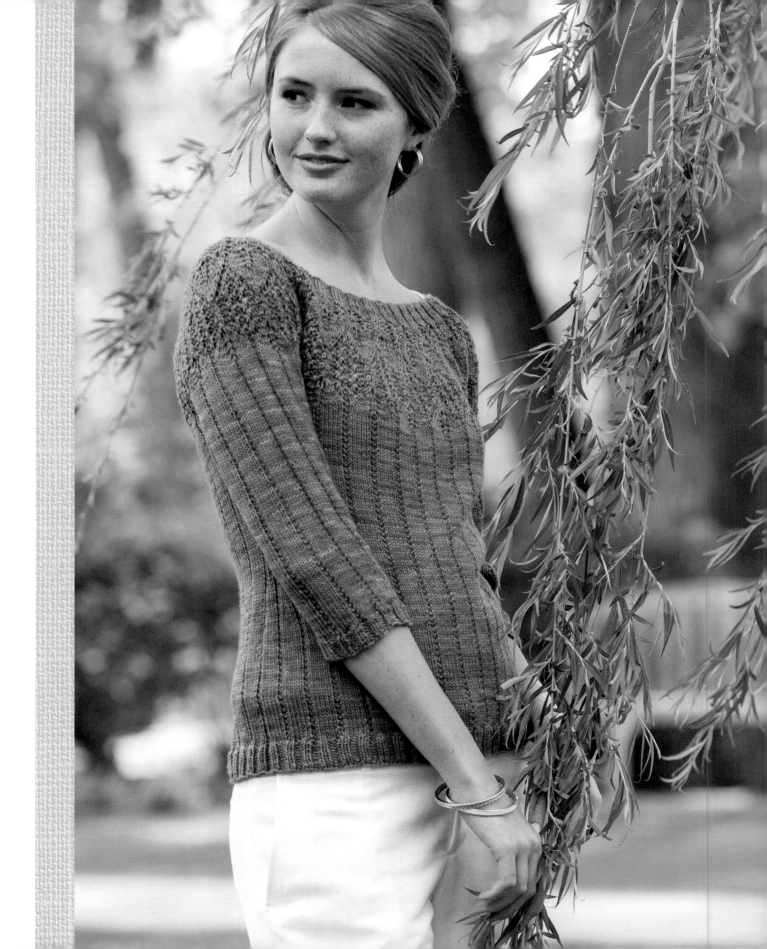

Bayard

CABLE-YOKE PULLOVER

Worked up in a ridiculously soft superwash merino wool yarn, Bayard is a wonderful transitional piece. Its fall color can replace the autumn foliage one might not find south of the Mason-Dixon Line.

FINISHED SIZE
About 34 (38, 42, 46, 50)" (86.5 [96.5, 106.5, 117, 127] cm) bust circumference.
Sweater shown measures 34" (86.5 cm).

YARN
DK weight (#3 Light).
Shown here: Sweet Georgia Superwash DK (100% merino wool; 256 yd [234 m]/4 oz [115 g]), ginger, 4 (4, 5, 5, 6) skeins.

NEEDLES
Size U.S. 5 (3.75 mm): 32" or 40" (81 or 100 cm) circular (cir) and set of 4 or 5 double-pointed (dpn).
Adjust needle size if necessary to obtain the correct gauge.

NOTIONS
Markers (m); stitch holders or waste yarn; tapestry needle.

GAUGE
22 sts and 34 rnds = 4" (10 cm) in Garter Rib.

Yoke

With cir needle, CO 144 (144, 156, 156, 168) sts. Join to work in the rnd, being careful not to twist sts, and place marker (pm) for beg of rnd. Work 10 rnds in K2, P2 Rib. Work the 30-rnd Lace Yoke Chart—288 (288, 312, 312, 336) sts.

Work charts as foll:

SIZE 34" (86.5 CM)

Work Chart A 5 times, Chart B once, Chart A 12 times, Chart B once, Chart A 7 times. Work through Rnd 18 of charts, end last rnd 3 sts before marker—300 sts.

SIZE 38" (96.5 CM)

[Work Chart A 5 times, Chart C once, Chart A 7 times, then Chart C once] twice. Work through Rnd 18 of chart, end last rnd 3 sts before marker—336 sts.

SIZE 42" (106.5 CM)

[Work Chart A 5 times, Chart C once, Chart A 8 times, Chart C once] twice. Work through Rnd 22 of charts, end last rnd 3 sts before marker—360 sts.

SIZE 46" (117 CM)

[Work Chart A 5 times, Chart C once] 4 times, work Chart A 6 times, work Chart C once. Work through Rnd 22 of charts, end last rnd 3 sts before marker—372 sts.

SIZE 50" (127 CM)

Work Chart A 4 times, Chart C once, work Chart A 6 times, Chart C once, [work Chart A 4 times, Chart C once, work Chart A 5 times, Chart C once] twice. Work through Rnd 26 of charts, end last rnd 3 sts before marker—408 sts.

SEPARATE ARMS AND BODY

Slip the next 60 (66, 72, 72, 78) sts to stitch holder or waste yarn for the right sleeve. CO 3 (3, 3, 6, 6) sts, place new marker for beg of rnd, CO 3 (3, 3, 6, 6) sts, work in patt across next 90 (102, 108, 114, 126) sts. Slip 60 (66, 72, 72, 78) sts to stitch holder or waste yarn for the left sleeve. CO 3 (3, 3, 6, 6) sts, pm for side, CO 3 (3, 3, 6, 6) sts, and work in patt to end—60 (66, 72, 72, 78) sts on hold for each sleeve and 192 (216, 228, 252, 276) sts for the body.

Body

Work through Rnd 26 of charts, if necessary, then cont in Garter Rib as established for 3½ (3½, 3¾, 3¾, 4)" (9 [9, 9.5, 9.5, 10] cm), end with Rnd 2 of Garter Rib.

WAIST SHAPING

DEC RND: *K1, ssk, k to 3 sts before m, k2tog, k1, sm; repeat from * once more—4 sts dec'd. Rep Dec rnd every 8th rnd twice more—180 (204, 216, 240, 264) sts. Work 11 rnds even.

INC RND: *K1, M1, k to one st before m, M1, k1, sm; repeat from * once more—4 sts inc'd.

Rep Inc rnd every 8th rnd twice more—192 (216, 228, 252, 276) sts.

Cont in Garter Rib until body measures 13¾ (13¾, 14¾, 14¾, 15¾)"(35 [35, 37.5, 37.5, 40] cm) or about 1¼" (3.2 cm) shorter than desired length.

Work in K2, P2 Rib for 10 rnds. BO loosely.

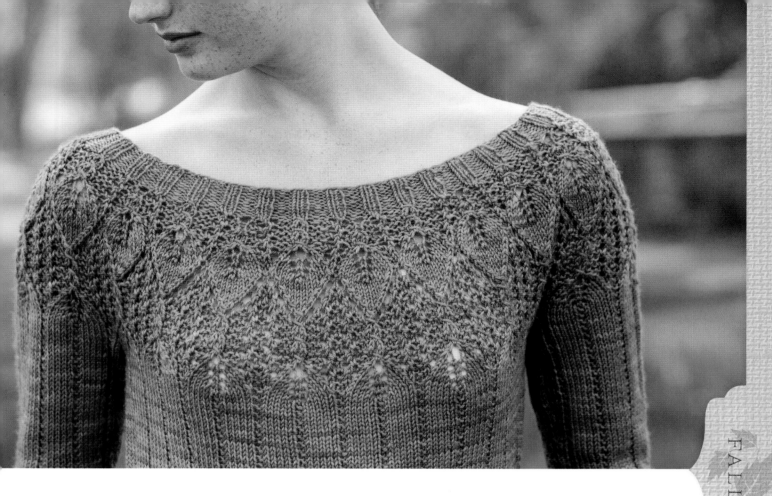

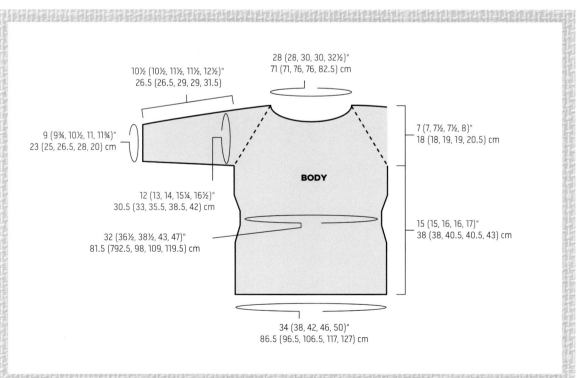

28 (28, 30, 30, 32½)"
71 (71, 76, 76, 82.5) cm

10½ (10½, 11½, 11½, 12½)"
26.5 (26.5, 29, 29, 31.5)

9 (9¾, 10½, 11, 11¾)"
23 (25, 26.5, 28, 20) cm

7 (7, 7½, 7½, 8)"
18 (18, 19, 19, 20.5) cm

BODY

12 (13, 14, 15¼, 16½)"
30.5 (33, 35.5, 38.5, 42) cm

32 (36½, 38½, 43, 47)"
81.5 (792.5, 98, 109, 119.5) cm

15 (15, 16, 16, 17)"
38 (38, 40.5, 40.5, 43) cm

34 (38, 42, 46, 50)"
86.5 (96.5, 106.5, 117, 127) cm

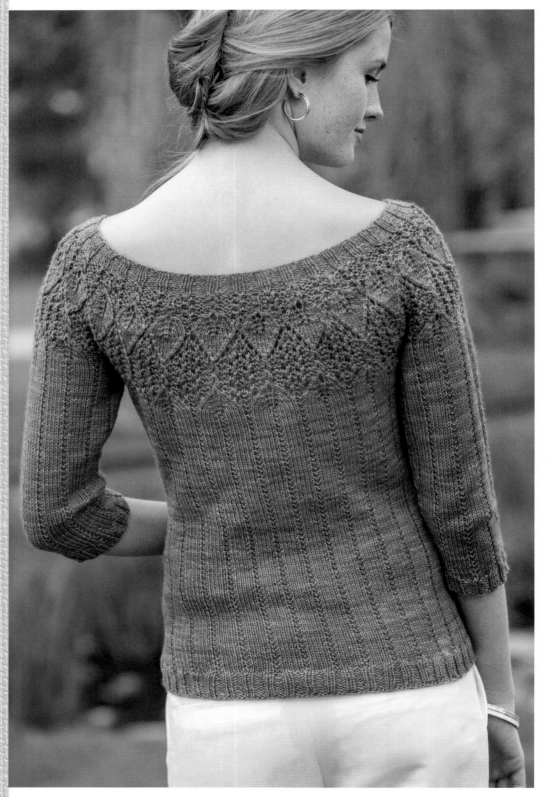

Sleeves

Place 60 (66, 72, 72, 78) sts on dpns. Beg at the underarm, CO 3 (3, 3, 6, 6) sts, place marker for beg of rnd, CO 3 (3, 3, 6, 6) sts, work in patt to end of rnd—66 (72, 78, 84, 90) sts. Cont in Garter Rib as established for 3 (2, 2, 1¼, 1¼)" (7.5 [5, 5, 3.2, 3.2] cm), end with Rnd 2 of Garter Rib.

DEC RND: K1, ssk, k to last 3 sts, k2tog, k1—2 sts dec'd.

Rep Dec rnd every 8th rnd 6 (7, 8, 9, 10) times—52 (56, 60, 64, 68) sts. Cont to work until sleeve measures 9½ (9½, 10½, 10½, 11½)" (24 [24, 26.5, 26.5, 29] cm) or about 1" (2.5 cm) shorter than desired length. Work in K2, P2 Rib for 8 rnds. BO loosely.

Finishing

Weave in all ends. Sew underarm seams. Block to measurements.

LACE YOKE

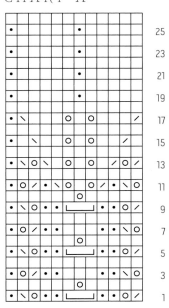

		k on RS; p on WS
	•	p on RS; k on WS
	O	yo
	/	k2tog
	\	sl 1, k1, psso
	↓2	knit into front and back of next st
	⅄	sl 1, k2tog, psso
	↓3	knit 1, yarn over, knit 1 in same st
	⌴	sl 1, k2, pass slipped st over both sts

CHART A

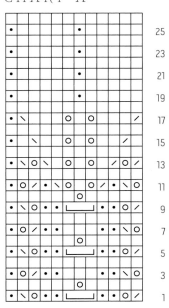

CHART B

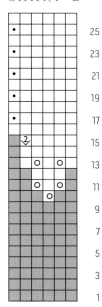

CHART C

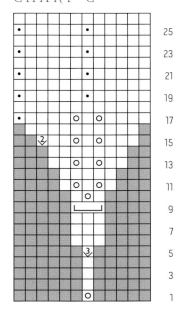

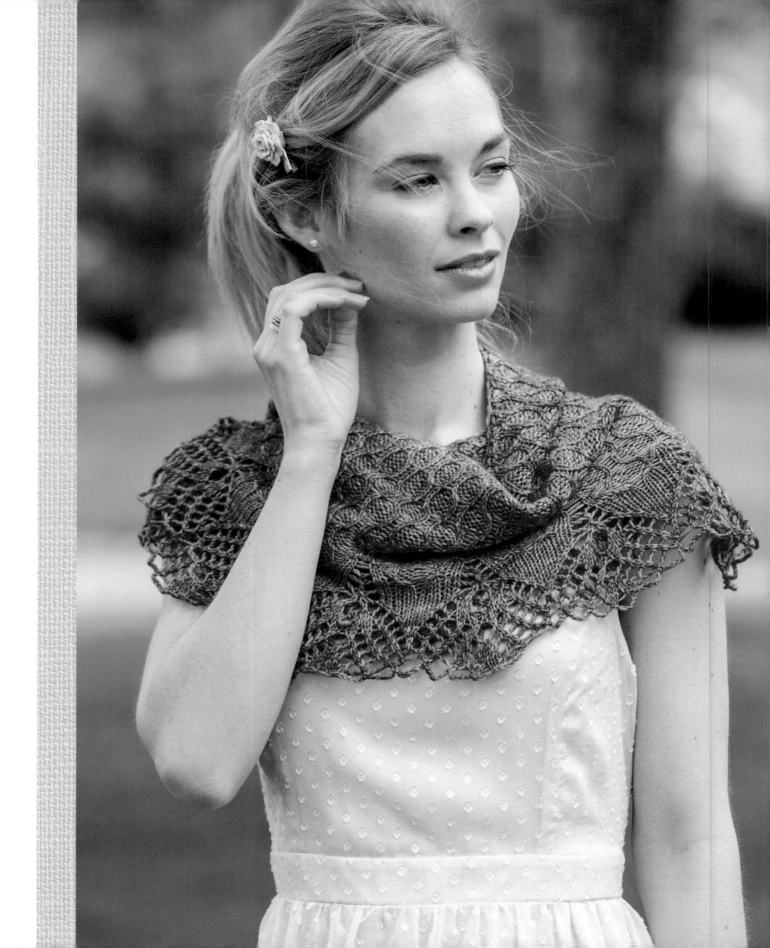

Emmylou

CRESCENT SHAWL

Short-rows and a gorgeous apple-colored yarn create a gently curved wrap that will brighten up your fall wardrobe. The simple cable patterns are a great way to practice cabling without a cable needle, and the texture of the body and simple lace edging let the gorgeous color and sheen of the yarn sing!

FINISHED SIZE
About 54" (137 cm) wide and 15" (38 cm) deep at center after blocking.

YARN
Fingering weight (#1 Super Fine).

Shown here: Hazel Knits Divine (75% superwash merino wool, 15% cashmere, 10% silk; 400 yd [366 m]/4 oz [115 g]), Braeburn, 1 skein.

NEEDLES
Size U.S. 6 (4 mm): 32" (81 cm) circular (cir).

Size U.S. E-4 (3.5 mm) crochet hook.

NOTIONS
Cable needle (cn); tapestry needle.

GAUGE
18 sts and 24 rows = 4" (10 cm) in Body Chart after blocking.

NOTES
This shawl is shaped with short-rows. At the beginning of each short-row, a yarnover is worked. These yarnovers will be worked together with the following st in pattern on the following row to close gaps using a k2tog or a p2tog. The yarnovers are not included in the stitch count.

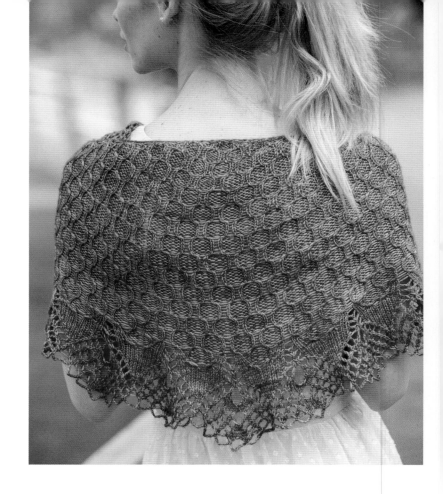

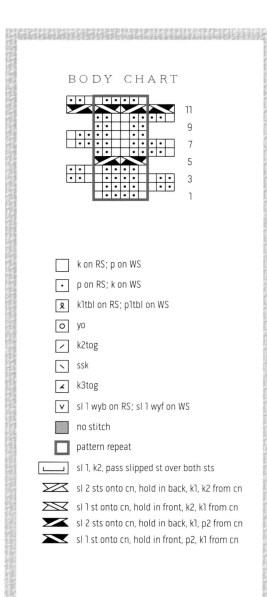

BODY CHART

11
9
7
5
3
1

☐	k on RS; p on WS
•	p on RS; k on WS
႙	k1tbl on RS; p1tbl on WS
o	yo
╱	k2tog
╲	ssk
�K	k3tog
v	sl 1 wyb on RS; sl 1 wyf on WS
▨	no stitch
☐	pattern repeat
⌣	sl 1, k2, pass slipped st over both sts
⧓	sl 2 sts onto cn, hold in back, k1, k2 from cn
⧓	sl 1 st onto cn, hold in front, k2, k1 from cn
⧓	sl 2 sts onto cn, hold in back, k1, p2 from cn
⧓	sl 1 st onto cn, hold in front, p2, k1 from cn

Shawl Body

CO 76 sts loosely over both needle tips. Carefully remove 2nd needle tip.

INC ROW: (RS) Sl 1, k1, *(k1, yo, k1) in next st; rep from * to last 2 sts, k1, k1 tbl—220 sts.

SET-UP ROW: (WS) Sl 1, k112, turn.

SHORT-ROW SHAPING
Work Body Chart as foll:

ROW 1: (RS) Yo, work 6 sts of chart, turn.

ROW 2: (WS) Yo, work 9 sts of chart, turn.

ROW 3: Yo, work 12 sts of chart, turn.

ROW 4: Yo, work 15 sts of chart, working 6-st rep twice, turn.

Continue to work chart in this way, working 3 more sts in each row and working a yarnover at the beg of each row, until Rows 1–12 of Body Chart have been worked 5 times, then work Rows 1–10 once more. Work yarnovers tog in patt with following st on following row using a k2tog or a p2tog.

ROW 11: (RS) Yo, work chart row to last 3 sts, k1, p1, k1 tbl.

ROW 12: (WS) Work chart row to last st, k1 tbl—220 sts.

Lace Edging

Work Rows 1–32 of the Edging Chart—404 sts.

EDGING CHART

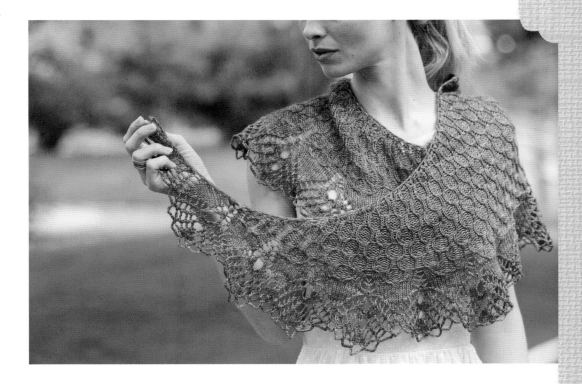

Crochet Bind-Off

With crochet hook, BO as follows: [insert hook in group of 2 sts, yarn over and draw lp through all sts on hook, ch 6] twice, *insert hook in group of 3 sts, yarn over and draw loop through all sts on hook, ch 6; rep from * to last 4 sts, insert hook in group of 2 sts, yarn over and draw lp through all sts on hook, ch 6, insert hook in group of 2 sts, yarn over and draw through all sts on hook. Fasten off.

Finishing

Weave in all ends, but do not trim. Block using desired method into crescent shape, pulling out points on crochet loops. Trim ends.

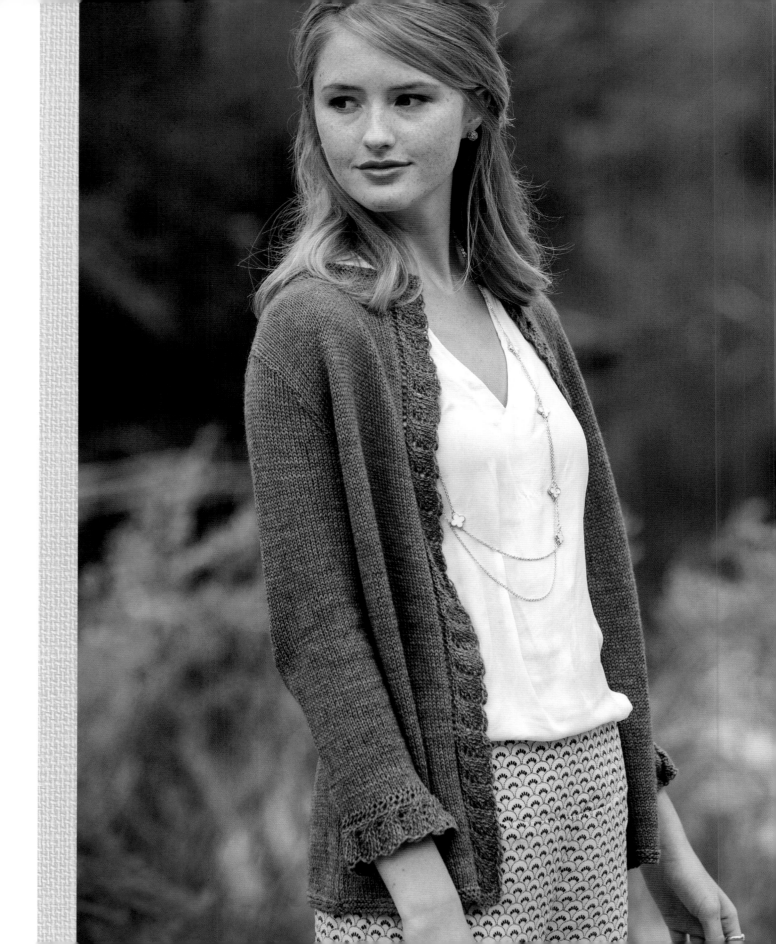

Rhetta

LACE-EDGED CARDIGAN

With an open, breezy silhouette and three-quarter sleeves, Rhetta is just right for those in-between days. The sumptuous yet lightweight alpaca and cotton yarn creates a piece you can easily fold up and carry in your purse for those just-in-case-you-need-a-sweater occasions.

FALL

FINISHED SIZE
About 29 (32, 36, 39½, 43)" (73.5 [81.5, 91.5, 100.5, 109] cm) bust circumference.

Sweater shown measures 32" (81.5 cm).

YARN
Fingering weight (#1 Super Fine).

Shown here: Manos del Uruguay Serena (60% alpaca, 40% cotton; 170 yd [155 m]/1¾ oz [50 g]), harbor (blue), 5 (5, 6, 7, 8) skeins.

NEEDLES
Size U.S. 5 (3.75 mm).

Adjust needle size if necessary to obtain the correct gauge.

NOTIONS
Markers (m); tapestry needle.

GAUGE
24 sts and 32 rows = 4" (10 cm) in St st.

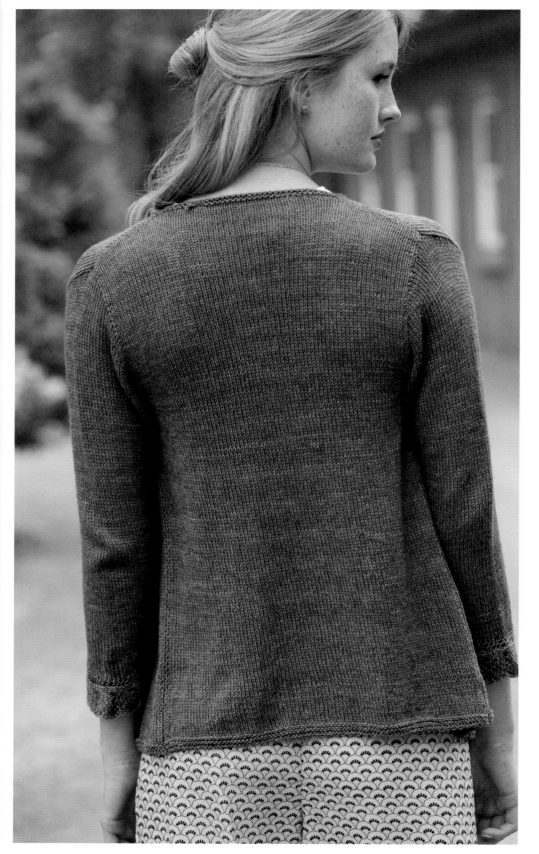

Back

CO 86 (96, 108, 118, 128) sts and work 5 rows in garter stitch (knit every row). Then work in St st (k on RS, p on WS) until back measures 15 (15, 16, 16, 17)" (38 [38, 40.5, 40.5, 43] cm) from the cast-on edge, end with a WS row.

ARMHOLE SHAPING

BO 4 (5, 5, 5, 6) sts at the beg of next 2 rows, 3 (3, 4, 5, 5) sts at the beg of the foll 2 rows. Then dec one st at each side of needle every RS row 3 times— 66 (74, 84, 92, 100) sts. Cont to work in St st until armhole measures 8 (8, 8½, 8½, 9)" (20.5 [20.5, 21.5, 21.5, 23] cm), end with a WS row.

SHAPE SHOULDERS

BO 6 (6, 8, 9, 9) sts at the beg of next 2 rows, 5 (6, 7, 8, 8) st at beg of foll 2 rows. Then BO 5 (6, 7, 7, 8) sts at beg of foll 2 rows— 34 (38, 40, 44, 50) sts. Work 4 rows in garter stitch. BO all rem sts.

Right Front

CO 60 (66, 72, 78, 84) sts and work 5 rows in garter stitch.

NEXT ROW: (RS) Work Right Lace Edging Chart over 12 sts, place marker (pm), work in St st to end.

Cont in patts as established until right front measures 15 (15, 16, 16, 17)" (38 [38, 40.5, 40.5, 43] cm) from the cast-on edge, end with a RS row.

ARMHOLE SHAPING

BO 4 (5, 5, 5, 6) sts at the beg of next WS row, 3 (3, 4, 5, 5) sts at the beg of the foll WS row. Then dec one st at armhole edge every RS row 3 times—50 (55, 60, 65, 70) sts.

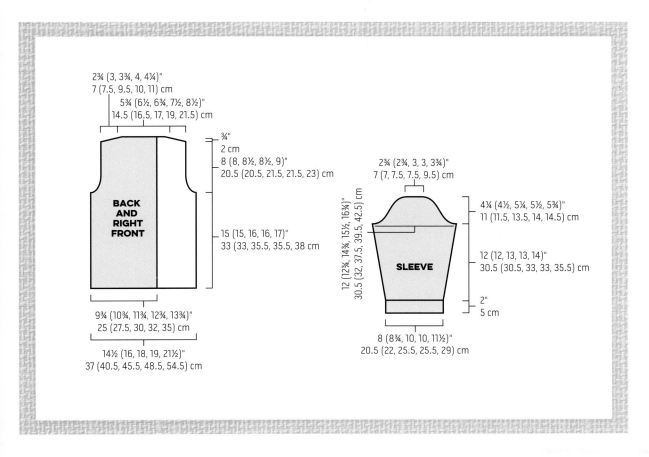

2¾ (3, 3¾, 4, 4¼)"
7 (7.5, 9.5, 10, 11) cm

5¾ (6½, 6¾, 7½, 8½)"
14.5 (16.5, 17, 19, 21.5) cm

¾"
2 cm

8 (8, 8½, 8½, 9)"
20.5 (20.5, 21.5, 21.5, 23) cm

BACK
AND
RIGHT
FRONT

15 (15, 16, 16, 17)"
33 (33, 35.5, 35.5, 38 cm

9¾ (10¾, 11¾, 12¾, 13¾)"
25 (27.5, 30, 32, 35) cm

14½ (16, 18, 19, 21½)"
37 (40.5, 45.5, 48.5, 54.5) cm

2¾ (2¾, 3, 3, 3¾)"
7 (7, 7.5, 7.5, 9.5) cm

4¼ (4½, 5¼, 5½, 5¾)"
11 (11.5, 13.5, 14, 14.5) cm

12 (12¾, 14¾, 15½, 16¾)"
30.5 (32, 37.5, 39.5, 42.5) cm

SLEEVE

12 (12, 13, 13, 14)"
30.5 (30.5, 33, 33, 35.5) cm

2"
5 cm

8 (8¾, 10, 10, 11½)"
20.5 (22, 25.5, 25.5, 29) cm

FALL

Cont to work in patts until armhole measures 8 (8, 8½, 8½, 9)" (20.5 [20.5, 21.5, 21.5, 23] cm), end with a RS row.

SHAPE SHOULDERS
BO 6 (6, 8, 9, 9) sts at the beg of next WS row, 5 (6, 7, 8, 8) sts at the beg of the foll WS row. Then BO 5 (6, 7, 7, 8) at the beg of the foll WS row—34 (37, 38, 41, 45) sts. Work 4 rows in garter stitch. BO all rem sts.

Left Front
CO 60 (66, 72, 78, 84) sts and work 5 rows in garter stitch.

NEXT ROW: (RS) Work in St st to last 12 sts, pm, work Left Lace Edging Chart to end.

Cont in patts as established until left front measures 15 (15, 16, 16, 17)" (38 [38, 40.5, 40.5, 43] cm) from the cast-on edge, end with a WS row.

ARMHOLE SHAPING
BO 4 (5, 5, 5, 6) sts at the beg of next RS row, 3 (3, 4, 5, 5) sts at the beg of the foll RS row.

Then dec one st at armhole edge every RS row 3 times—50 (55, 60, 65, 70) sts.

Cont to work in patts until armhole measures 8 (8, 8½, 8½, 9)" (20.5 [20.5, 21.5, 21.5, 23] cm), end with a WS row.

SHAPE SHOULDERS
BO 6 (6, 8, 9, 9) sts at the beg of next RS row, 5 (6, 7, 8, 8) sts at the beg of the foll RS row. Then BO 5 (6, 7, 7, 8) at the beg of the foll RS row—34 (37, 38, 41, 45) sts. Work 1 WS row in patt. Work 4 rows in garter stitch. BO all rem sts.

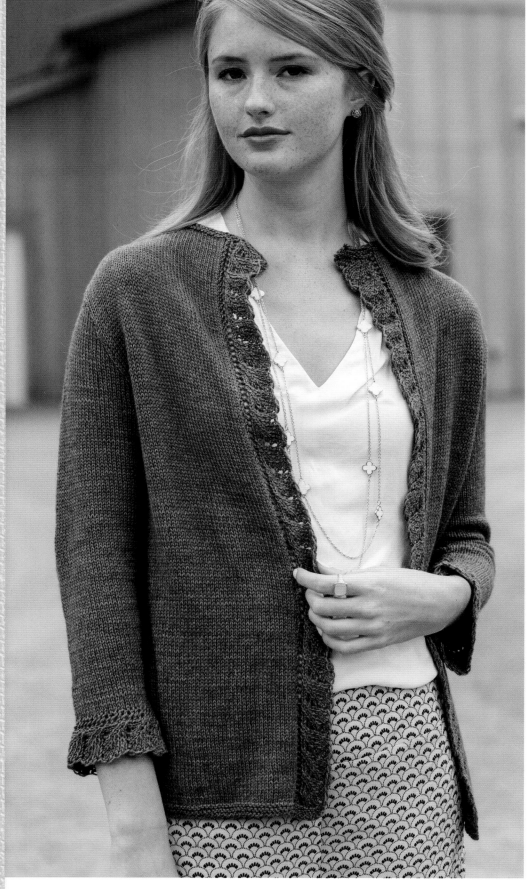

Right Sleeve

CO 12 sts. Work 12 rows of Right Lace Edging Chart 6 (6, 7, 7, 8) times, then work through row 0 (8, 4, 4, 8) once more. BO loosely.

With RS facing and working along garter (left) side edge, pick up and knit about 2 sts for every 3 rows—48 (52, 60, 60, 68) sts.

Work in St st, increasing one st at each side every 6 rows 6 (6, 8, 12, 12) times, then every 8 rows 6 (6, 6, 4, 4) times—72 (76, 88, 92, 100) sts. Work even until sleeve measures 12 (12, 13, 13, 14)" (30.5 [30.5, 33, 33, 35.5] cm) from pick-up row, end with a WS row.

ARMHOLE/SLEEVE CAP SHAPING

BO 4 (5, 5, 5, 6) sts at the beg of next 2 rows, 3 (3, 4, 5, 5) sts at the beg of the foll 2 rows. Then dec one st at armhole edge every RS row 11 (12, 14, 15, 16) times. BO 2 sts at the beg of next 4 (4, 6, 6, 6) rows, then BO 3 sts at the beg of next 4 rows—16 (16, 18, 18, 22) sts. BO all sts.

Left Sleeve

Work as for right sleeve, working Left Lace Edging Chart at cuff.

Finishing

Block pieces to measurements. Sew shoulder, side, and sleeve seams. Set in sleeves. Weave in remaining ends.

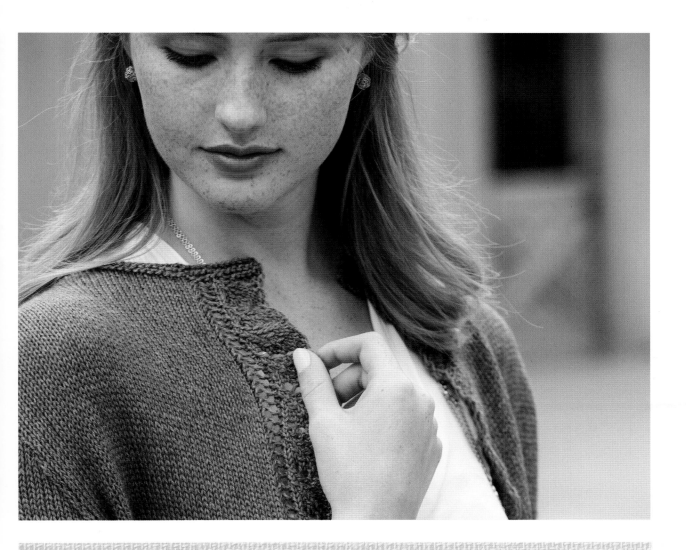

RIGHT LACE EDGING CHART

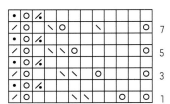

LEFT LACE EDGING CHART

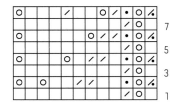

	k on RS; p on WS
•	p on RS; k on WS
o	yo
/	k2tog
\	ssk
⟋	k2tog on WS

FALL

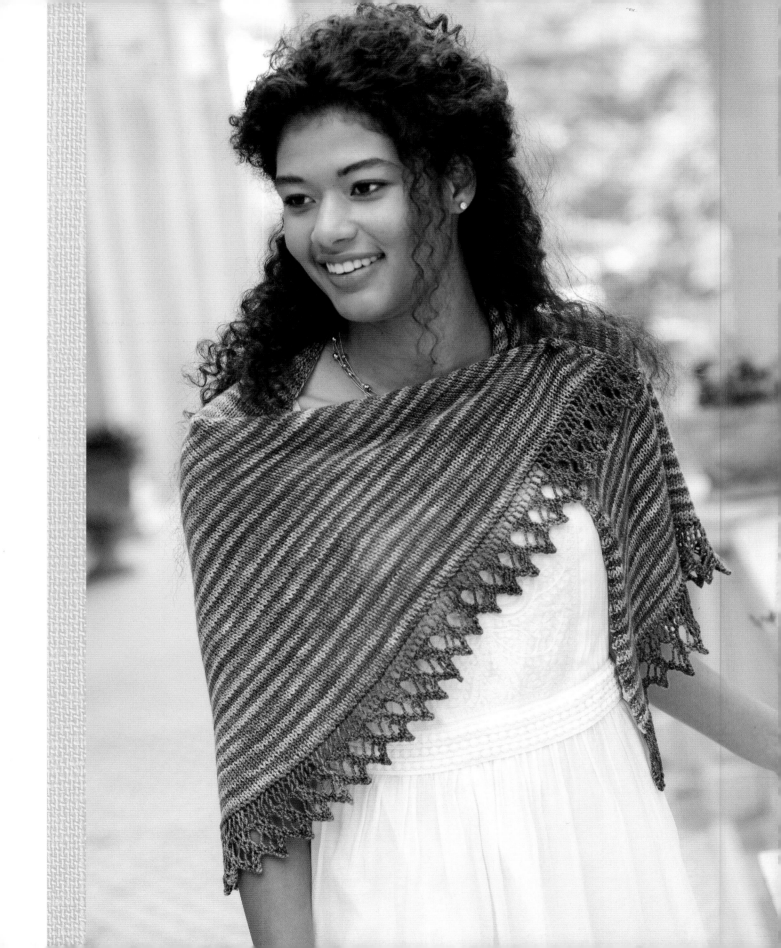

Wiley

STRIPED SHAWL

Wiley is a great choice for a beginner's shawl project. A simple lace edging is applied at the end, binding off all the live stitches as you go, so no unmanageably long bind-off is required. Soft stripes in coordinating colors and a five-eighths-circle shape make for a sumptuous shawl that's perfect to wrap up in when the first chill of fall rolls in.

FINISHED SIZE
About 47" (119.5 cm) wide and 27" (68.5 cm) long from center of top edge to tip of lower point after blocking.

YARN
Fingering weight (#1 Super Fine)

Shown here: Baah Yarn La Jolla (100% superwash merino wool; 400 yd [366 m]/3½ oz [100 g]), pecan (MC) and sage (CC), 1 hank of each.

NEEDLES
Size U.S. 6 (4 mm): 40" (100 cm) circular (cir) and 1 double-pointed (dpn) if desired to work edging.

Adjust needle size if necessary to obtain the correct gauge.

NOTIONS
Markers (m); tapestry needle.

GAUGE
19 sts and 30 rows = 4" (10 cm) in St st after blocking.

NOTES
This shawl has slightly unusual shaping. Instead of the standard 4 increases on every right-side row, there are 10 increases worked over 4 rows—4 on the first row and 6 on the 3rd row.

It's easy to keep track of the increases on the striped portion; the contrast color stripes have 6 increases on the right side, and the main color stripes have only 4.

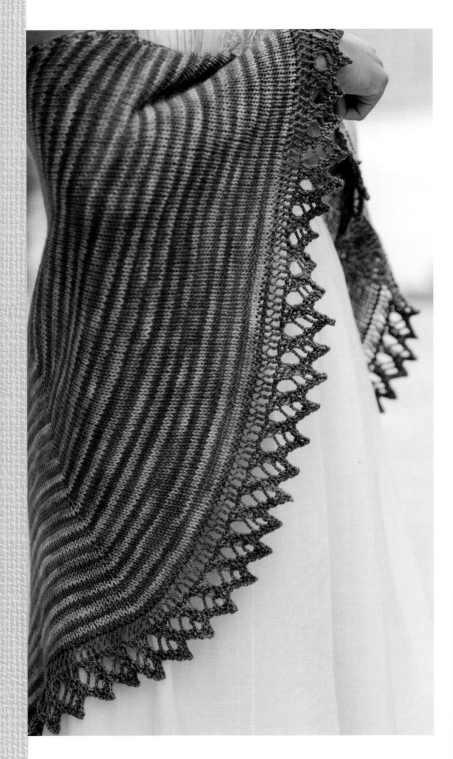

Shawl

With cir needle and MC, CO 5 sts.

ROW 1: (RS) With MC, [k1f&b] 4 times, k1—9 sts.

ROW 2: (WS) With CC, k2, p5, k2.

ROW 3: With CC, k1, [k1f&b] 6 times, k2—15 sts.

ROW 4: With MC, k2, p3, place marker (pm), p3, pm, p2, pm, p3, k2.

INCREASE AND STRIPE SEQUENCE

ROW 1: (RS) With MC, [k to one st before maker, k1f&b, sm] twice, k1f&b, k to marker, sm, k1f&b, k to end—4 sts inc'd.

ROW 2: (WS) With CC, k2, p to last 2 sts, k2.

ROW 3: With CC, k1, k1f&b, [k to one st before maker, k1f&b, sm] twice, k1f&b, k to marker, sm, k1f&b, k to last 3 sts, k1f&b, k2—6 sts inc'd.

ROW 4: With MC, k2, p to last 2 sts, k2.

Rep Rows 1–4, inc'ing 10 sts each 4-row rep, 32 more times— 345 sts.

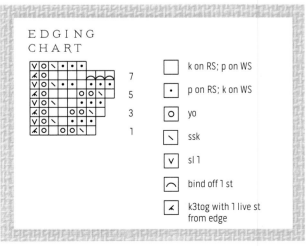

EDGING CHART

											7
											5
											3
											1

☐ k on RS; p on WS

• p on RS; k on WS

○ yo

╲ ssk

∨ sl 1

⌒ bind off 1 st

⟋ k3tog with 1 live st from edge

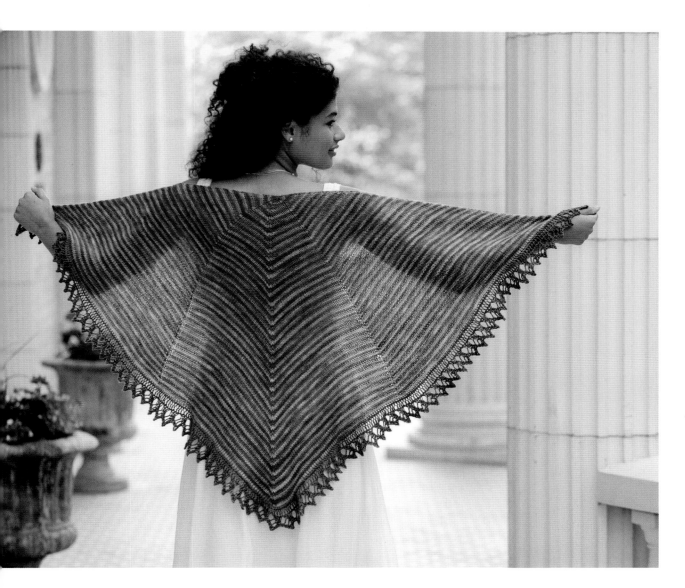

Edging

With MC, CO 6 sts. With dpn, rep Rows 1–8 of Edging Chart, working a k3tog at the end of every RS row with one live stitch from the shawl until all live sts have been joined. BO edging sts.

Finishing

Weave in ends, but do not trim. Block shawl using desired method, bringing out the points on the shawl edging. Trim ends.

Glossary

ABBREVIATIONS

beg	begin(ning)	**LH**	left hand	**sl1yo**	slip one, yarnover
BO	bind off	**m**	marker(s)	**sm**	slip marker
ch	chain	**M1**	make one (increase)	**ssk**	slip 2 stitches knitwise one at a time; insert point of left needle into front of 2 slipped stitches and knit them together through back loops with right needle
cir	circular	**M1P**	make one purl		
cn	cable needle	**p**	purl		
CO	cast on	**p1f&b**	purl into front and back of same stitch		
cont	continue(s); continuing	**p2tog**	purl 2 stitches together		
dec(s)('d)	decrease(s); decreasing; decreased	**patt(s)**	pattern(s)	**sssk**	slip 3 stitches knitwise one at a time; insert point of left needle into front of 3 slipped stitches and knit them together with right needle
dpn(s)	double-pointed needle(s)	**pm**	place marker		
foll(s)	follow(s); following	**pwise**	purlwise, as if to purl		
inc(s)('d)	increase(s); increasing; increased	**rem**	remain(s); remaining	**St st**	stockinette stitch
		rep	repeat(s); repeating	**st(s)**	stitch(es)
k	knit	**RH**	right hand	**tbl**	through back loop
k1f&b	knit into the front and back of the same stitch	**rnd(s)**	round(s)	**tog**	together
		RS	right side	**WS**	wrong side
k2tog	knit 2 stitches together	**sc**	single crochet	**wyb**	with yarn in back
k3tog	knit 3 stitches together	**sl**	slip	**wyf**	with yarn in front
kwise	knitwise, as if to knit	**sl st**	slip stitch (crochet)	**yo**	yarnover

Bind-Offs

STANDARD BIND-OFF

Knit the first stitch, *knit the next stitch (two stitches on right needle), insert left needle tip into first stitch on right needle (**fig. 1**) and lift this stitch up and over the second stitch (**fig. 2**) and off the needle (**fig. 3**). Repeat from * for the desired number of stitches.

THREE-NEEDLE BIND-OFF

Place the stitches to be joined onto two separate needles and hold the needles parallel so that the right sides of knitting face together. Insert a third needle into the first stitch on each of two needles (**fig. 1**) and knit them together as one stitch (**fig. 2**), *knit the next stitch on each needle the same way, then use the left needle tip to lift the first stitch over the second and off the needle (**fig. 3**). Repeat from * until no stitches remain on first two needles. Cut yarn and pull tail through last stitch to secure.

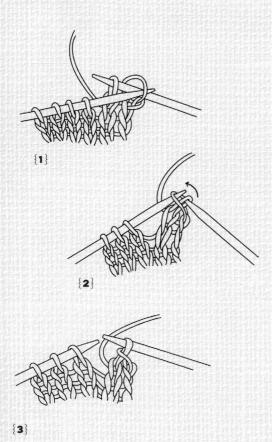

{1}

{2}

{3}

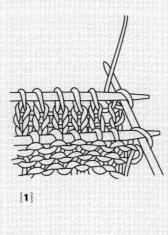

{1}

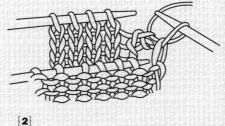

{2}

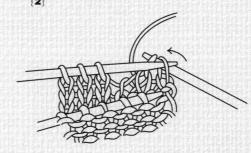

{3}

Cast-Ons

BACKWARD-LOOP CAST-ON

*Loop working yarn and place it on needle backward so that it doesn't unwind. Repeat from *.

CABLE CAST-ON

If there are no stitches on the needles, make a slipknot of working yarn and place it on the left needle, then use the knitted method to cast-on one more stitch—two stitches on needle. When there are at least two stitches on the left needle, hold needle with working yarn in your left hand. *Insert right needle between the first two stitches on left needle (**fig. 1**), wrap yarn around needle as if to knit, draw yarn through (**fig. 2**), and place new loop on left needle (**fig. 3**) to form a new stitch. Repeat from * for the desired number of stitches, always working between the first two stitches on the left needle.

KNITTED CAST-ON

If there are no stitches on the needles, make a slip-knot of working yarn and place it on the left needle. When there is at least one stitch on the left needle, *use the right needle to knit the first stitch (or slip-knot) on left needle (**fig. 1**) and place new loop onto left needle to form a new stitch (**fig. 2**). Repeat from * for the desired number of stitches, always working into the last stitch made.

LONG-TAIL (CONTINENTAL) CAST-ON

Leaving a long tail (about ½" [1.3 cm] for each stitch to be cast on), make a slipknot and place on right needle. Place thumb and index finger of your left hand between the yarn ends so that working yarn is around your index finger and tail end is around your thumb and secure the yarn ends with your other fingers. Hold your palm upward, making a V of yarn (fig. 1). *Bring needle up through loop on thumb (fig. 2), catch first strand around index finger, and go back down through loop on thumb (fig. 3). Drop loop off thumb and, placing thumb back in V configuration, tighten resulting stitch on needle (fig. 4). Repeat from * for the desired number of stitches.

Crochet

CHAIN

Make a slipknot and place on crochet hook. *Yarn over hook and draw through a loop on the hook. Repeat from * for the desired number of stitches. To fasten off, cut yarn and draw end through last loop formed.

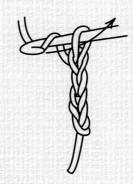

SLIP STITCH (SL ST)

*Insert hook into stitch, yarn over hook and draw loop through stitch and loop on hook. Repeat from *.

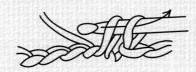

SINGLE CROCHET

*Insert hook into the second chain from the hook (or the next stitch), yarn over hook and draw through a loop, yarn over hook (fig. 1), and draw it through both loops on hook (fig. 2). Repeat from * for the desired number of stitches.

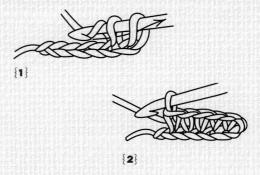

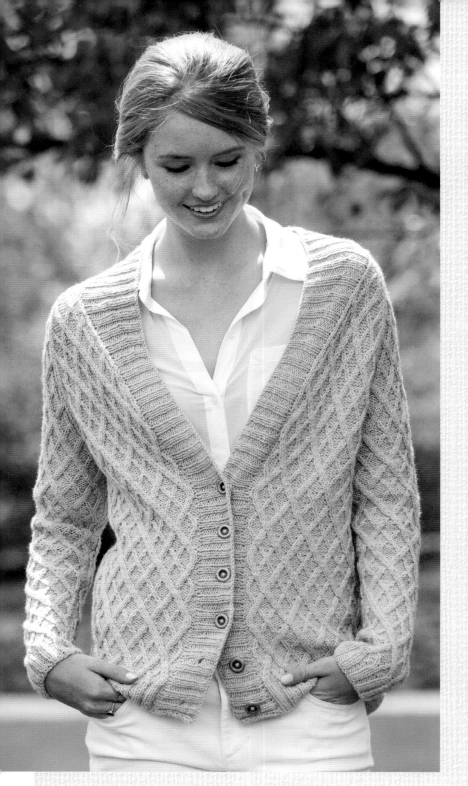

Decreases

KNIT 2 TOGETHER (K2TOG)

Knit two stitches together as if they were a single stitch.

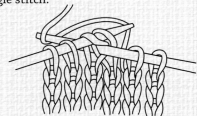

KNIT 3 TOGETHER (K3TOG)

Knit three stitches together as if they were a single stitch.

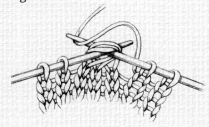

SLIP, SLIP, KNIT (SSK)

Slip two stitches individually knitwise (**fig. 1**), insert left needle tip into the front of these two slipped stitches, and use the right needle to knit them together through their back loops (**fig. 2**).

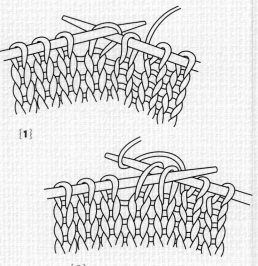

{1}

{2}

Grafting

KITCHENER STITCH

Arrange stitches on two needles so that there is an equal number of stitches on each needle. Hold the needles parallel to each other with wrong sides of the knitting together. Allowing about ½" (1.3 cm) per stitch to be grafted, thread matching yarn on a tapestry needle. Work from right to left as follows:

Step 1. Bring tapestry needle through the first stitch on the front needle as if to purl and leave the stitch on the needle (**fig. 1**).

Step 2. Bring tapestry needle through the first stitch on the back needle as if to knit and leave that stitch on the needle (**fig. 2**).

Step 3. Bring tapestry needle through the first front stitch as if to knit and slip this stitch off the needle. Then bring tapestry needle through the next front stitch as if to purl and leave this stitch on the needle (**fig. 3**).

Step 4. Bring tapestry needle through the first back stitch as if to purl and slip this stitch off the needle. Then bring tapestry needle through the next back stitch as if to knit and leave this stitch on the needle (**fig. 4**).

Repeat Steps 3 and 4 until one stitch remains on each needle, adjusting the tension to match the rest of the knitting as you go. To finish, bring tapestry needle through the front stitch as if to knit and slip this stitch off the needle. Then bring tapestry needle through the back stitch as if to purl and slip this stitch off the needle.

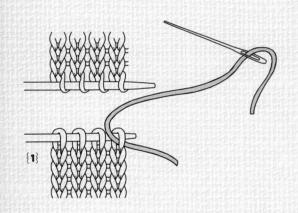

{1}

{2}

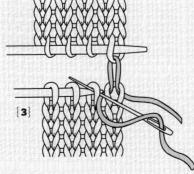

{3}

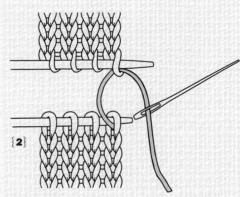

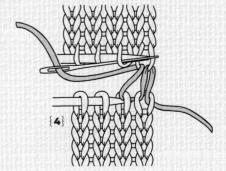

{4}

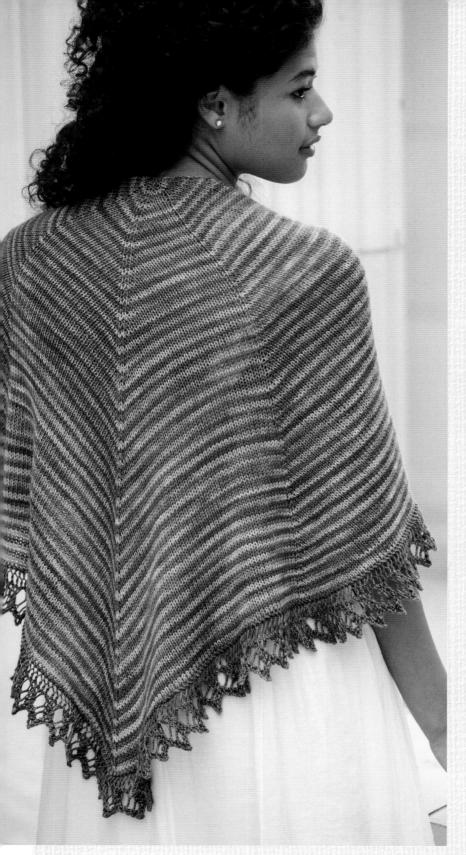

I-Cord

APPLIED I-CORD

When attaching to an edge without live stitches: With double-pointed needle, cast on number of stitches directed in pattern. With right side of garment facing, *pick up and knit one stitch from edge, slide stitches to opposite end of double-pointed needle, knit to last two stitches, knit two together through the back loop; repeat from * for I-cord.

I-CORD

This is worked with two double-pointed needles. Cast on the desired number of stitches (usually three to four). Knit across these stitches, then *without turning the needle, slide stitches to other end of needle, pull the yarn around the back, and knit the stitches as usual. Repeat from * for desired length.

Increases

BAR INCREASE

KNITWISE (K1F&B)

Knit into a stitch but leave the stitch on the left needle (**fig. 1**), then knit through the back loop of the same stitch (**fig. 2**) and slip the original stitch off the needle (**fig. 3**).

PURLWISE (P1F&B)

Work as for a knitwise bar increase, but purl into the front and back of the same stitch.

RAISED MAKE-ONE (M1) INCREASE

Note: Use the left slant if no direction of slant is specified.

RIGHT SLANT (M1R)

With left needle tip, lift the strand between the needles from back to front (**fig. 1**). Knit the lifted loop through the front (**fig. 2**).

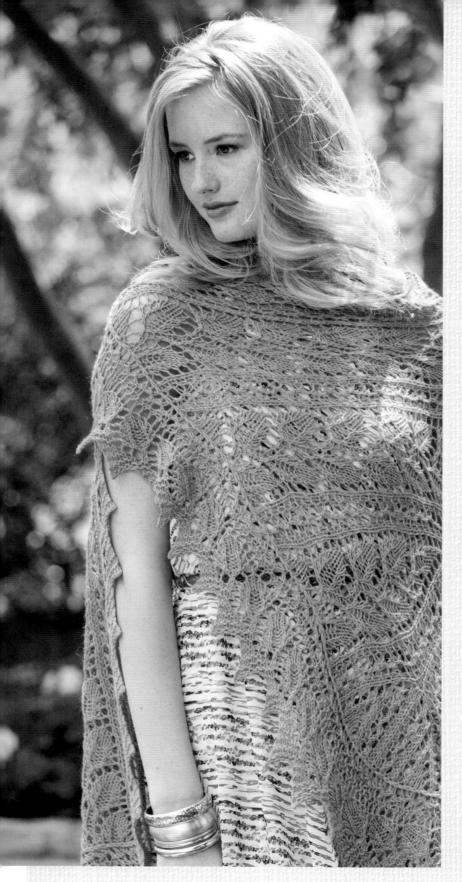

LEFT SLANT (M1L)

With left needle tip, lift the strand between the last knitted stitch and the first stitch on the left needle from front to back (**fig. 1**), then knit the lifted loop through the back (**fig. 2**).

{1}

{2}

PURLWISE (M1P)

With left needle tip, lift the strand between the needles from front to back (**fig. 1**), then purl the lifted loop through the back (**fig. 2**).

{1}

{2}

Pick Up and Knit

ALONG CAST-ON OR BIND-OFF EDGE

With right side facing and working from right to left, insert the tip of the needle into the center of the stitch below the bind-off or cast-on edge (**fig. 1**), wrap yarn around needle, and pull through a loop (**fig. 2**). Pick up one stitch for every existing stitch.

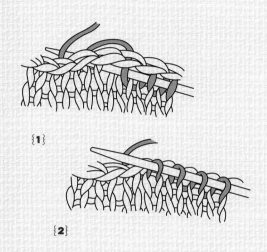

ALONG SHAPED EDGE

With right side facing and working from right to left, insert tip of needle between last and second-to-last stitches, wrap yarn around needle, and pull through a loop. Pick up and knit about three stitches for every four rows, adjusting as necessary so that picked-up edge lays flat.

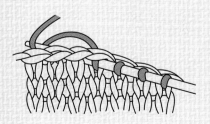

Pick Up and Purl

With wrong side of work facing and working from right to left, *insert needle tip under purl stitch in the last row from the far side to the near side (**fig. 1**), wrap yarn around needle, and pull a loop through (**fig. 2**). Repeat from * for desired number of stitches.

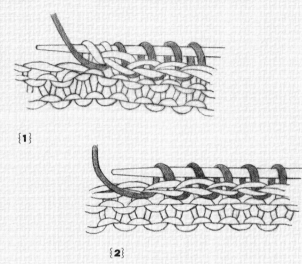

Wrap and Turn (w&t)

KNIT ROW: With yarn in back, slip next st as if to purl (**fig. 1**) and bring yarn to front. Return the slipped stitch to the left needle (**fig. 2**). Take the yarn to the back between the needles and turn the work.

PURL ROW: With yarn in front, slip next stitch as if to purl and bring yarn to back. Return the slipped stitch to the left needle, take the yarn to the front between the needles, and turn the work.

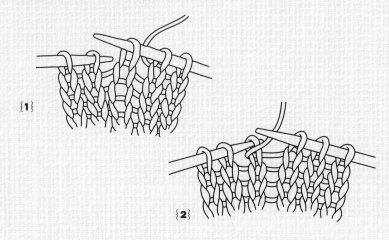

Yarn Sources

ANZULA
740 H St.
Fresno, CA 93721
anzula.com

BAAH YARN!
(760) 917-4151
baahyarn.com

**CRYSTAL
PALACE YARNS**
160 23rd St.
Richmond, CA 94804
straw.com

DREAM IN COLOR
907 Atlantic Ave.
West Chicago, IL 60185
dreamincoloryarn.com

**THE FIBRE COMPANY/
KELBOURNE WOOLENS**
2000 Manor Rd.
Conshohocken, PA 19428
(484) 368-3666

**GREEN MOUNTAIN
SPINNERY**
7 Brickyard Ln.
Putney, VT 05346
(800) 321-9665
spinnery.com

HAZEL KNITS
PO Box 28921
Seattle, WA 98118
hazelknits.com

KNITTED WIT
knittedwit.com

LORNA'S LACES YARNS
4229 N. Honore St.
Chicago, IL 60613
(773) 935-3803
lornaslaces.net

**MANOS DEL
URUGUAY/FAIRMOUNT
FIBERS**
915 N. 28th St.,
Philadelphia, PA 19130
(888) 566-9970
fairmountfibers.com

SHALIMAR YARNS
(240) 357-4614
shalimaryarns.com

SHIBUI KNITS
1500 NW 18th Ave., Ste. 110
Portland, OR 97209
shibuiknits.com

SINCERE SHEEP
sinceresheep.com

STITCH SPROUTS
(877) 781-2042
stitchsprouts.com

**SWEET GEORGIA
YARNS INC.**
110-408 E. Kent Ave. So.
Vancouver, BC
Canada V5X 2X7
(604) 569-6811
sweetgeorgiayarns.com

Index

KNIT MORE *stylish* DESIGNS FOR ANY SEASON
WITH THESE RESOURCES FROM INTERWEAVE

NEW AMERICAN KNITS
Classic Sportswear Patterns
Amy Christoffers
ISBN 978-1-62033-099-9, $24.99

FREE-SPIRIT SHAWLS
20 Eclectic Knits for Every Day
Lisa Shroyer
ISBN 978-1-59668-904-6, $24.95

LIGHT & LAYERED KNITS
19 Sophisticated Designs
for Every Season
Vicki Square
ISBN 978-1-59668-795-0, $24.95

Join Knittingdaily.com, an online community that shares your passion for knitting. You'll get a free eNewsletter, free patterns, a projects store, a daily blog, event updates, galleries, tips and techniques, and more. Sign up at **Knittingdaily.com.**

KNITS

From cover to cover, *Interweave Knits* magazine presents great projects for the beginner to the advanced knitter. Every issue is packed full of captivating, smart designs, step-by-step instructions, easy-to–understand illustrations, plus well-written, lively articles sure to inspire. **Interweaveknits.com**

AVAILABLE AT YOUR FAVORITE RETAILER
OR SHOP.KNITTINGDAILY.COM